A THRILLING RIDE

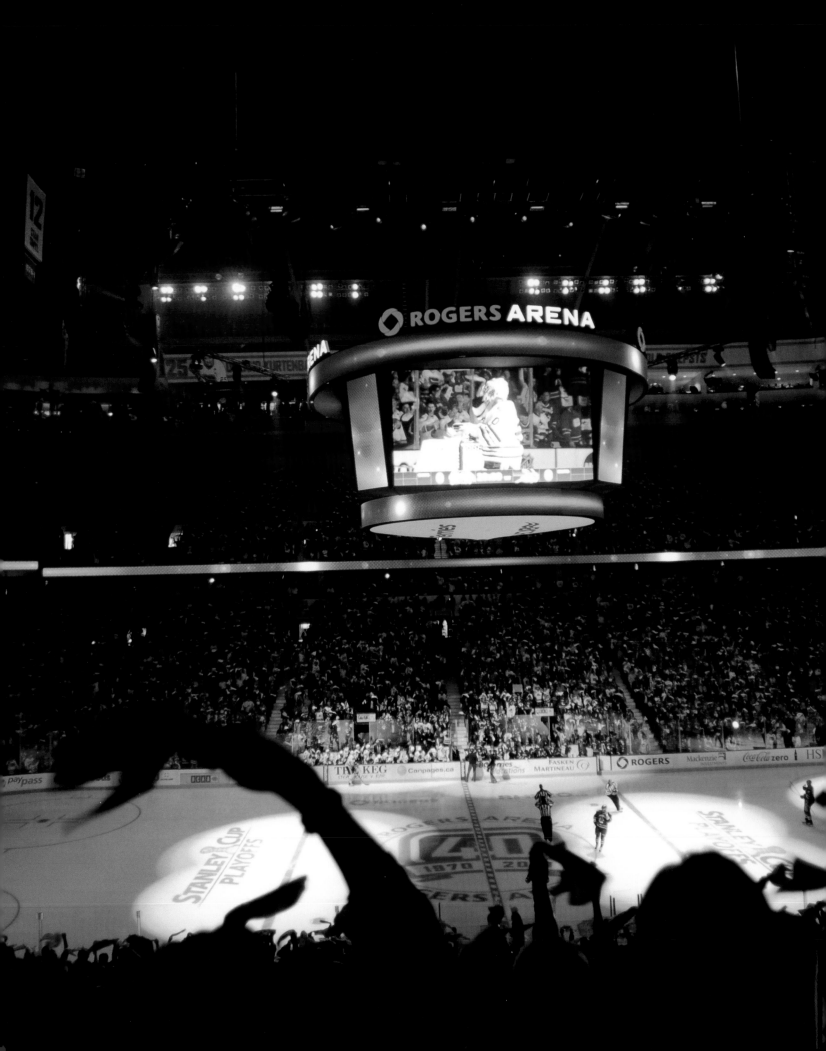

The Vancouver Canucks' 40th Anniversary Season

A THRILLING RIDE

Foreword by **PAT QUINN**

Featuring writers from
THE PROVINCE and **THE VANCOUVER SUN**

Edited by **Paul Chapman** and **Bev Wake**

GREYSTONE BOOKS
D&M PUBLISHERS INC.
Vancouver/Toronto/Berkeley

THE VANCOUVER SUN The Province

POSTMEDIA NETWORK INC.™

To the loyal Canuck fans who steadfastly supported
their team on this forty-year journey and who keep believing.

And to the 2010–11 Canucks: Thanks for a magical season.

Co-published by Greystone Books, *The Province,* and *The Vancouver Sun*

Greystone Books
An imprint of D&M Publishers Inc.
2323 Quebec Street, Suite 201
Vancouver BC Canada V5T 4S7
www.greystonebooks.com

Cataloguing data available from Library and Archives Canada
ISBN 978-1-926812-91-5 (pbk.)
ISBN 978-1-926812-92-2 (ebook)

Editing by Michelle Benjamin
Copyediting by Peter Norman
Interior design by Heather Pringle
Front cover photograph by Jeff Vinnick/NHLI/Getty Images
Back cover photograph by Ian Lindsay/PNG
Full photography credits on page 157
Printed and bound in Canada by Friesens
Text printed on acid-free paper
Distributed in the U.S. by Publishers Group West

Greystone gratefully acknowledges the financial support of the Canada Council for the
Arts, the British Columbia Arts Council, the Province of British Columbia through the
Book Publishing Tax Credit, and the Government of Canada through the Canada Book
Fund for our publishing activities.

CONTENTS

FOREWORD
BY PAT QUINN

I CAME TO VANCOUVER in 1970 from Toronto, which was a good city to play in—they could fill the building. But when I arrived to play with the new expansion Canucks, fans were interested in the Original Six teams. And we couldn't even get our ownership right. Things were unstable until 1974 when the Griffith family stepped in and saved the franchise.

When I came back in 1987 as President and General Manager, alumni were ignored, and we had ongoing coaching and management issues. It led to instability. We drew 6,500 people per game, the organization was going out of business, and ownership wanted to sell the club, but nobody would buy it. In the 1990s, we built up this team and made an exciting run for the Cup. But more ownership changes brought more instability.

Those are the ups and downs players and fans in this city have faced. I've watched these fans over the years—it used to be a quiet crowd, even when the building was full. But this city has grown a love for the game. The team captured imaginations again and the fans came back.

The 2010–2011 Canucks carried great expectations on their shoulders from day one of training camp—from management, from the media, from fans. People believed in these Canucks, even though past performances wouldn't lead you to think this would be a good playoff team, that they'd be a final-four team, or a final-two for that matter. But that's fandom, that's hope.

At the start of this season, I didn't necessarily see that this was a winning team. It was a good roster, but it takes more than that. The defence was skilled and quick, but had been pushed around by Chicago for the past two playoffs. There were questions about whether the team's top players could be top players come playoffs. But the regular season was phenomenal. They had top performances from terrific hockey players. The players grew. We didn't hear any more "woe is me" when things weren't going well. Alain Vigneault weathered the

criticism, and this team got better as the year went on. Ryan Kesler emerged as a star. The Sedins—their talent is incredible. I also liked the team's depth—they could play four lines, and that's one similarity with the 1994 team.

Once they hit the playoffs, there was another burden to overcome. They hadn't been a strong playoff team, and they were facing Chicago. They were exceptional the first three games, but we saw a bit of doubt creep into their game. They started to hang back, they gave Chicago space to play and, sure enough, the Blackhawks made a series of it. Seven games and then overtime—that was a big hump to get over, but they did it.

That victory seemed to bring air into their lungs.

Next came Nashville, and even though the scores were close, I don't think the Predators gave them much competition. Vancouver looked much better as a team. A lot of us thought San Jose would give them a ride, but it turned out that the Sharks weren't in the same class.

In the tremendous final series, goaltending made the difference—good goalies can do that, and Roberto Luongo and Tim Thomas are two of the best. It was a fast, hard-hitting, rough-and-tumble series, but in the end the Boston Bruins came out on top. The Bruins won the Stanley Cup and once again Canucks fans—who have been waiting for so long—had to put their celebrations on hold. But no one can deny that they enjoyed an entertaining and exciting season, full of promise and skill. All in all, it was a fantastic year for this franchise. And even though they didn't get to carry the Cup, the players earned their spurs. And they'll be back next year.

 PAT QUINN was a powerful blueliner for the inaugural Vancouver Canucks team in 1970. He returned as President and General Manager in 1987 and took over head coaching duties from 1991 to 1994. He was responsible for significant player acquisitions including Kirk McLean, Pavel Bure, and Trevor Linden, and in 1994 led the team to the Stanley Cup finals against the New York Rangers. A two-time Jack Adams Award winner, Quinn coached NHL teams in Edmonton, Philadelphia, Los Angeles, and Toronto, and coached Team Canada to gold medals at the 2002 Winter Olympics, 2008 IIHF World Under 18 Championship, 2009 World Junior Championship, and the World Cup of Hockey in 2004.

INTRODUCTION

THE VANCOUVER CANUCKS never had a chance. Or so it seemed. They were 0–1 before ever playing a game in the National Hockey League. The Canucks' roulette-wheel loss that allowed the Buffalo Sabres to pick Gilbert Perreault first in the 1970 entry draft came to represent a lot more than one unlucky day. That unfortunate spin symbolized the bad luck and bad decisions that would stall the Canucks for most of their first two decades.

They finished above .500 just twice in their first twenty-one seasons and won their way past the first round of the playoffs only once—during the franchise's lightning-strike run to the 1982 Stanley Cup Final after a seventy-seven-point regular season.

Former coach and general manager Pat Quinn brought credibility and better players to the Canucks in the early 1990s, and when a dynamic Vancouver team lost the 1994 Stanley Cup Final to the New York Rangers in seven games, the franchise seemed finally on the cusp of a golden era. Four years later, they had become one of the worst teams in hockey. The arrival of general manager Brian Burke probably saved the franchise in Vancouver, and the Canucks have been a superior team since the start of the twenty-first century.

But when they crashed several times against the glass ceiling of the playoffs' second round, it merely reinforced the Canucks' hard-earned reputation for underachievement.

Under coach Alain Vigneault and GM Mike Gillis, who arrived in 2008, the Canucks became better than they'd ever been, averaging 107 points in the tandem's first three seasons. Gillis retained the best pieces accumulated by Burke and former manager Dave Nonis—Daniel and Henrik Sedin, Ryan Kesler and Alex Burrows, Roberto Luongo—and augmented those with strategic acquisitions like Manny Malhotra and Dan Hamhuis, and an ambitious player-development program that provided depth to the organization.

The Canucks had never had a season like 2010–2011. They crushed the old franchise record with a 117-point campaign and won their first Presidents' Trophy by ten points. Vancouver was first in the NHL in scoring and in goals against. The Canucks led in power play efficiency and were third in penalty killing. Daniel Sedin won the scoring title.

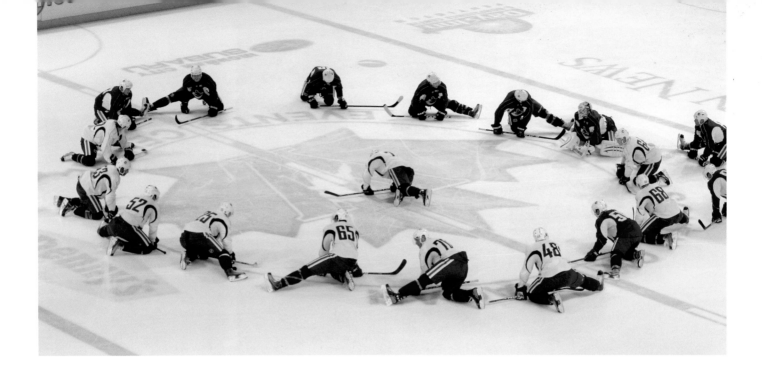

Even luck, the Canucks' blood enemy, seemed to be on their side, as only a well-timed series of major injuries allowed Vancouver to navigate the NHL salary cap and retain all their best players. It seemed too good to believe. We kept waiting for a trap door to open, a booby trap to spring, or the hockey gods to strike down the Canucks, because down was where we were accustomed to finding them in spring.

TOP: Training camp opened in Penticton, with most analysts agreeing that the Canucks had never had a better shot to win the Stanley Cup.

Neither talent nor optimism in Vancouver had ever been higher when the Canucks' playoffs began, which is why the spring of 2011 was so gratifying. The Canucks roared through the playoffs as favourites, as confident front-runners, unencumbered of forty years of bad luck, who believed that they were the best team in the NHL and could win—would win—the franchise's first Stanley Cup.

At some point, maybe when Burrows slapped a fluttering puck past Chicago Blackhawks goalie Corey Crawford in overtime for an epic series-winner in Round 1, the Canucks' story became much broader than the team. As Chief Operating Officer Victor de Bonis, an East Vancouver boy who grew up watching the Canucks lose, explained: "You think: It's just a hockey game. But it isn't just that. It's about everybody coming together with a common goal and feeling like they can contribute. And people have."

When the Canucks beat the San Jose Sharks in the Western Conference final and confetti fell like absolution on long-suffering fans, de Bonis said: "I looked around and people literally had their arms up spread wide. They were looking up to the sky and—I don't even know how to describe it—it was like they were in heaven."

People in B.C. will be talking about these Canucks forever. Two remarkable months came close to erasing four decades of disappointment. They didn't bring home the Cup, but—from start to finish—it was a season to remember.

IAIN MACINTYRE, *The Vancouver Sun*

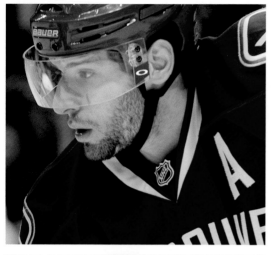

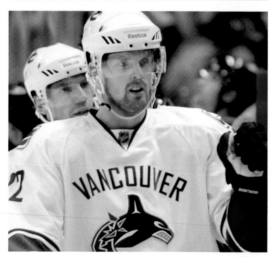

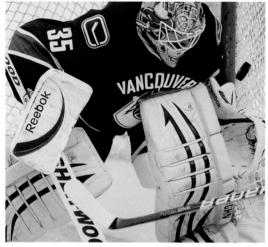

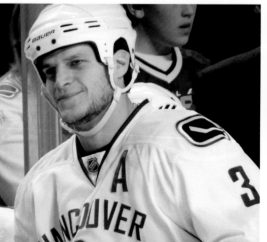

"My main focus in coming to Vancouver is that there is an opportunity to win now. That's what I want. I've been in situations where I've been in a rebuilding organization and gone through those kinds of years when it's very frustrating going to the rink every day and not knowing what to expect. Ask any player in the league: you want a realistic opportunity to win a Stanley Cup."

MANNY MALHOTRA, on signing with the Canucks on the first day of free agency.
The Canucks also signed Dan Hamhuis, Jeff Tambellini, and Joel Perrault on July 1

> **"The fact he put the team ahead of himself is a real statement to the leadership he does have. He loved being the guy, the captain of this team ... But he thought in order to be the best prepared to play and to win it was in the team's best interest he go this route."**
>
> GM **MIKE GILLIS,** on goaltender Roberto Luongo's decision to relinquish the captaincy

October

OPENING NIGHT of the Vancouver Canucks' fortieth season was a glorious and ceremonial event, an old-time family reunion with emotional appearances by Canucks heroes from seasons past, including the handoff of the captain's jersey from the team's first captain—Orland Kurtenbach—to the new leader, Henrik Sedin. That first game, on October 9 against the Los Angeles Kings, came forty years to the day after the first time the Canucks took to home ice, also against the Kings. The ceremony was designed to send a message to loyal fans that this was going to be a season like no other.

But despite the ceremony and the promises, the Canucks began their season slowly, posting a 4–3–2 record in the month of October. They showed signs of dominance but struggled to adjust to the many changes—both in personnel and personality—from the previous season. New goaltending coach Rollie Melanson called for Roberto Luongo to play deeper in his crease, an adjustment that took some time to pay off. New power play coach Newell Brown moved Ryan Kesler from his position as leader of the second unit in favour of loading up the top line, and Kesler struggled away from linemate Mason Raymond. At times, the team appeared to lack passion, and they couldn't string together wins. By the end of October, fans were beginning to question whether this team was as good as they had been told; expectations were high, and a .500 hockey team wasn't good enough.

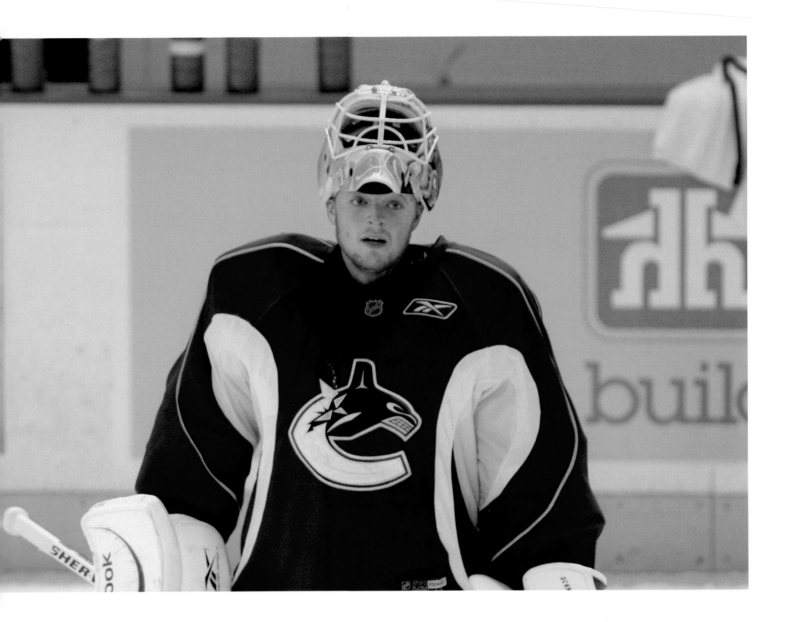

"My job is to give [Luongo] a break and keep him fresh down the stretch and fresh for the playoffs, and that's what I'm going to try to do."

GOALIE CORY SCHNEIDER, on signing a one-way, two-year contract extension worth $900,000 per year to back up Roberto Luongo

TOP: Henrik Sedin, the new face of the Canucks. The C comes with more microphones.

BOTTOM: Coach Alain Vigneault was more than happy to talk to the media daily about the demands of a hockey-crazed market and the ability of his new captain to handle it.

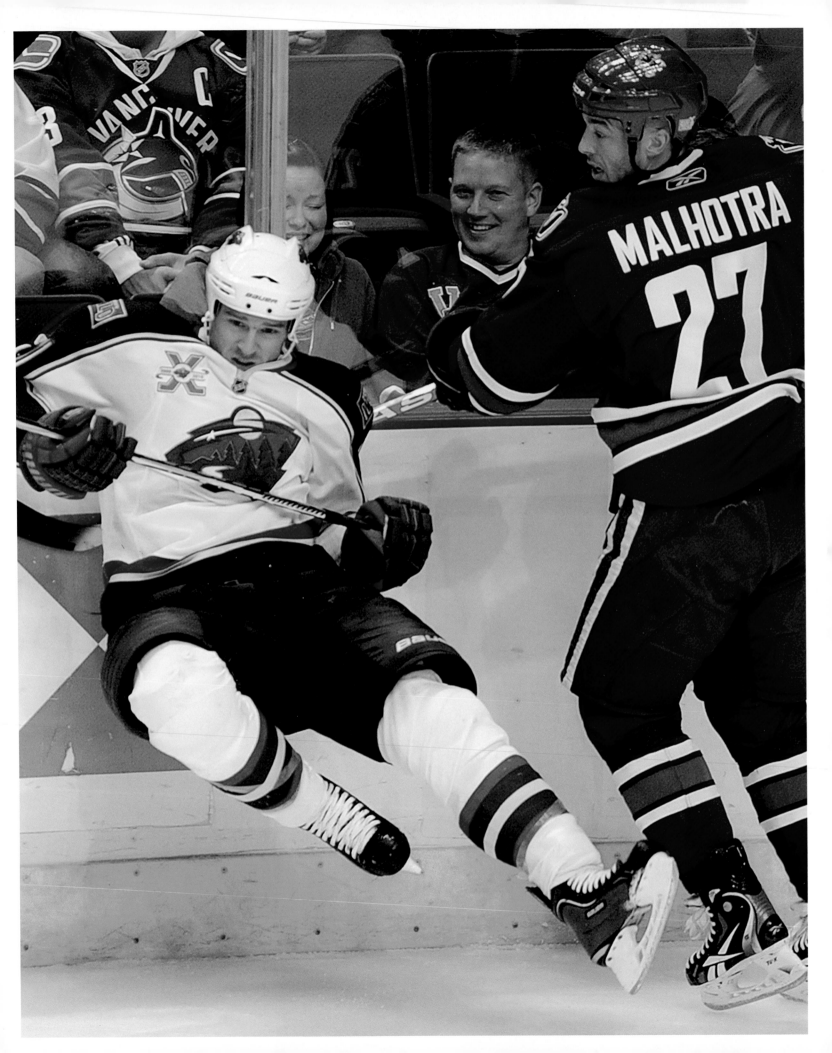

FACING: Manny Malhotra started the season with a bang, bringing grit and faceoff finesse to the third line.

BOTTOM: Daniel Sedin began the season with one goal: to win the Stanley Cup. Matching brother Henrik's Art Ross trophy as NHL scoring leader would be a bonus.

"Oh wow, was this airbrushed?"

TANNER GLASS, on the publicity photos for Ryan Kesler's new RK17 clothing line for which the Canuck posed in his underwear. Fans dubbed the shot "The Undresler."

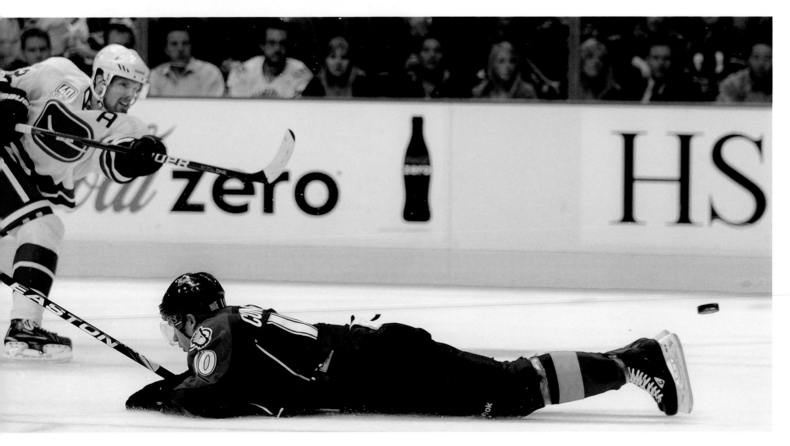

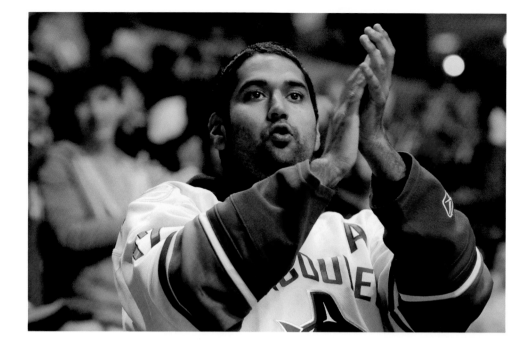

TOP: Canuck fans had plenty to cheer about from the first drop of the puck: new players, new style, and a new attitude of confidence.

FACING: Canuck Guillaume Desbiens battles Minnesota's Clayton Stoner.

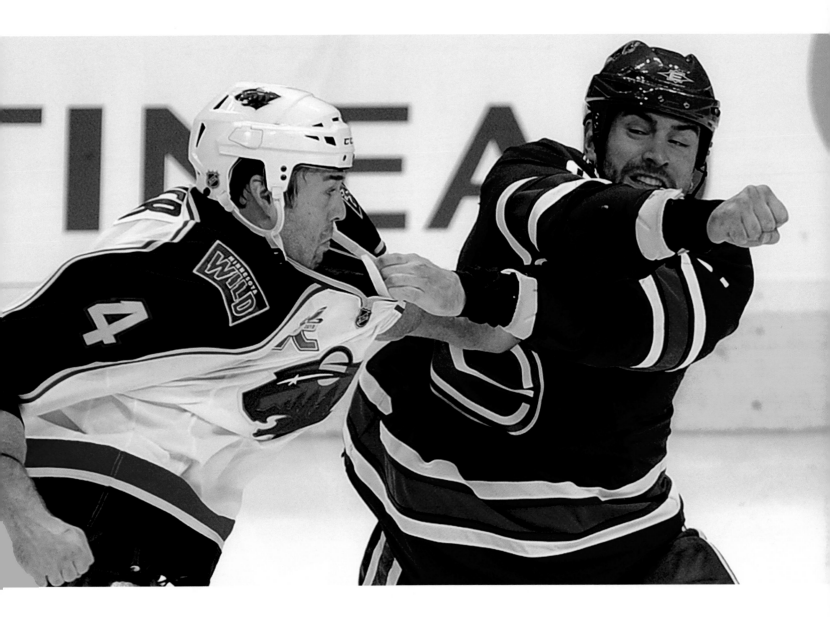

"There's plenty to like here. Torres brings things to the table the Canucks are woefully lacking in. He brings size, muscle, sandpaper. He will forecheck, be a net presence and score garbage goals."

JASON BOTCHFORD, on the addition of Raffi Torres (facing page, bottom) to the Canucks' roster

TOP: The Canucks' fortieth anniversary celebrations kicked off with the unveiling of the Ring of Honour. Original Vancouver Captain Orland Kurtenbach was the first honouree.

BOTTOM: Henrik Sedin picked up where he left off the season before—as one of the elite offensive players in the NHL.

FACING: Ryan Kesler emerged as a true star and elite NHLer, an offensive threat and a shutdown defensive player.

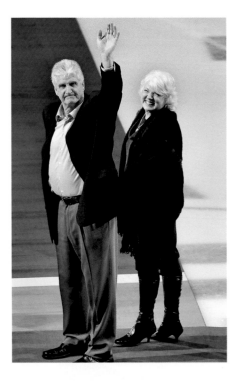

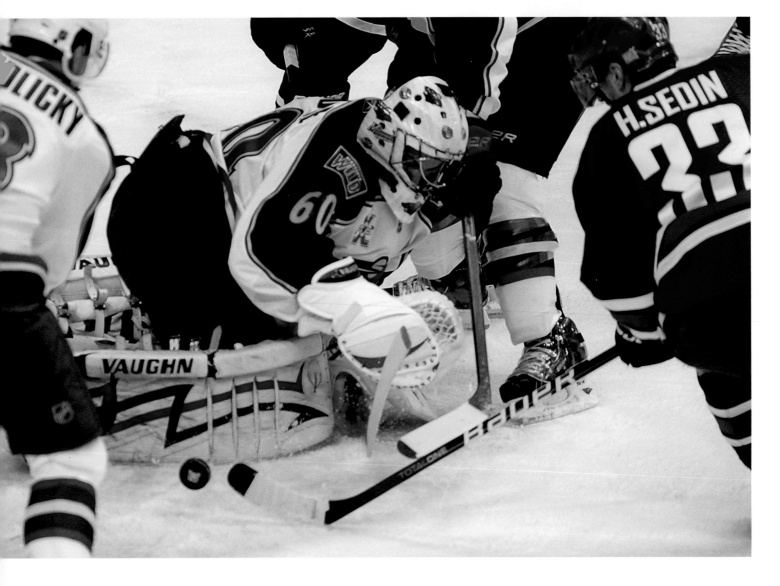

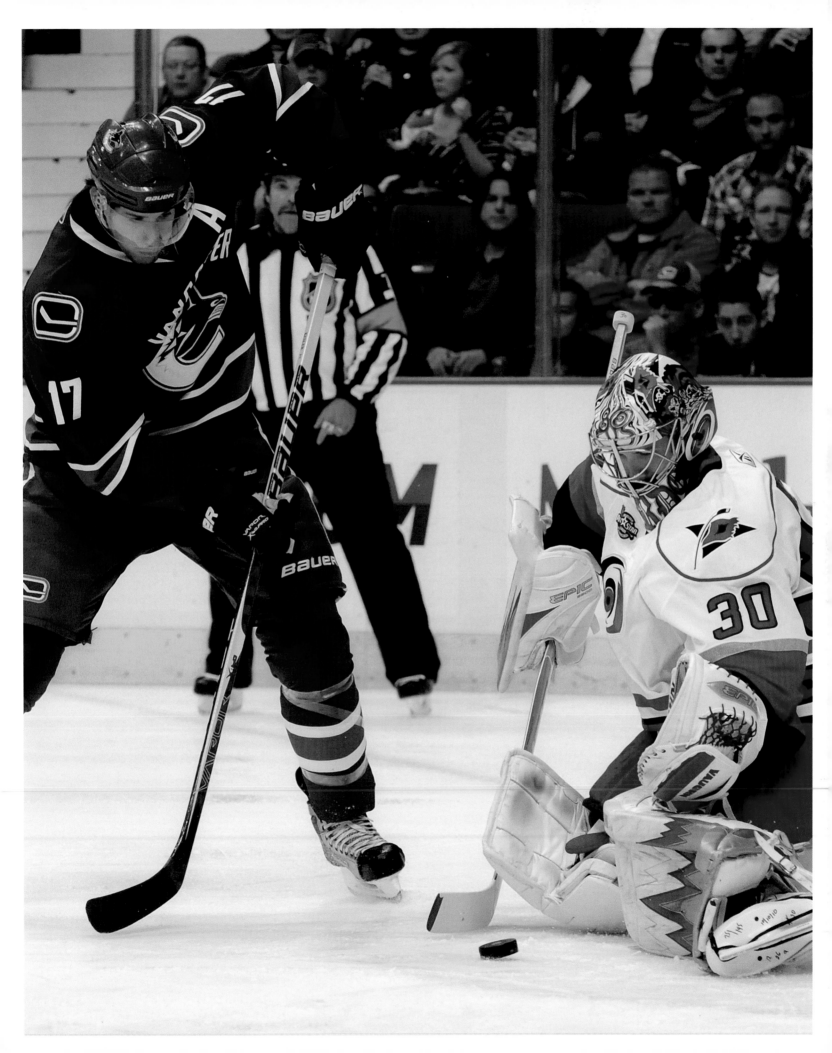

November

THE CANUCKS RECEIVED A BOOST when Alex Burrows—who was returning from a shoulder injury—returned to the lineup in early November. The team put up a much better record (8–4–1), including a four-game winning streak to start the month. That said, they continued to play inconsistent hockey. At times they were strong, trouncing Ottawa 6–2 and—in one of the year's most entertaining games—taking Detroit 6–4. At other times they were appalling: the devastating 7–1 shellacking at the hands of the Chicago Blackhawks sent a familiar shiver through Canuck Nation. But that game—a punch in the gut to anyone weary of watching the Blackhawks eliminate the Canucks in the post-season—served as a wake-up call. Most people in the Canucks organization will acknowledge it as the turning point of the season. In a players-only meeting after the loss, Henrik Sedin and his leadership corps took control of the room, laying down expectations and pledging accountability to one another. Small personnel moves were made immediately afterward, as Rick Rypien took a leave of absence for personal reasons and Peter Schaefer was put on waivers. The team began to take shape.

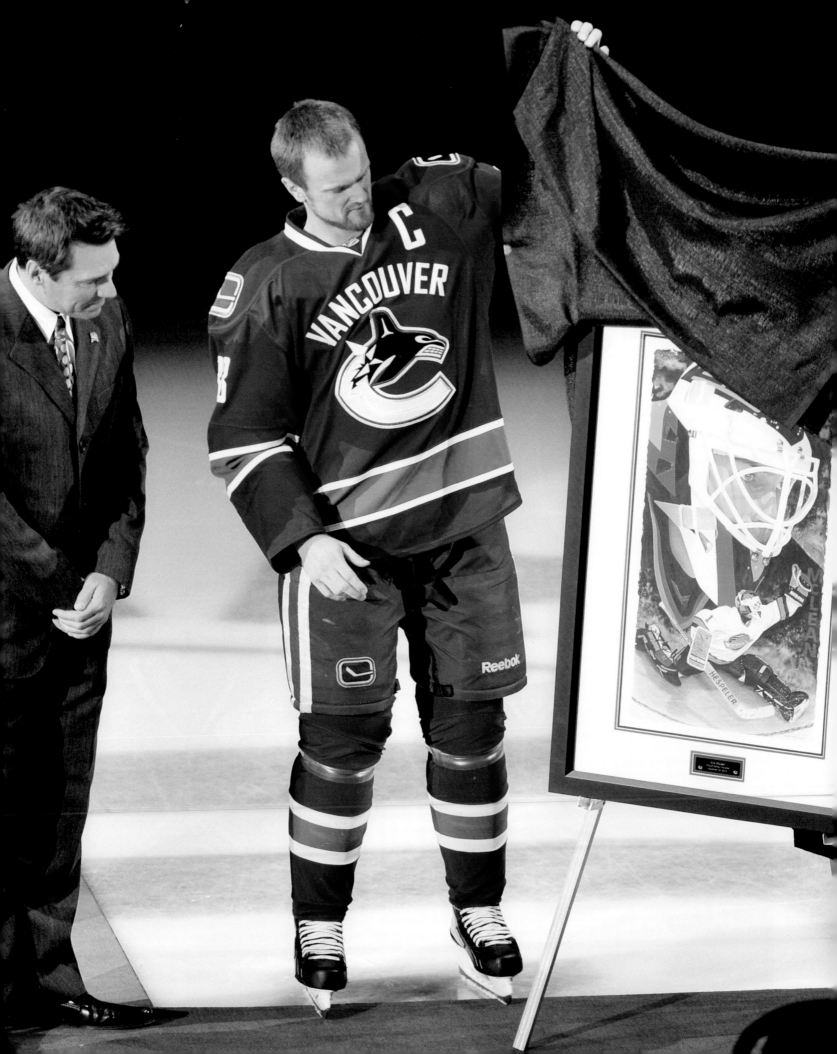

TOP: Henrik Sedin beat the great Marty Brodeur on a penalty shot in a 3–0 win over the Devils as the team really started to hit stride.

BOTTOM: Ever since joining the Canucks, Daniel and Henrik Sedin have quietly become staples of the community. Their generosity—including a $1.5 million donation in 2010 to build a new BC Children's Hospital—has endeared them to fans.

FACING: After appearing at Remembrance Day celebrations in Ottawa, on November 22 the Canucks mingled on home ice with members of the Armed Forces. They received a raucous ovation.

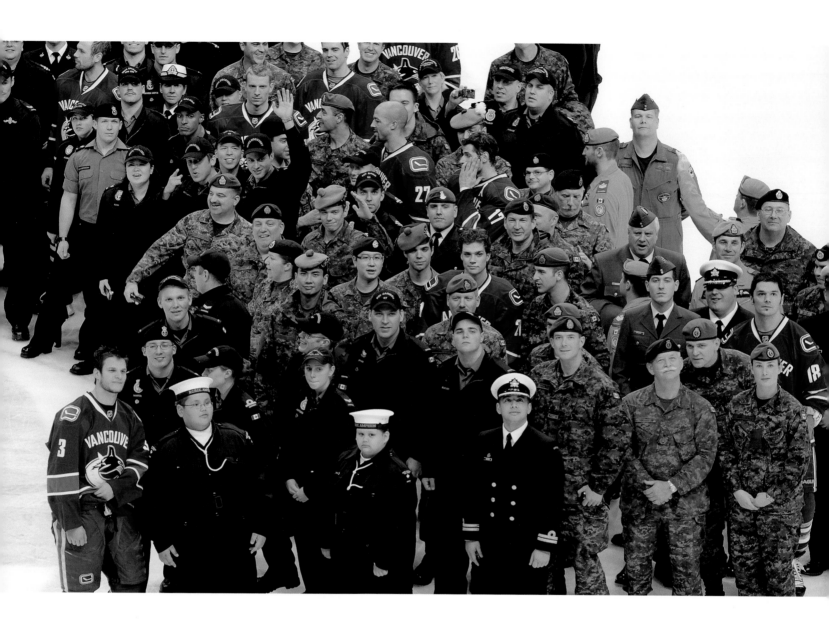

"When you participate in the NHL, it's easy to lose sight of other things that are very important. It's good for everyone to have some perspective about life. If these guys can go and see the emotions and the interaction of veterans, it will be a healthy and lasting memory."

GM **MIKE GILLIS,** on cancelling morning practice for a road game in Ottawa to allow players to attend the Remembrance Day ceremony

"You know what? It was hurting me more than anything. It was hurting the team, too. I have just really focused on keeping my head down and going forward, staying positive. It's been working."

RYAN KESLER, on his new attitude

TOP: The 2010–11 season saw many spectacular saves from Roberto Luongo, but he also faced the usual criticism—that he was unreliable in the playoffs. When the Canucks were shelled 7–1 by Chicago and Luongo was pulled for Cory Schneider, the spectre of the last two playoff meltdowns came back to haunt Canucks fans.

BOTTOM: Keith Ballard, a new addition to the Canucks blueline, was popular with fans but his risk-taking style had him in and out of coach Vigneault's doghouse all year.

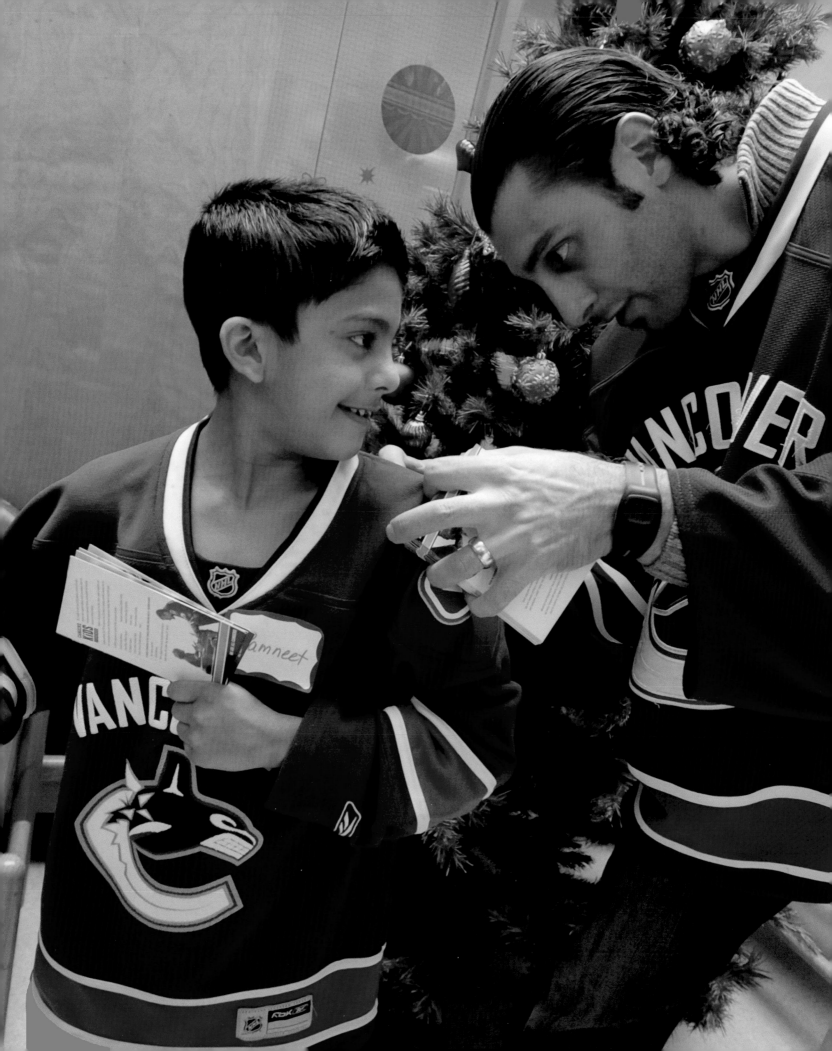

December

REGROUPED AND REFOCUSED, December's Canucks began to resemble the team that would eventually compete for the Stanley Cup. They marched through the month, posting an 11–1–2 record, including noteworthy victories over the Chicago Blackhawks (3–0) and late-month drubbings of the Columbus Blue Jackets, Philadelphia Flyers, and Dallas Stars. Ryan Kesler exploded as a scorer, with three multi-goal games, including his first career hat trick, and eighteen points in the month. Roberto Luongo rounded into form and began to carve his middling early-season numbers into Vezina-quality stats. The Canucks' defensive pairings, too, began to take shape, as Alex Edler and Christian Ehrhoff formed one of the league's best offensive tandems, both on the power play and at even strength, while Dan Hamhuis and Kevin Bieksa morphed into one of the league's finest shutdown blueline duos. By month's end, the Canucks were on top of the NHL, a revered position they wouldn't relinquish for the rest of the regular season.

"We feel fortunate to be able to support BC Children's Hospital with this gift. This gift is our opportunity to give back to a community that has given us so much."

VICTOR DE BONIS, vice-president of the Canucks for Kids Fund board, on a $5-million donation to bc Children's Hospital

"To the amazing fans of this team, thanks for everything you have given me during my time here. It was a privilege to play for you for twelve years... Your support is what is going to make winning a Stanley Cup in this city so special. And I have a feeling it is going to happen here soon."

MARKUS NASLUND, at the ceremony where his jersey was raised to the rafters on December 11

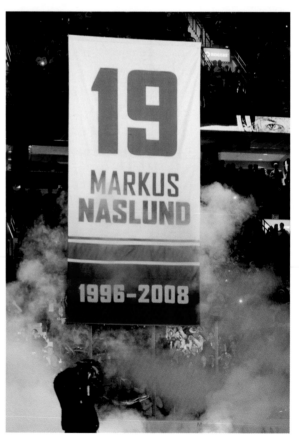

FACING: Goaltender Cory Schneider was brilliant in his back-up role, allowing Luongo to pace himself and stay fresh for the playoffs, and for the team to not miss a beat in the standings while giving their star goalie a breather.

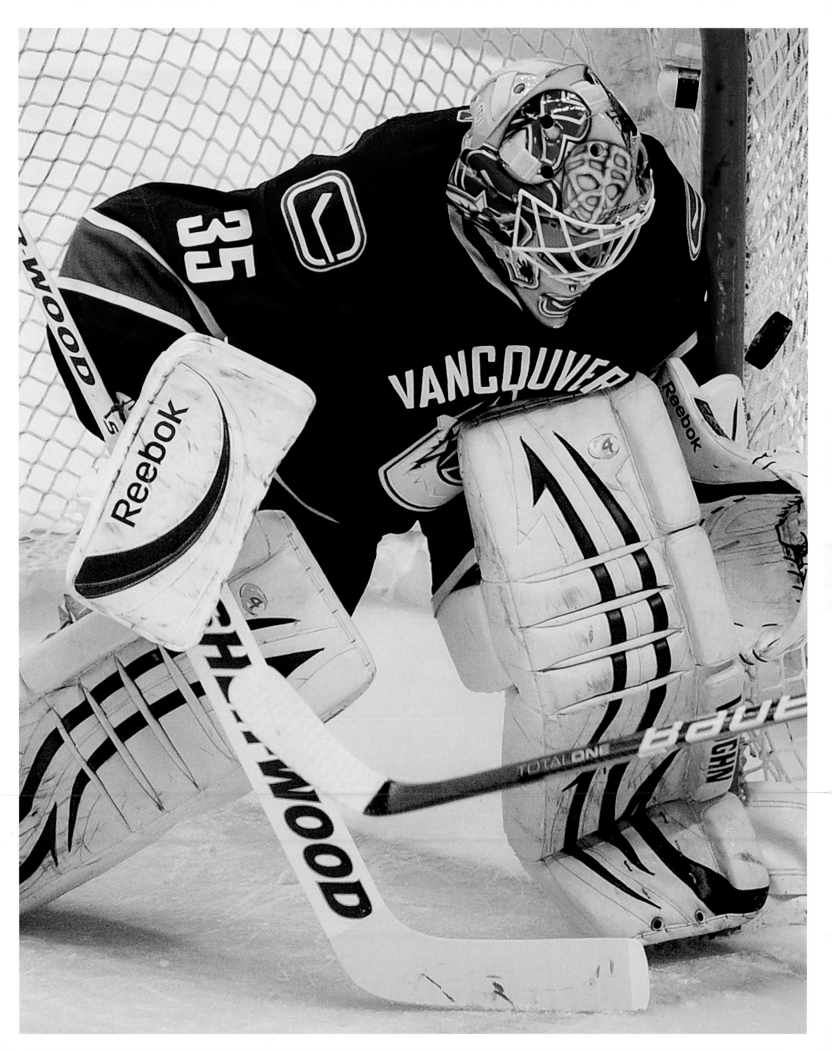

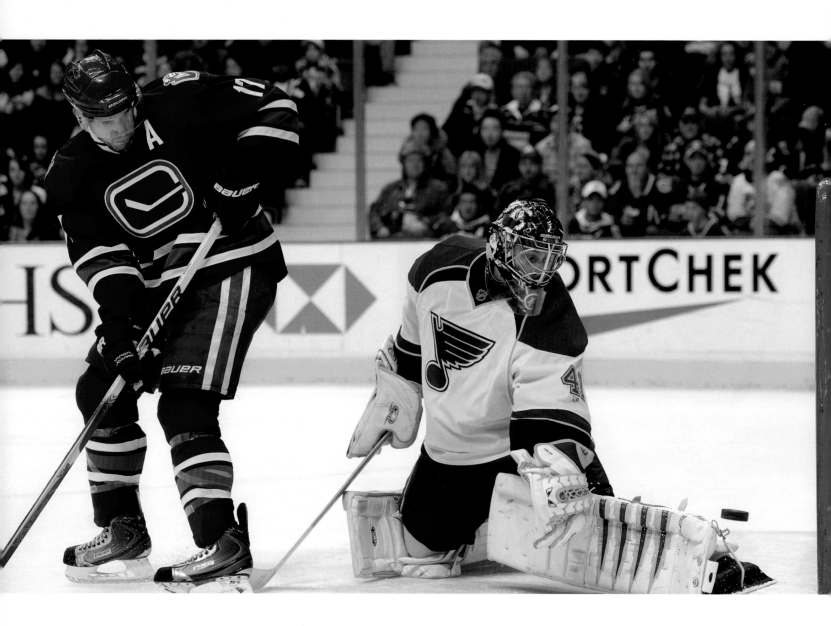

"I haven't been satisfied since I've been in the league, and this year is no different. I want to be a better all-round player. We're using our speed and playing the right way. It's pretty fun playing with those guys, and we're playing with a lot of confidence. The good thing with this group is that we're not satisfied with the streak we're on. We want to get better."

RYAN KESLER, after the Canucks finished a 12-1-2 run on their way to first place in the Western Conference.

TOP: Alexandre Burrows focused on being a better player and contributor and less of a pest. But the feisty winger was still a target for every team the Canucks played.

BOTTOM: December saw the Canucks lose only twice, and fans really started to believe the team could win it all. As the Olympic year came to a close, the Canucks established themselves as the team to beat.

"It was a pretty good day for me today."

RYAN KESLER, on being selected for his first All-Star Game and scoring a goal and the shootout winner against the New York Islanders on January 11. Daniel and Henrik Sedin were also named to the All-Star team, Henrik for a second time.

January

THE CANUCKS GREETED the new year as the best team in the NHL, and their late-December push continued into January with wins at Colorado and San Jose and at home against the two Alberta clubs. But then they hit one of their few bumps of the season, winning just once in regulation through their next eight games.

"We're fine," Roberto Luongo said after a shootout loss to Calgary, which dropped Vancouver's record to 2–2–4 over eight games. "When you go through a stretch of games like we did over the last couple of months, there's always bound to be a little correction."

And it wasn't all bad. Luongo himself hadn't lost in regulation in fifteen games—he went 10–0–5 over that stretch—and the Canucks went on to finish the month 8–2–4, despite several injuries to the blueline.

Defenceman Chris Tanev, who'd spent the previous two seasons playing Junior A in Ontario, was called up on January 18 for a temporary visit and wound up playing twenty-nine games, averaging 13:47 minutes of ice time. Despite his thin resume—the twenty-one-year-old had a year of NCAA and a half-season of AHL experience—Tanev immediately impressed with his poise and was part of the Canucks' starting six until he was run from behind, face-first into the boards, by L.A.'s Kyle Clifford on March 31. Tanev was one reason why the Canucks didn't miss a beat during their blueline crisis, which saw Dan Hamhuis, Keith Ballard, Kevin Bieksa, and Sami Salo sidelined with injuries.

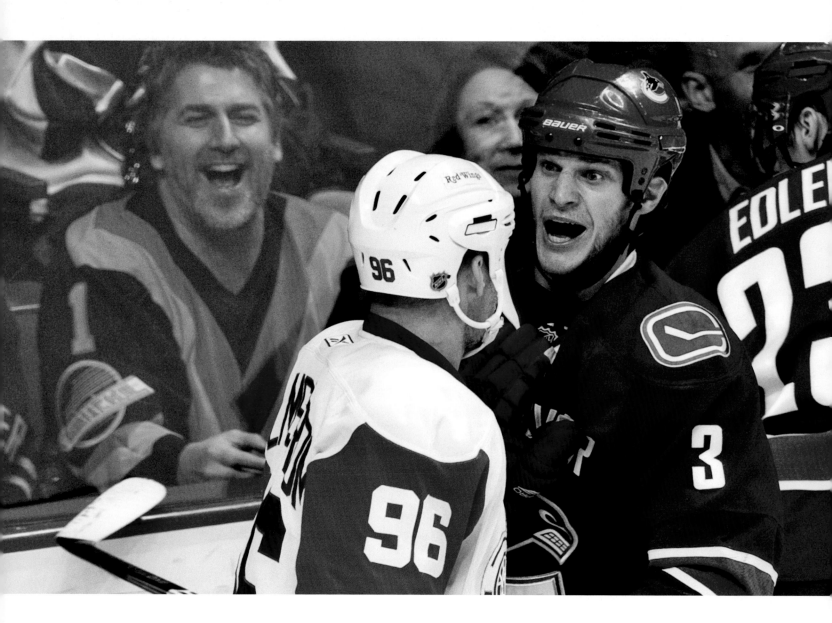

"Maybe I'm a little nastier this year, a little more of a chip on my shoulder, but that's just something I thought about in the summer. I wanted to come in and have a good year and be hungry again."

KEVIN BIEKSA

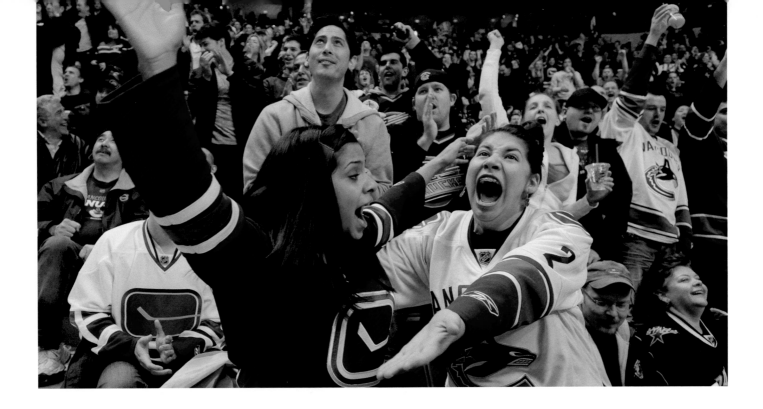

BOTTOM: Henrik and Daniel Sedin shake hands after the All Star Game in Raleigh, North Carolina, where they played on different teams for the first time. For the record, Henrik's team won 11–10.

"I had a few chances; I could have scored on three or four good chances, and finally Henrik touched my stick and I scored a goal."

SERGEI SHIROKOV (below), on scoring his first NHL goal in a 4–3 OT loss to Colorado on January 18. It came after Shirokov asked the captain to touch his stick for luck.

TOP: Fans celebrated alongside Alex Burrows on January 26, as he scored a game-tying goal against Nashville. The Canucks went on to win 2–1.

BOTTOM: Cory Schneider stymies Sharks snipers Patrick Marleau and Joe Thornton during a 4–3 win in San Jose on January 3. It was one of two road wins by Schneider against the Sharks in the regular season.

FACING: Jeff Tambellini and Calgary's Mark Giordano go airborne after a spectacular collision at Rogers Arena on January 5. The Canucks beat their divisional rival 3–1.

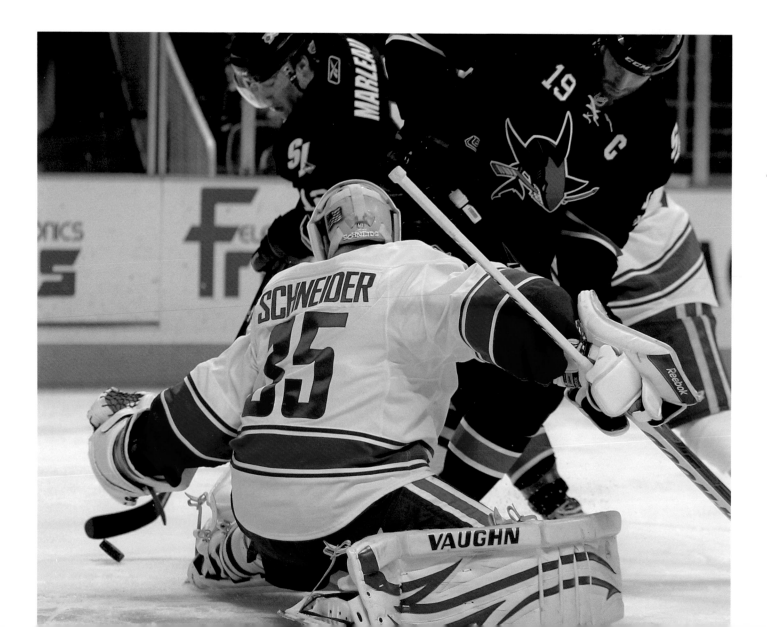

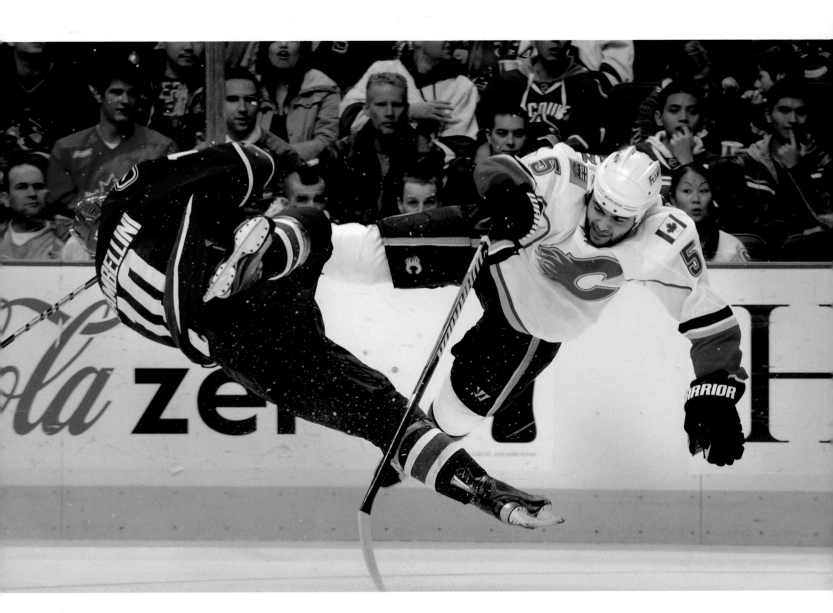

As the Vancouver Canucks reached the halfway point of their National Hockey League season better than they've ever been, captain Henrik Sedin was asked if there was anything he didn't like about his team.

"Eight losses," he replied. That's out of forty-one games. Henrik was joking, but just a little...

IAIN MACINTYRE, *The Vancouver Sun*

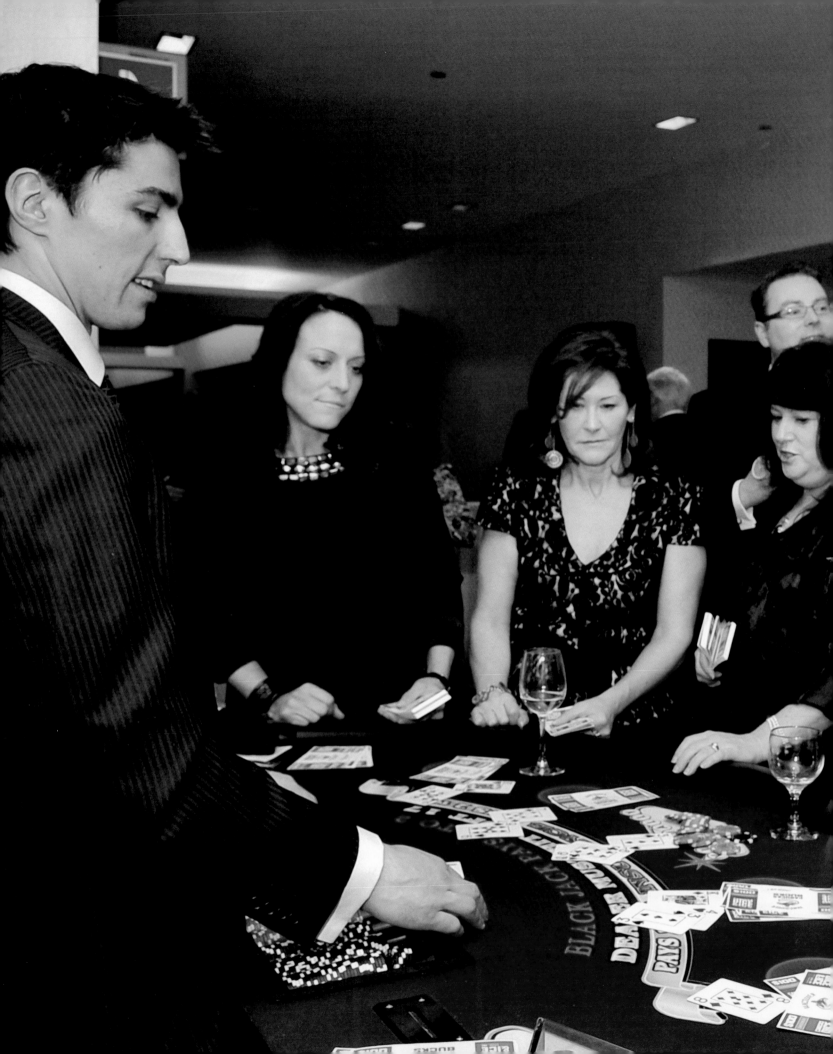

February

THE CANUCKS BEGAN FEBRUARY in Dallas—during a frigid Super Bowl week—and notched up two power-play points to go with a short-handed goal in a 4–1 win over the hard-charging Stars. In three previous games against Dallas, the Canucks' power play was eight for fifteen.

"We own a lot of teams," Henrik Sedin said. "We're playing good hockey. Nothing against Dallas—they've got a good team over there—but it seems we get up for the great teams." Dallas was the third-best team in the West at that point in the season. There would be more stumbling down the road, however, as the Canucks finished the month 8–5–0, going on a win-lose-win-lose combination over the last ten games, finishing the month with a 3–1 loss to Boston at Rogers Arena.

"They're a very talented team, very dangerous, and to come in and grind out a win on their ice is a big victory for us," Boston goalie Tim Thomas said, in words that would foreshadow the Bruins' task later in June. The Canucks came up short on the scoreboard against the Bruins but out-hit and out-hustled their visitors. Each team would take something from that game into the Stanley Cup Final. "These are the type of games we will be involved in all the time down the stretch and through the playoffs," Luongo said. "We knew coming in, this was the type of game it was going to be. As a team we can't be satisfied with a loss. We're a good team in this league and we want to win."

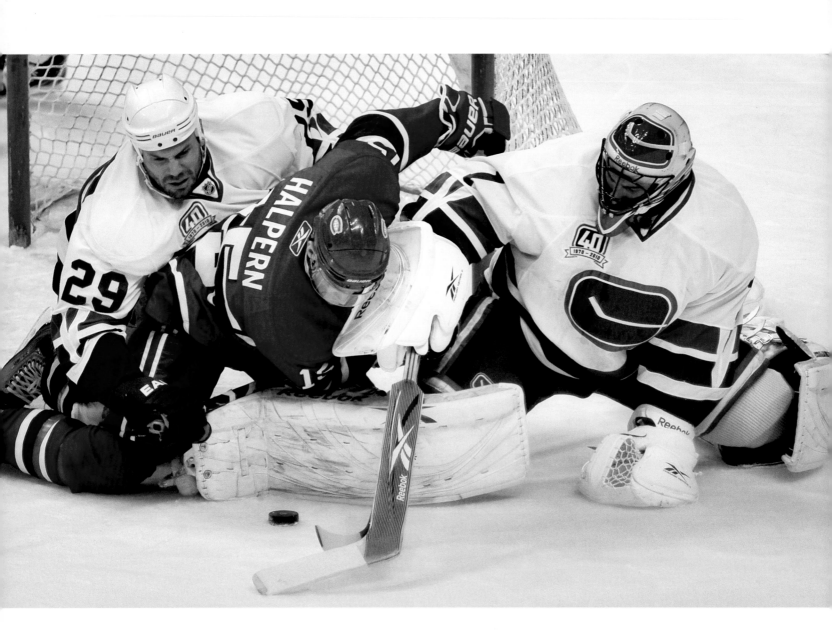

"He's going to play the way we want him to play, like every player does here, or they don't get the ice time. It has been made clear to everybody that we have brought in, that we expect a certain type of play that's going to be effective in our team game. And both new players will receive the same consideration from the coaching staff. They will learn to comply with what we need."

GM MIKE GILLIS, on his trade-deadline acquisitions Maxim Lapierre and Chris Higgins

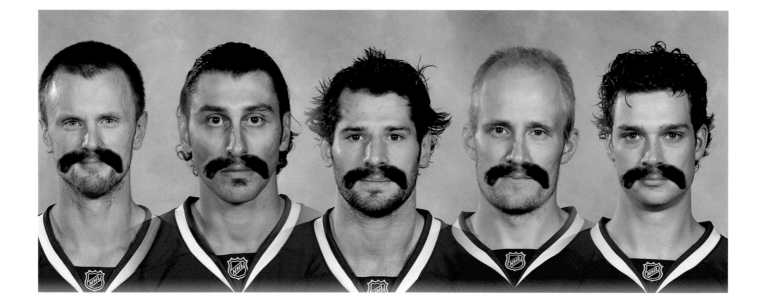

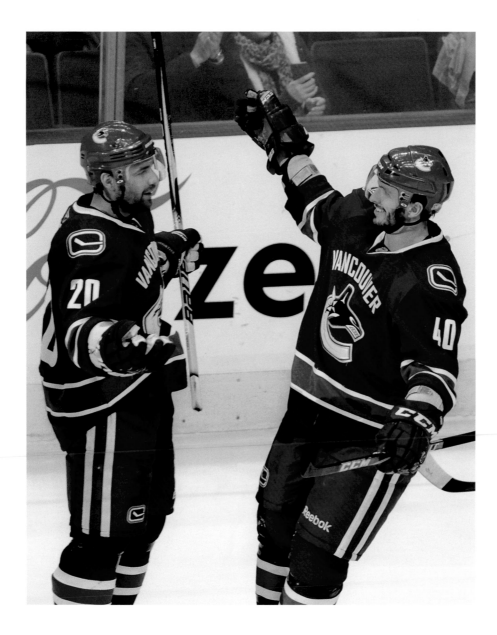

FACING: Roberto Luongo fends off Montreal Canadien Jeff Halpern with some help from Aaron Rome.

TOP: Canuck legend Harold Snepsts was named the fourth member of the Canucks' Ring of Honour on February 16. *The Vancouver Sun* had fun with some current Canucks, imagining how they'd look sporting their predecessor's famous moustache.

BOTTOM: The Canucks acquired Chris Higgins from Florida and Maxim Lapierre from Anaheim at the trade deadline. They were teammates in Montreal for three seasons.

"The temptation has always been to make jokes, and heaven knows we've made a few of them here. But in the end... the saga of Sami Salo is less about all the weird and awful ways he's been knocked down than the number of times he's got up again without complaint."

CAM COLE, in *The Vancouver Sun*, on Salo's return to the lineup on February 12 after tearing his Achilles tendon in July

FACING: Alex Burrows screens Blackhawks goalie Marty Turco on February 4 in a 4–3 win.

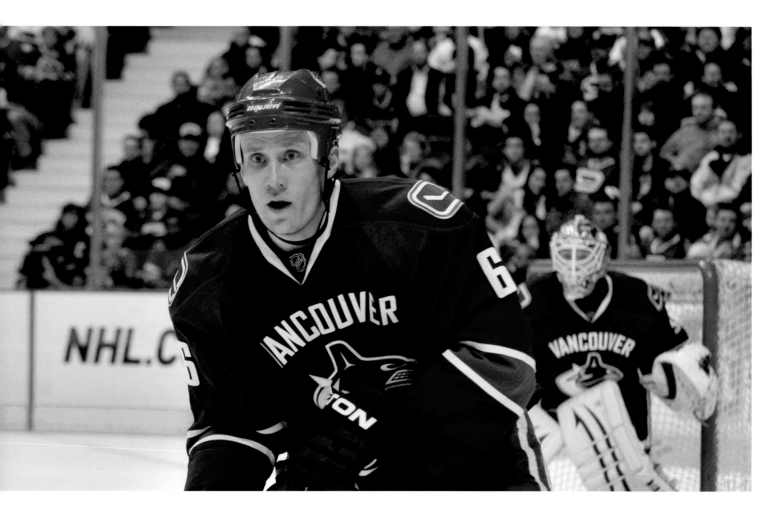

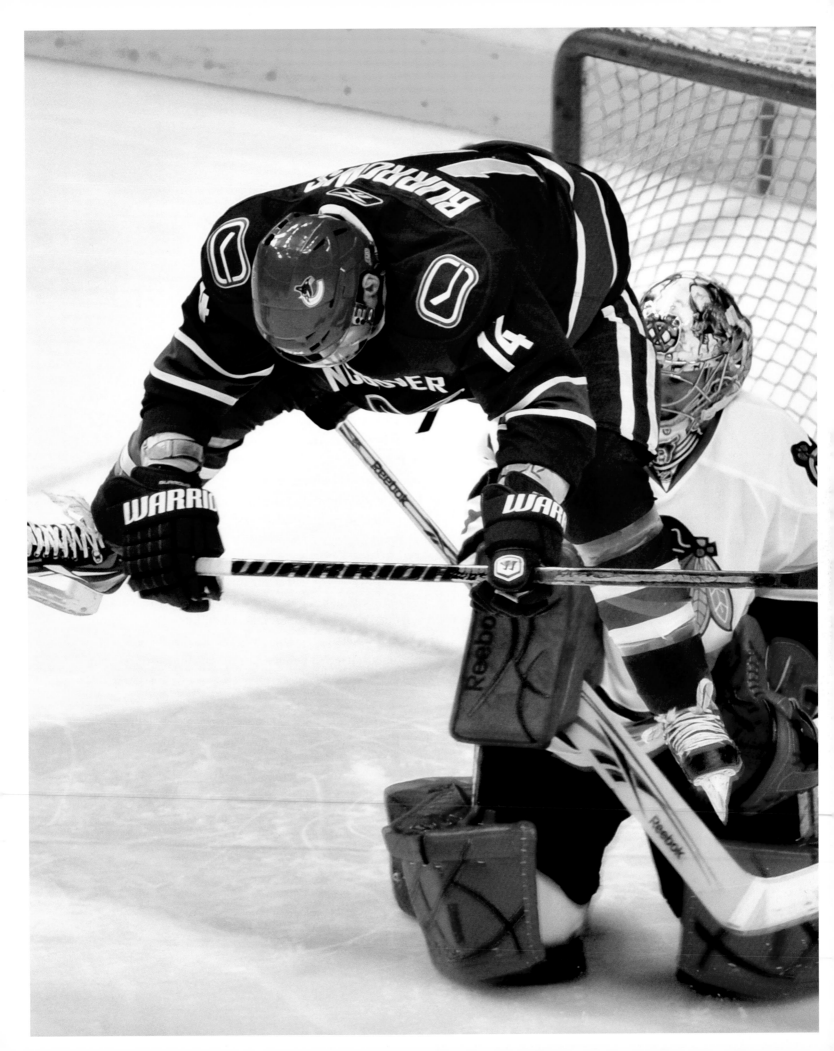

March

MARCH PROVIDED THE CANUCKS with a glimpse of what was to come in the playoffs, courtesy of two tough games against the Nashville Predators. Given what transpired, no one should have been surprised by the tight play in Round 2: it was exactly what the regular season portended.

The Predators blanked the Canucks 3–0 early in the month—extending the Canucks' win-loss-win-loss streak to twelve games—then the Canucks turned the tables and beat the Preds 3–1 at the end of the month, evening the season series at 2–2.

"They've been different types of games. I don't think there's really a pattern there," Roberto Luongo said of playing Nashville. "Just because we win or lose, I don't think it's because we played good or bad. They just made fewer mistakes than we did." All told, it was a wonderful month for the Canucks, who went 13–2–0 to pad their Presidents' Trophy lead to an insurmountable eleven points over Philadelphia in the East and fourteen points over San Jose in the West.

Fans in Vancouver genuinely started to believe this team could win the Stanley Cup. Perhaps the biggest victory came on March 23, a 2–1 win at Detroit. Luongo made thirty-nine saves and Daniel Sedin scored both goals, arriving in Detroit shortly after his third child was born. "Imagine if he would've practised once," coach Alain Vigneault said. "He was off for four days, flew in [the night before the game] and was able to get in a morning skate."

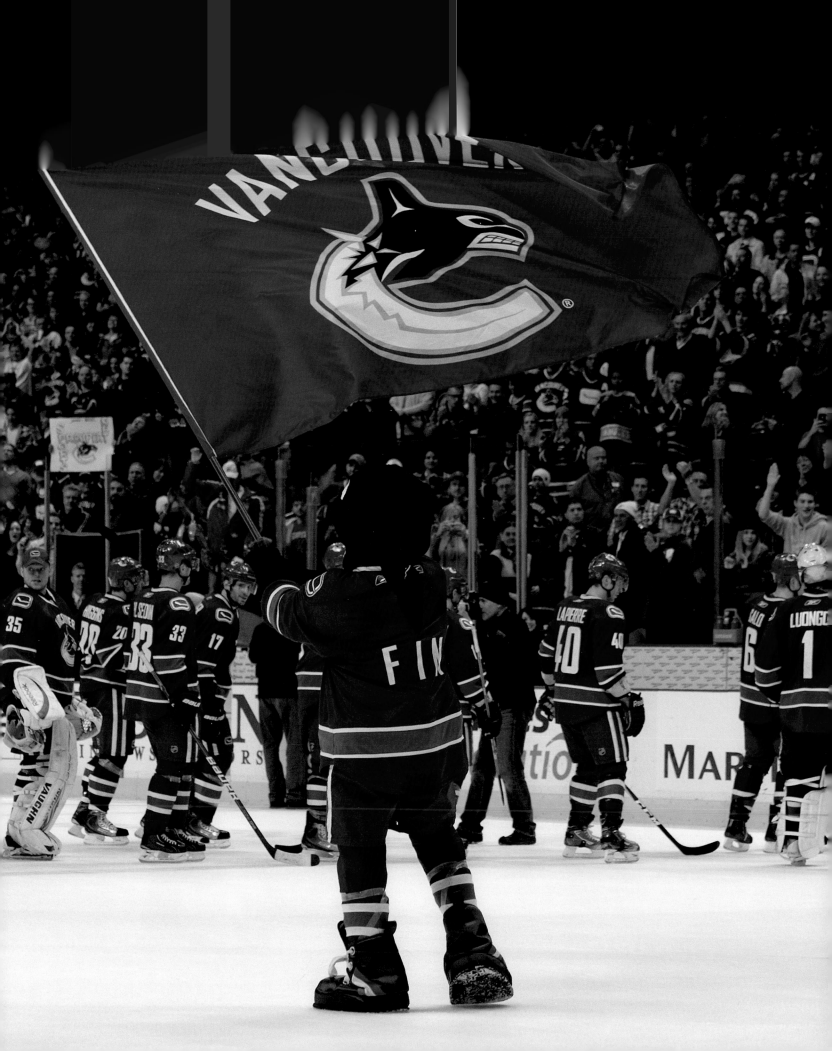

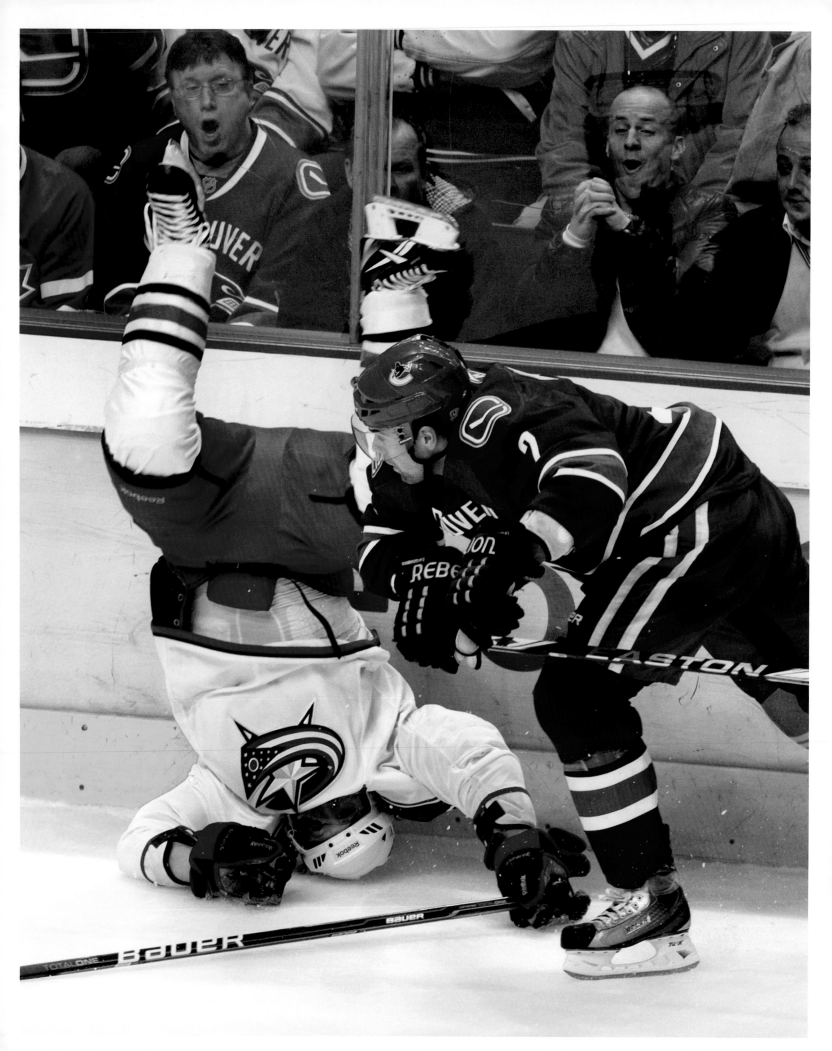

FACING: Dan Hamhuis upends Blue Jacket Jakub Voracek. Roberto Luongo stopped four breakaways in regulation—and six more in an eight-round shootout—as the Canucks picked up a 2–1 win.

"If Edler misses only two months (with an injury), the Canucks could go into the Stanley Cup playoffs with potentially the strongest defence in the NHL: Edler, Kevin Bieksa, Dan Hamhuis, Christian Ehrhoff, Sami Salo, and Keith Ballard."

IAIN MACINTYRE, *The Vancouver Sun*

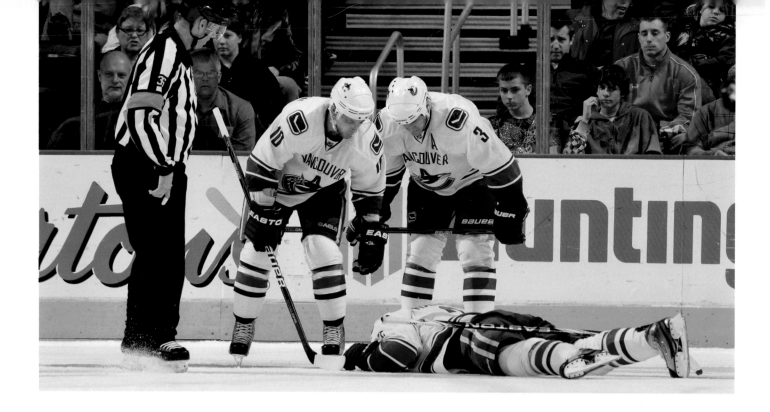

TOP: Jeff Tambellini and Kevin Bieksa look over Dan Hamhuis, who suffered his second concussion of the season on March 27 against the Columbus Blue Jackets. Hamhuis did not play again until April 9, the final game of the regular season.

BOTTOM: At the start of the season, fans were calling for Kevin Bieksa to be traded. By April he was arguably the Canucks' best blueliner. He shows his toughness here, taking a hit from the Predators' Jordin Tootoo during the Canucks' 3–1 win at Nashville.

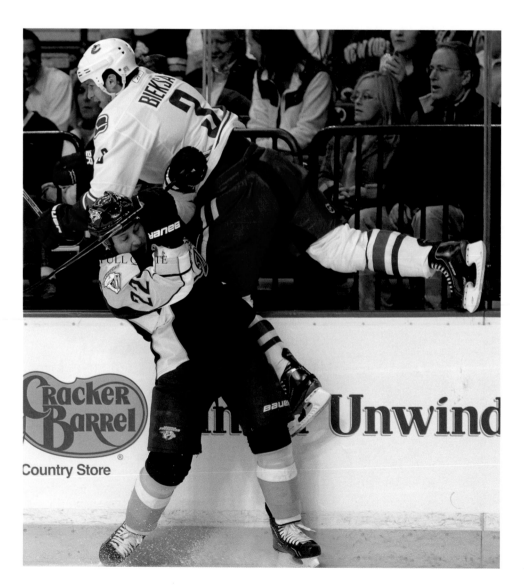

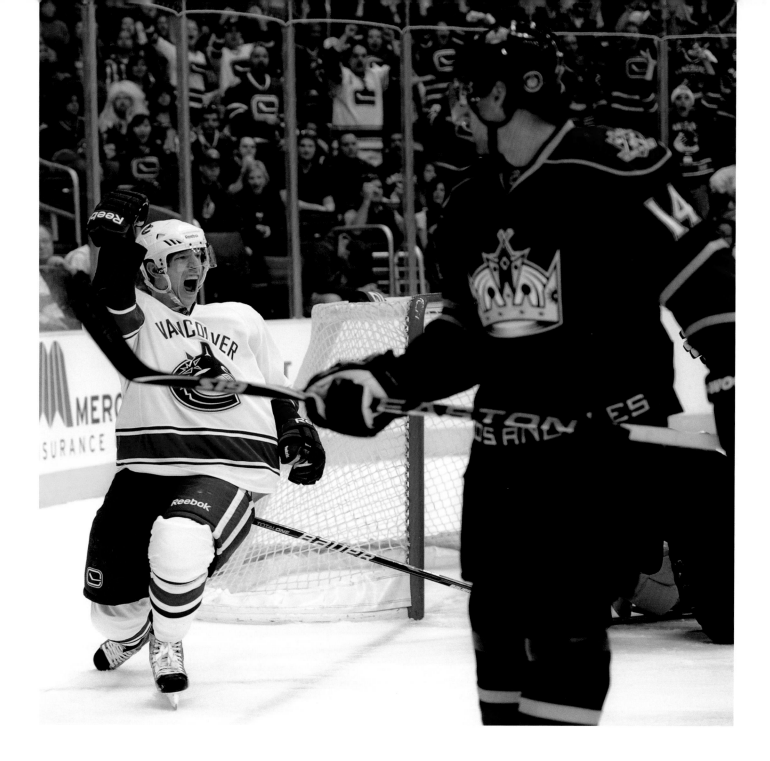

"In L.A., when we came out for the warm-up and see ten rows of Canuck sweaters, it helps us for sure. They start the 'Go, Canucks, go!' chant and for sure we notice it."

HENRIK SEDIN, acknowledging the impact of Canuck Nation.

The Canucks swept their five-game road swing through California, buoyed by massive fan support in every city.

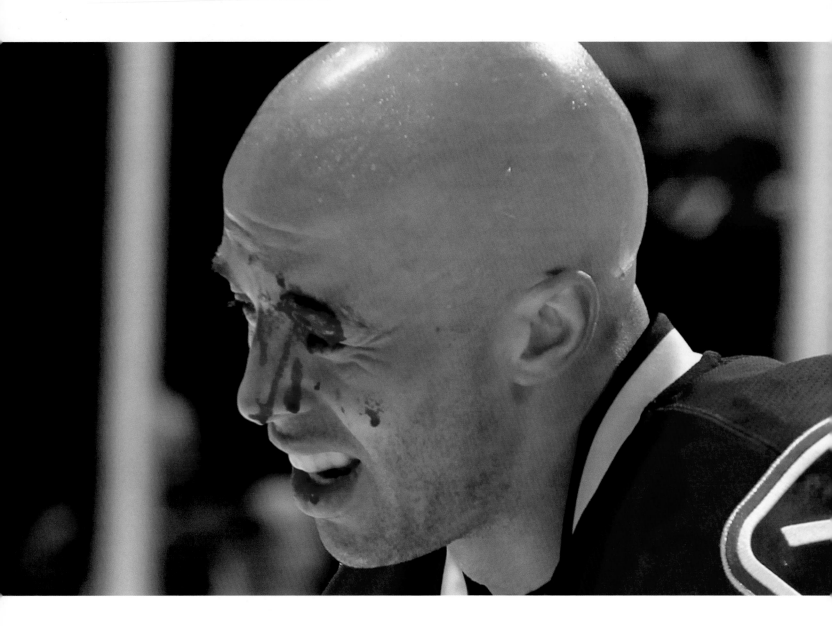

Malhotra's gruesome injury, and the task of filling the gaps he leaves behind, is why every team that wins a title begins its post-championship speech with: "A lot of people said we couldn't do it," or "We overcame a lot of adversity." They're clichés. They're also true. An 82-game season, followed by two months of playoffs, represents a long battle of attrition. Adversity is standard equipment. If the Canucks get through this, the way they've got through the almost laughable epidemic of injuries to defencemen all season without missing a beat, they will have something far greater to remember than a year in which everything went right.

CAM COLE in *The Vancouver Sun* on March 17, the day after Manny Malhotra took a puck in the eye against Colorado. Four days later, the Canucks released a statement saying Malhotra would miss the rest of the regular season and the playoffs.

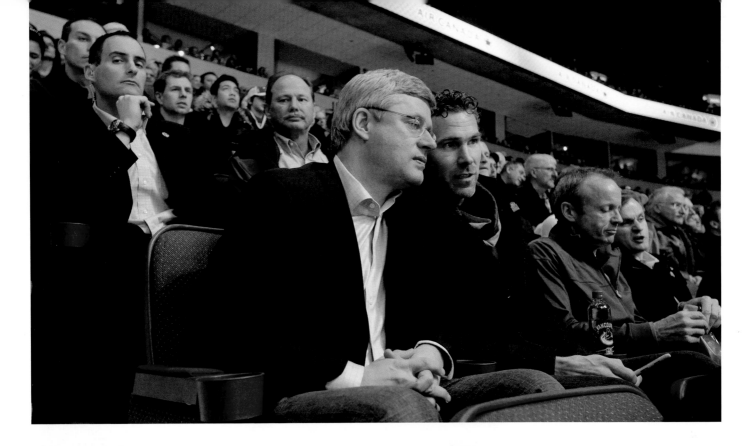

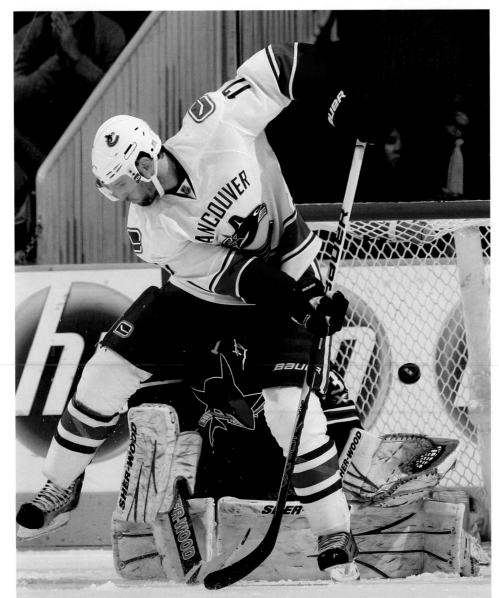

TOP: Prime Minister Stephen Harper enjoys a game with former Canuck Trevor Linden and retiring MP Stockwell Day on March 14. The Canucks put on a good show, beating Minnesota 4–2.

BOTTOM: Ryan Kesler screened Antii Niemi perfectly during a 5–4 shootout win over San Jose on March 10. The Canucks finished the season with a 3–0–1 record against their eventual opponent in the Western Conference Final.

ROGER NEILSON
JUNE 16, 1934 – JUNE 21, 2003 *"I've been really lucky to be able to be in hockey all my life, doing the thing I love."* – Roger Neilson

> **"The Presidents' Trophy... means you're going in the right direction. But does it mean that much? I don't know. Everyone has his mind on one trophy, and that's the Stanley Cup... We haven't won anything before, and we haven't won anything yet."**
>
> **MIKAEL SAMUELSSON**

April

IT WAS GARBAGE TIME stretched to 240 minutes after the Canucks went on a twelve-of-thirteen tear to clinch the Presidents' Trophy. With home-ice advantage throughout the playoffs sewn up, the Canucks went through the motions over their final four games, losing back-to-back for the first time since a pair of shootout defeats to end January.

Who could blame them? All they'd done by April 1, while other teams were scrambling for playoff position, was to score the most goals and allow the fewest. They'd put up the best home record in the league, and the best road record. They were best in the league five-on-five, best on the power play, and best at killing penalties—and, according to the NHL, no team since the Original Six era (which ended in 1967) had led in goals for and against, power play, and penalty kill in the same season. They dropped to third in penalty kills by the end of the season, but there was no arguing their dominance.

They had also racked up an impressive host of awards—the Art Ross (Daniel Sedin), Jennings Trophy (Roberto Luongo and Cory Schneider)—and nominations: the Hart (Daniel Sedin), Vezina (Luongo), Selke (Ryan Kesler), Jack Adams (Alain Vigneault), Ted Lindsay (Daniel Sedin), NHL Foundation Award (Daniel Sedin, Henrik Sedin), and GM of the Year (Mike Gillis).

The only loss that really mattered over the final four games was forward Raffi Torres. In Game 80, he hit Edmonton's Jordan Eberle into the boards from behind, drawing a five-minute penalty and a game misconduct. Observers expected Torres to get a two-game suspension; the league surprised almost everyone by adding the first two playoff games, taking from the Canucks one of their prime physical forecheckers. Torres's unrepentant attitude after the Eberle hit may have led to a longer-than-expected suspension, but that same attitude made him a vital cog in key moments to come in the post-season.

FACING: As part of the team's fortieth anniversary celebrations, Canucks GM Mike Gillis and owner Francesco Aquilini unveil a statue outside Rogers Arena, commemorating former Canucks coach Roger Neilson and the start of the white towel tradition.

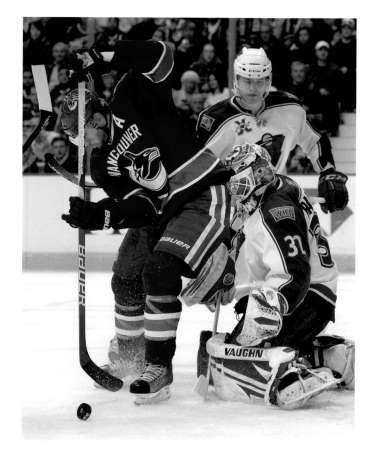

TOP: Ryan Kesler tries to redirect the puck past Niklas Backstrom during the Canucks' 5–0 win over Minnesota on April 7. He finished the game with a hat trick.

BOTTOM: Canucks fans were already in playoff mode outside Rogers Arena in April.

FACING: Daniel and Henrik Sedin: They even wipe their visors in unison.

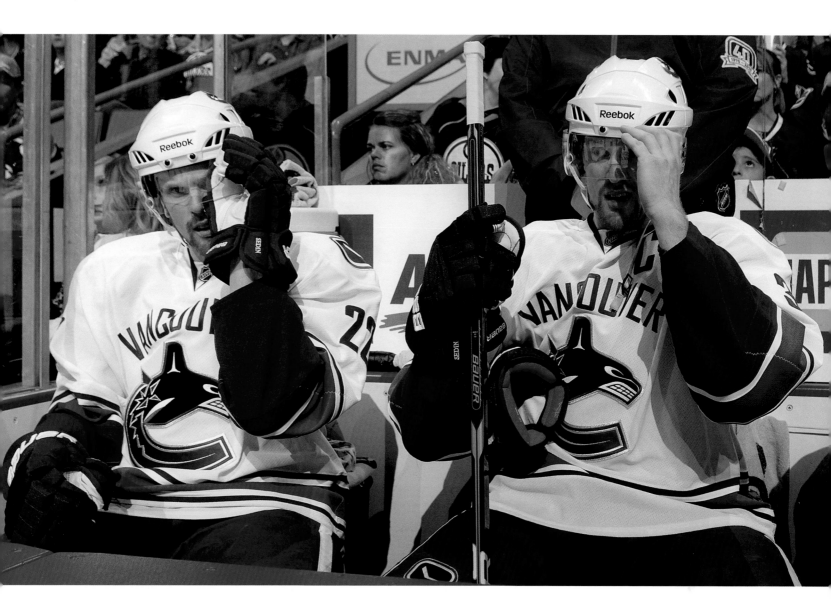

"We have nothing more to learn. We know what it takes. We know we have a good enough team to do it. We know from the regular season, if we play the right way we have a good enough team to beat anyone in a seven-game series."

DANIEL SEDIN, on his hopes for the playoffs

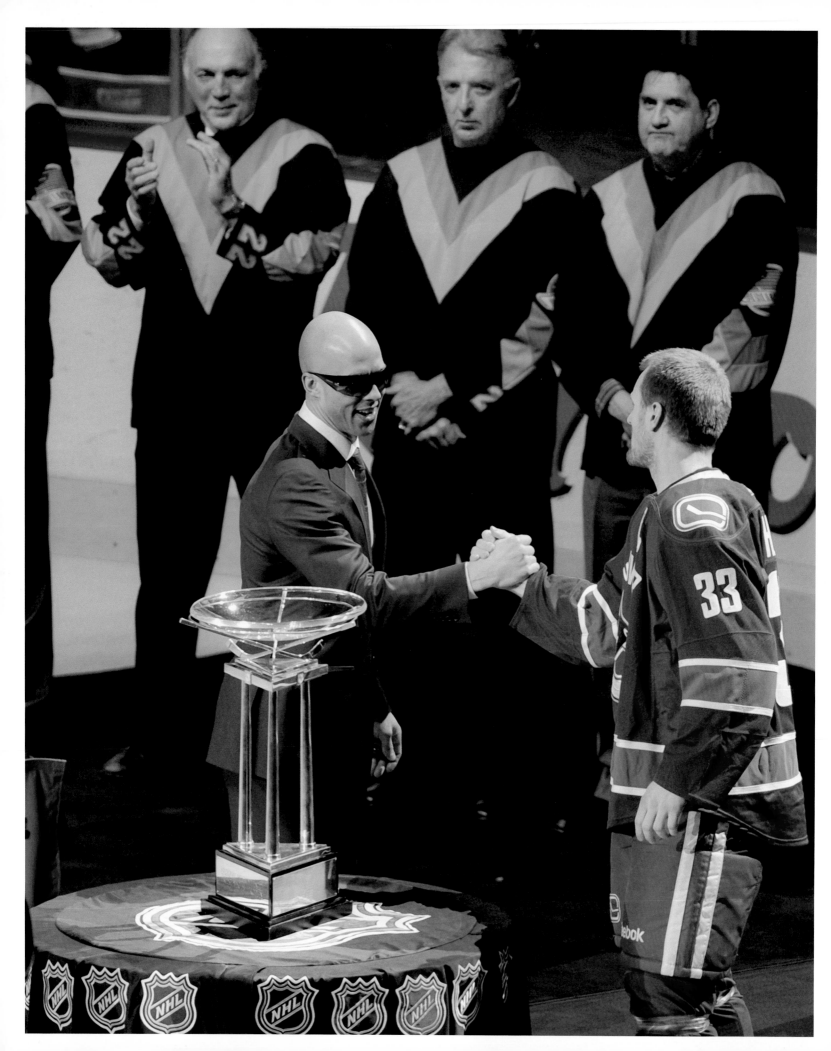

FACING: Manny Malhotra—making his first public appearance at Rogers Arena since a horrific eye injury in March—accepts the Presidents' Trophy with captain Henrik Sedin on April 7.

BOTTOM: We are all Canucks! Trevor Stuart snaps a photo of Tyler Balance as Roberto Luongo, while the Canucks prepared for their opening game of the playoffs against the Chicago Blackhawks.

"Nope, nothing. It means we have home-ice advantage, but other than that, no."

DANIEL SEDIN, on the significance of clinching the Presidents' Trophy on March 31

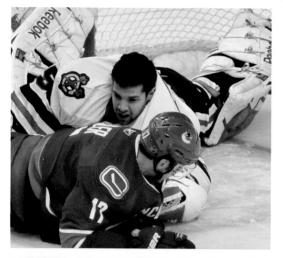
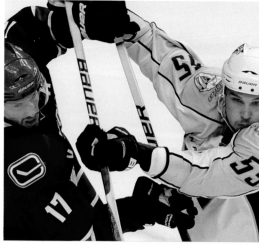

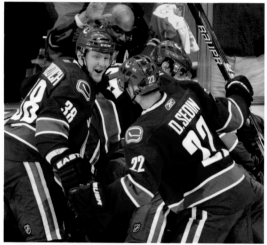
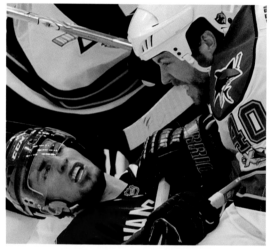

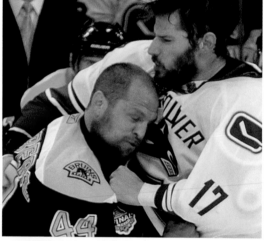

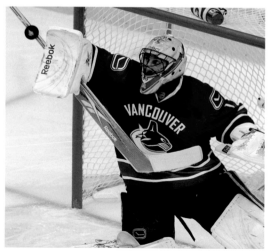
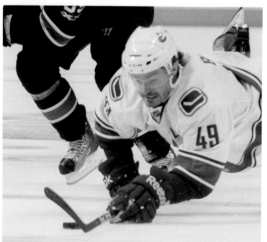

"I think with the group that we have, we don't

want to tiptoe our way to the Stanley Cup.

If we're going to win it I think we'd prefer to

go through the best and . . . Chicago are the

defending champs. Until someone wins it

this year, they are the champs. So what

better way to start than with the champs?"

KEVIN BIEKSA, on learning the Canucks would play Chicago during the first round

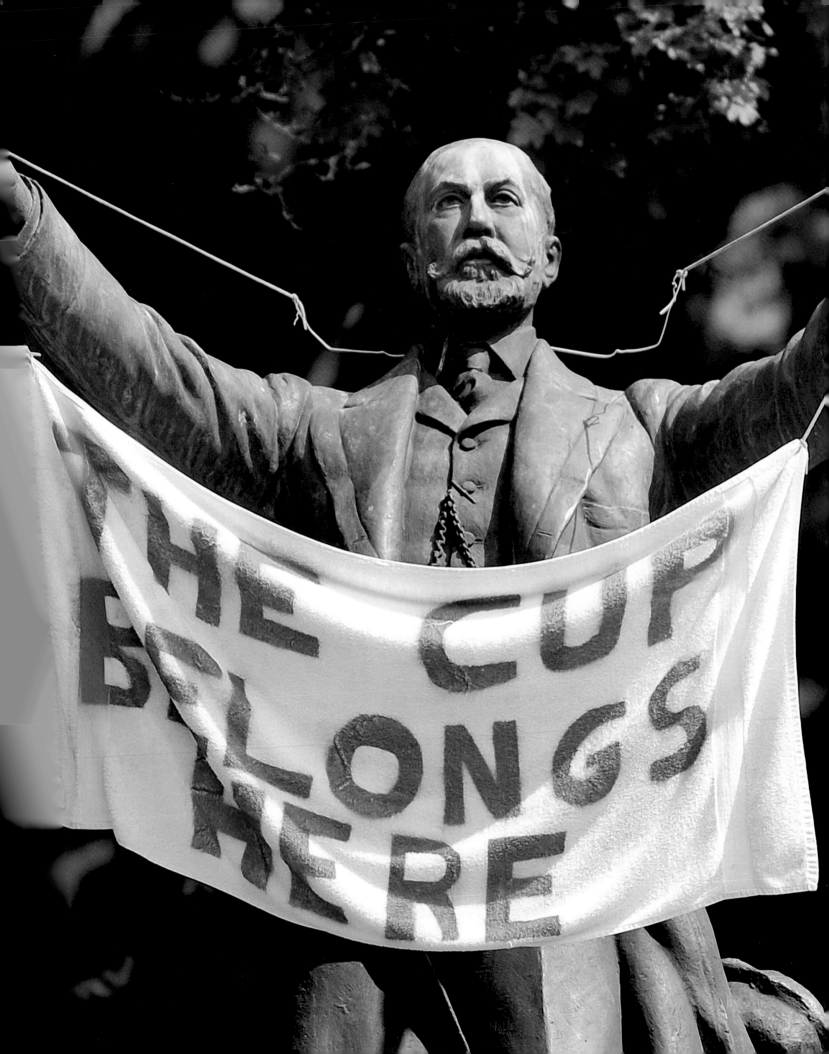

THE CHICAGO BLACKHAWKS

Round 1

THE CHICAGO BLACKHAWKS were like a train in the distance. You could hear them—and the playoffs—approaching simultaneously. Other first-round opponents were possible, as the identity of the number-eight seed seemed to change daily in the final month of the regular season. But one way or another, it felt like destiny that the Canucks should have to face their very own Moby Dick right off the hop, if they were really serious about this Stanley Cup thing.

The Hawks were not the same team that had won it all a year earlier. Half the team's depth and its starting goaltender were lost in an off-season salary dump. But they still had Jonathan Toews and Patrick Kane and Patrick Sharp and Marian Hossa, still had Duncan Keith and Brent Seabrook on the blueline to harass the Sedin twins—and most of all, they still had the knowledge that they had eliminated the Canucks in the second round each of the past two seasons.

In the early going, none of that appeared to matter.

Roberto Luongo kicked off his first post-season since shedding the captaincy with a 2–0 shutout—a clean sheet in Game 1 would be his signature in these playoffs—and the Canucks, with trade-deadline acquisition Chris Higgins scoring the only goal Luongo needed, were off and rolling.

Two nights later, the crowd at Rogers Arena cheered Daniel Sedin off the ice with cries of "MVP! MVP!" after the Art Ross Trophy winner scored two goals and assisted on another in a tense 4–3 victory. The game also featured the second goal in as many games by Jannik Hansen, the Danish speedster whose wheels and hustle and palpable will would make him a major player later in the Cup run.

CANUCKS WIN SERIES 4–3

GAME 1, APRIL 13: CANUCKS 2, BLACKHAWKS 0
GOALS: Higgins, Hansen

GAME 2, APRIL 15: CANUCKS 4, BLACKHAWKS 3
GOALS: Canucks: D Sedin (2), Hansen, Edler
Blackhawks: Smith (2), Stalberg

GAME 3, APRIL 17: CANUCKS 3, BLACKHAWKS 2
GOALS: Canucks: Ehrhoff, D Sedin, Samuelsson
Blackhawks: Keith, Sharp

GAME 4, APRIL 19: BLACKHAWKS 7, CANUCKS 2
GOALS: Blackhawks: Sharp (2), Bickell, Campbell, Keith, Bolland, Frolik
Canucks: Salo, D Sedin

GAME 5, APRIL 21: BLACKHAWKS 5, CANUCKS 0
GOALS: Hossa (2), Keith (2), Kane

GAME 6, APRIL 24: BLACKHAWKS 4, CANUCKS 3 (OT)
GOALS: Blackhawks: Bickell, Bolland, Frolik, Smith
Canucks: D Sedin, Burrows, Bieksa

GAME 7, APRIL 26: CANUCKS 2, BLACKHAWKS 1 (OT)
GOALS: Canucks: Burrows (2)
Blackhawks: Toews

Brimming with confidence and heading for the Windy City up two games to none, the Canucks eked out a 3–2 win in Game 3. But a thunderous and controversial Raffi Torres hit on Seabrook behind the Chicago net would echo—and nearly come back to haunt the Canucks—over the next three games. Seabrook was concussed on the play and missed the next two games, and without him on the Hawks' shutdown defence pair, the series looked to be over. It didn't turn out that way.

Angry at the hit, and knowing that they'd had chances to win all three games, the Hawks took advantage of a lackadaisical Game 4 effort by the visitors—and exploited the return from concussion of pesky checking centre Dave

Bolland—to rout the Canucks 7–2. Then they won the fifth game 5–0 at Rogers Arena. Fans were afraid to breathe, and the pressure was squarely on Vancouver.

Then came the shocker: Coach Alain Vigneault, who had pulled Luongo in the fourth and fifth games of the series, elected to start Cory Schneider in net for Game 6. After the rookie gave up two free goals on puck-handling mistakes, then cramped up and had to leave the game, the Hawks won 4–3 to force Game 7. Back home, the city's heart was in its throat.

Ah, but glorious Game 7: when Luongo was magnificent, shutting the Hawks out until a stupendous effort by Toews with 116 seconds left in regulation time—shades of the gold-medal game in the Olympics—forced the home team to overtime.

Glorious Game 7: when Alex Burrows, not long out of the penalty box, gloved an attempted clearance by defenceman Chris Campoli, dropped it to his stick, and fired the rolling puck past Corey Crawford—and was mobbed by teammates and serenaded by a deliriously happy, massively relieved crowd.

And just like that, Moby Dick was no more.

"They've slayed the dragon!" was play-by-play man John Shorthouse's memorable call. And they were just getting started...

CAM COLE, *The Vancouver Sun*

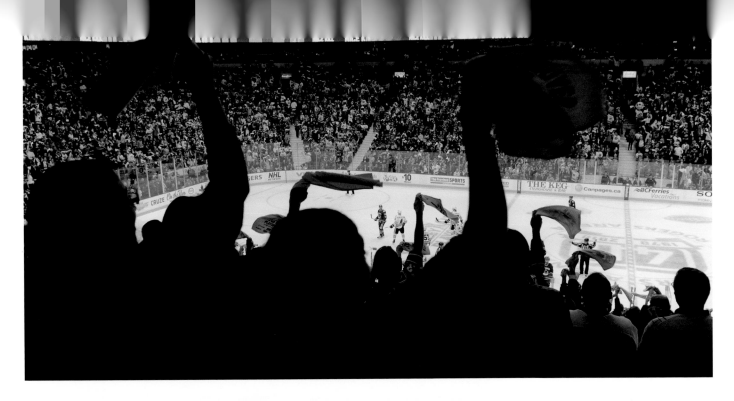

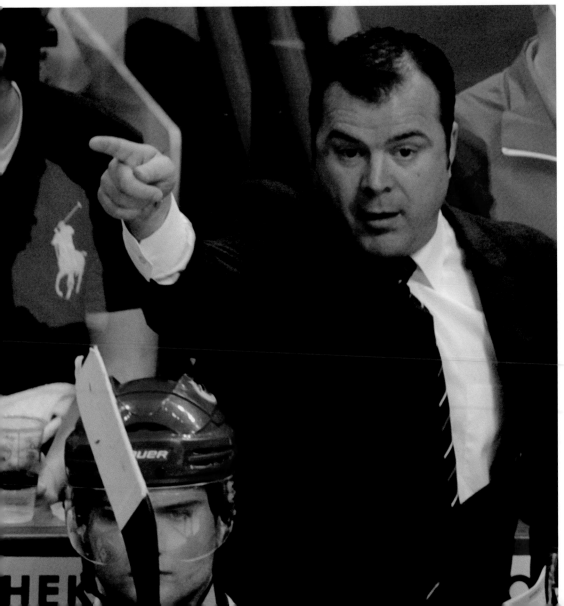

FACING: Troy Harold and Ryan Spence were among the first to take their seats in Rogers Arena on April 13 for the opening game of the playoffs.

TOP: Canuck fans spin their white towels, carrying on the tradition dating back to the 1982 playoffs, when Canucks coach Roger Neilson waved a white towel to protest officiating.

BOTTOM: Perhaps no one faced more pressure heading into the playoffs than Alain Vigneault. Lose against Chicago for a third straight post-season, and the popular coach would, in all likelihood, lose his job.

TOP: Chicago may not have the Green Men, but they did have actor Vince Vaughn, who sat front row in his jersey and taunted the Canucks throughout the series.

BOTTOM: Ryan Kesler squared off throughout the series with Blackhawks captain Jonathan Toews—Conn Smythe Trophy winner in 2010—who led his team back from a 3–0 deficit to overtime of Game 7, though he finished the series with just one goal and three assists.

FACING: Cory Schneider was the surprise starter in Game 6 of the series—he replaced Luongo late during losses in Games 4 and 5—and stopped seventeen of twenty shots before cramping up and being forced to leave the game.

"They're a beatable team. They have weaknesses just like any other team. I think it is up to us to expose them, and we haven't done a good enough job of that. It's pretty simple."

BLACKHAWKS CAPTAIN **JONATHAN TOEWS,** as his team looked to rebound from a 3–0 series deficit

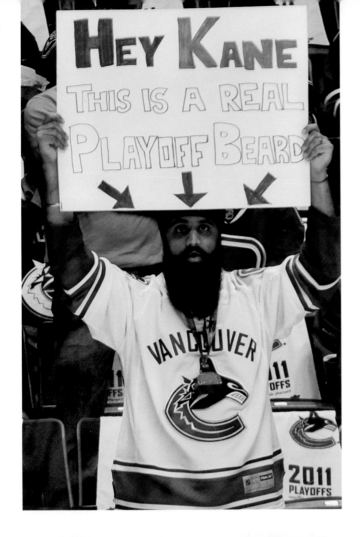

FACING: What's not to celebrate for Roberto Luongo and Chris Higgins? The Canucks had taken a 3–0 series lead, Luongo had allowed just five goals in three games, and Higgins—the trade-deadline acquisition—had proven his worth by scoring the winner in Game 1.

TOP: Canucks fans kept things simple, targeting players like Patrick Kane.

BOTTOM: Glenn Pryor took fandom seriously, smashing a van painted in Blackhawks colours prior to the start of Game 7. The good news? It was for charity.

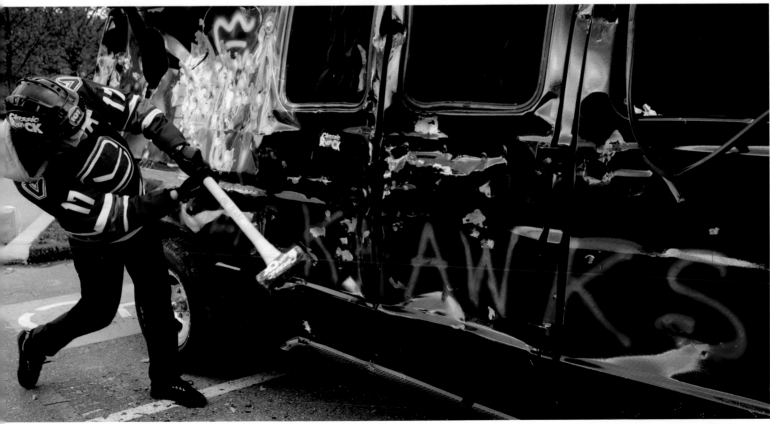

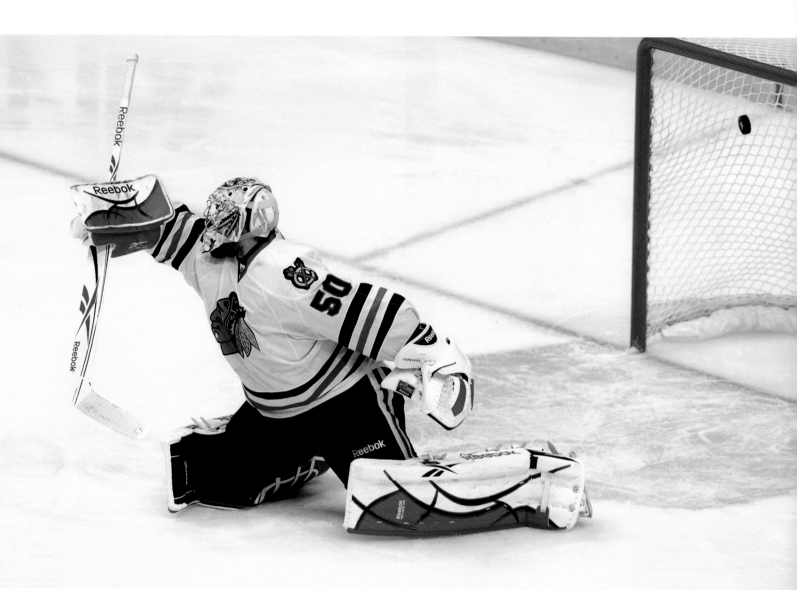

"We didn't make it easy on ourselves. It was pretty devastating when they got that tying goal. But we believed we could get it done and it felt even better getting it done this way. We told ourselves tonight was our night and we weren't going to get outdone by them and we found a way. It feels good."

ALEX BURROWS, after scoring the winning goal in Game 7 shortly after the Canucks finished killing off his penalty

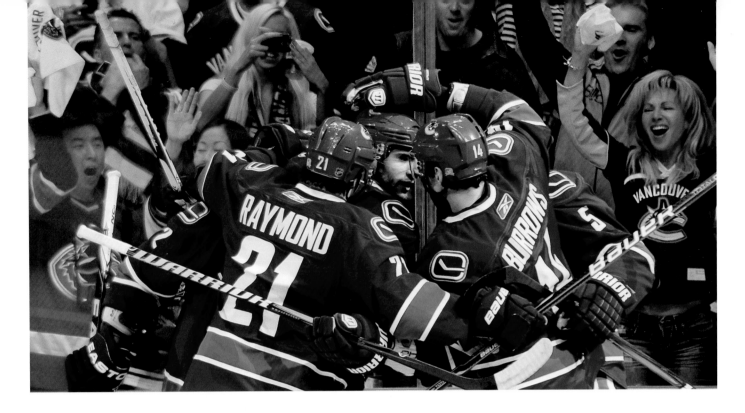

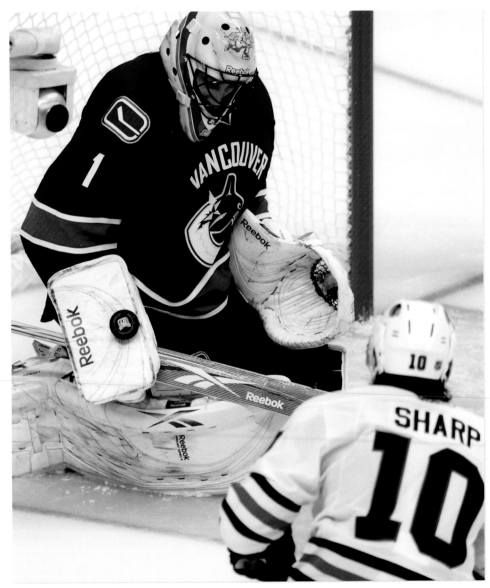

FACING: Rookie Corey Crawford surrenders the series-winning goal as the Canucks oust the defending Stanley Cup champion in overtime of Game 7. Crawford was outstanding for the Blackhawks, posting a 2.21 goals-against average and a save percentage of .927.

TOP: Every game has its hero, and in Game 7 it was Alex Burrows, who scored early in the first to give his team a 1–0 lead, and then again in overtime. Before the overtime period began, Roberto Luongo had said, "Somebody is going to be a hero in here. This is what legends are made of."

BOTTOM: Roberto Luongo saves the series by stopping this Patrick Sharp overtime power play blast. Without this save, many Vancouver coaches and players might have worked their final game as a Canuck.

THE NASHVILLE PREDATORS

Round 2

MOST OF NASHVILLE'S big stars wear cowboy hats. This one wore a hockey helmet.

Vancouver centreman Ryan Kesler left Music City's hockey fans with achy breaky hearts as he almost single-handedly carried the Canucks past the Predators and into the Western Conference Final. The Canucks scored fourteen goals in their tough six-game second-round series win over the Preds. Kesler was in on eleven of those goals—and eight of his points came in Vancouver's three wins on Nashville's home ice, Bridgestone Arena.

It was a redemption of sorts for Kesler, a forty-one-goal scorer in the regular season who had been blanked in Vancouver's emotional seven-game win over the Chicago Blackhawks in the first round. With Daniel and Henrik Sedin held in check by Nashville's dynamic defensive duo of Shea Weber and Ryan Suter, it was up to Kesler to shoulder the offensive load. It didn't figure to be easy against a defensively sound Nashville team backed by superb Finnish goalie Pekka Rinne.

The Predators seemed to have momentum on their side after earning a split in the first two games of the series at Rogers Arena. And then Kesler went to work. In Game 3, he scored two goals, including the winner at 10:45 of overtime, and assisted on Vancouver's other goal in a 3–2 win. Two nights later, he scored another game-winner and set up two goals as Vancouver won 4–2 to take a 3–1 series lead. After a two-goal performance in a 4–3 Game 5 loss at Rogers Arena, all Kesler did was return to Nashville to heroically set up both Vancouver goals in a 2–1 series-clinching win.

"He just had one of those series that is absolutely remarkable for one player," Nashville coach Barry Trotz said of Kesler when it was over. "He played to a level few people can reach."

CANUCKS WIN SERIES 4–2

GAME 1, APRIL 28: CANUCKS 1, PREDATORS 0
GOALS: Higgins

GAME 2, APRIL 30: PREDATORS 2, CANUCKS 1 (2OT)
GOALS: Predators: Suter, Halischuk
Canucks: Burrows

GAME 3, MAY 3: CANUCKS 3, PREDATORS 2 (OT)
GOALS: Canucks: Kesler (2), Higgins
Predators: Legwand, Ward

GAME 4, MAY 5: CANUCKS 4, PREDATORS 2
GOALS: Canucks: Ehrhoff, Edler, Kesler, H Sedin
Predators: Ward, Franson

GAME 5, MAY 7: PREDATORS 4, CANUCKS 3
GOALS: Predators: Legwand (2), Ward (2)
Canucks: Kesler (2), Torres

GAME 6, MAY 9: CANUCKS 2, PREDATORS 1
GOALS: Canucks: Raymond, D Sedin
Predators: Legwand

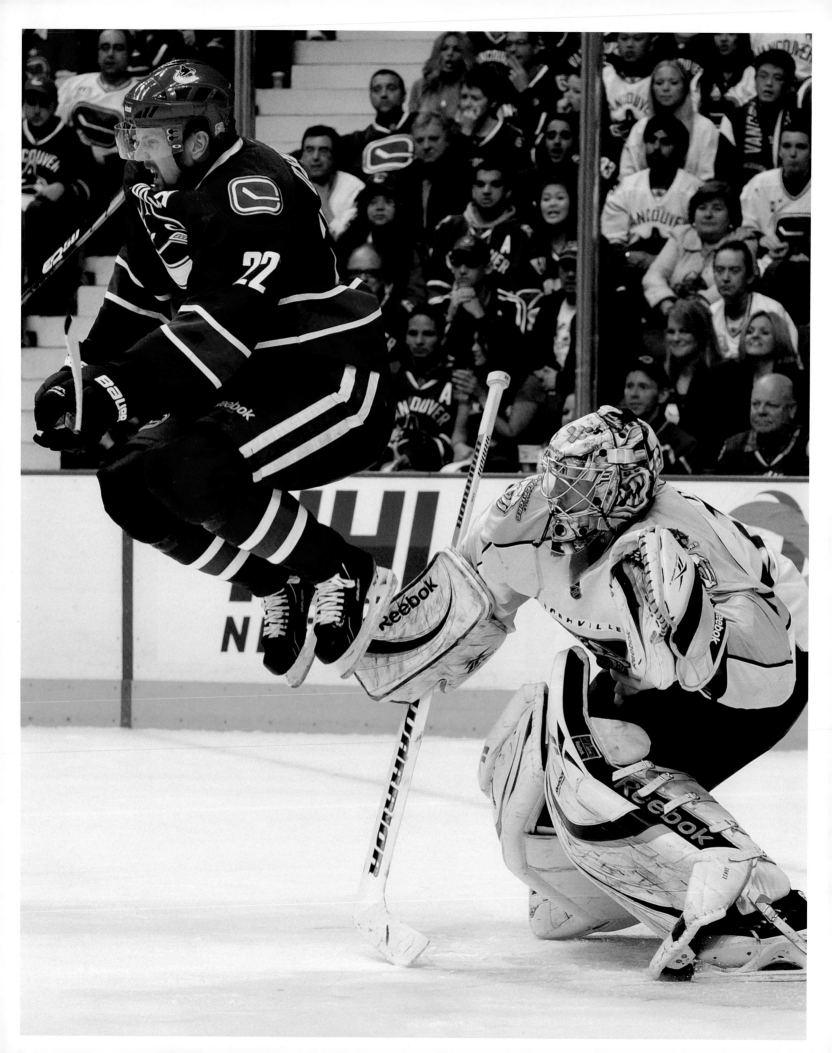

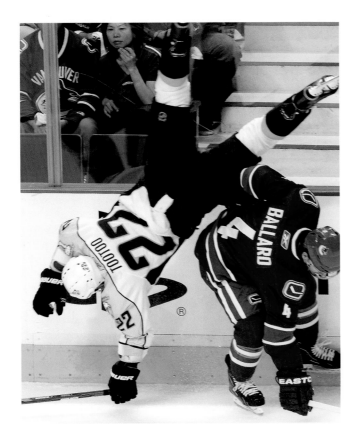

On April 28, the Canucks opened their series versus the Nashville Predators with a 1–0 victory. After the game, Nashville allegedly filed a complaint with the NHL about the popular green men—which only served to make them more popular.

BOTTOM: The small-market Predators didn't provide many players to pick on, but Mike Fisher's wife—country music superstar Carrie Underwood—prompted a playful reaction from many fans.

FACING: Pekka Rinne stones Alex Burrows in the Canucks' Game 2 loss.

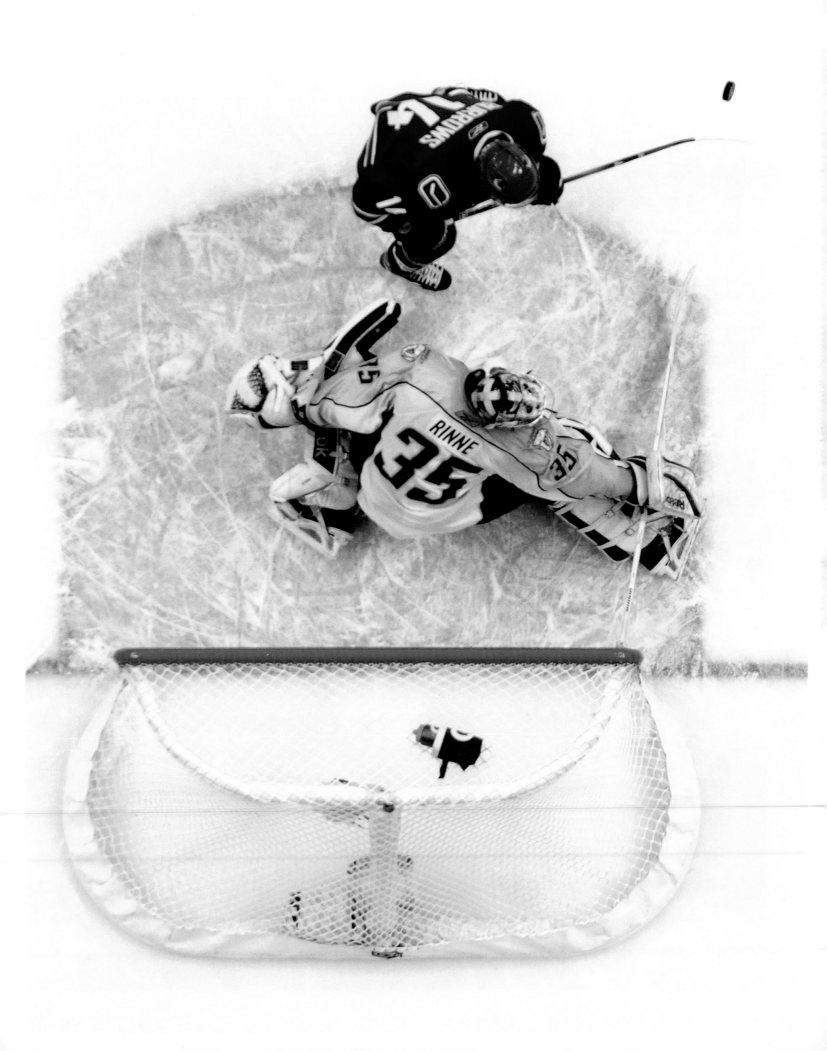

TOP: Pekke Rinne was good, but Ryan Kesler was better. Kesler's play against the Predators, especially in Nashville, drew comparisons to legend Mark Messier from Nashville coach Barry Trotz.

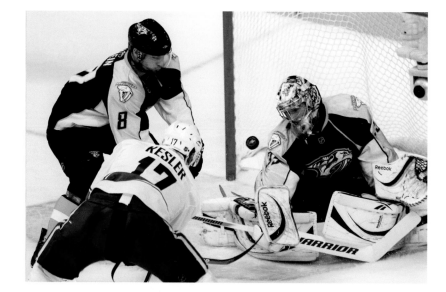

BOTTOM: Alex Burrows solved Rinne, as the Canucks winger continued his habit of scoring massive goals.

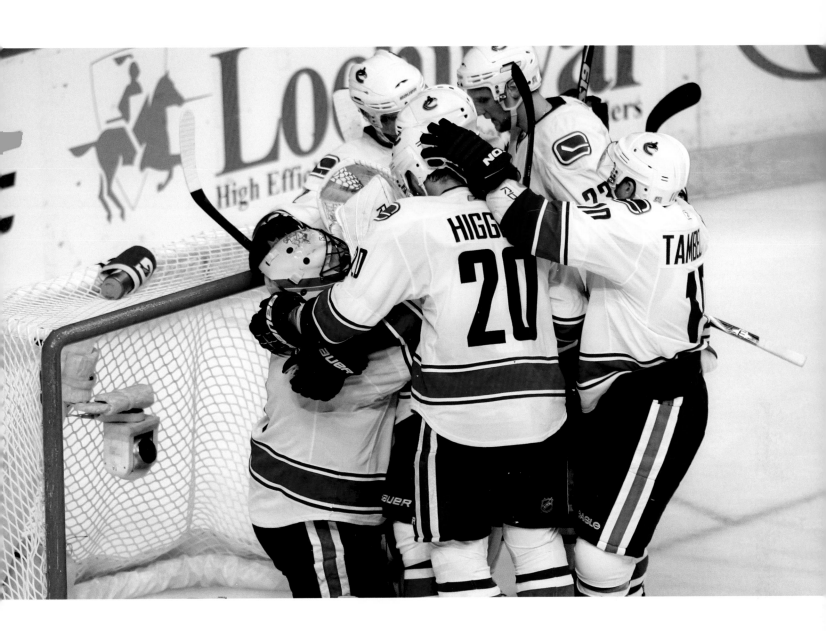

"There were a lot of ups and downs in the Chicago series, and a storybook ending. This one was more about moving to the Conference Final that most of us haven't been to. I was just happy that we were able to get it done. We definitely didn't want to go to a Game 7 again—you never know what can happen."

ROBERTO LUONGO

THE SAN JOSE SHARKS

Round 3

WE ARE ALL CANUCKS, but Kevin Bieksa almost wasn't. Sami Salo's injury saved him from becoming trade bait last summer, and in the Western Conference Final the two Vancouver blueliners combined to reel in the San Jose Sharks.

Bieksa scored three goals in Vancouver's five-game dismantling of San Jose, while Salo scored two of his own in a span of sixteen seconds. Salo's goals, a pair of blistering slappers that sealed the deal in Game 4 at the HP Pavilion, both came on five-on-three power plays. They helped give Vancouver a 3–1 series lead and set the stage for Bieksa's Game 5 heroics at Rogers Arena.

Bieksa, a terrific two-way defenceman, was at his swashbuckling best when he scored two goals off the rush in Games 1 and 2 of the series. Those goals were of the highlight-reel variety, combining speed and skill. Bieksa required neither of those attributes for his double-overtime series-clinching goal in Game 5. This one was more about luck, a sharp eye, lightning reflexes, and a couple of fortu-itous bounces. The luck came when fellow defenceman Alex Edler tried to rim the puck around the glass inside the San Jose zone. The puck hit the stanchion supporting the glass and popped high into the air. No one seemed to know where it went, except eagle-eyed Bieksa, who watched as it rolled right in front of him and onto his stick. He floated a long shot—a knuckleball, he called it—at San Jose goalie Antti Niemi, who didn't—couldn't possibly—see it coming. The puck bounced once and then again before beating Niemi low to the glove side.

Bieksa called it the biggest goal of his career, but the ugliest. To the Canucks and their fans it was a thing of beauty, and it sent the team on only their third run at the Stanley Cup.

And it might never have happened if not for Salo's Achilles tendon, which he ruptured the summer before while playing floorball in his native Finland. That injury allowed the Canucks to free up enough salary cap space to keep Bieksa.

The rest is, well, so much history.

CANUCKS WIN SERIES 4–1

GAME 1, MAY 15: CANUCKS 3, SHARKS 2
GOALS: Canucks: Lapierre, Bieksa, H Sedin
Sharks: Thornton, Marleau

GAME 2, MAY 18: CANUCKS 7, SHARKS 3
GOALS: Canucks: D Sedin (2), Torres, Bieksa,
Higgins, Rome, Raymond
Sharks: Couture, Marleau, Eager

GAME 3, MAY 20: SHARKS 4, CANUCKS 3
GOALS: Sharks: Marleau (2), Clowe, Boyle
Canucks: Burrows, Hamhuis, Bieksa

GAME 4, MAY 22: CANUCKS 4, SHARKS 2
GOALS: Canucks: Salo (2), Kesler, Burrows
Sharks: Desjardins, Clowe

GAME 5, MAY 24: CANUCKS 3, SHARKS 2 (2OT)
GOALS: Canucks: Burrows, Kesler, Bieksa
Sharks: Boyle, Setoguchi

TOP: The spandex-suit phenomenon spread as the "pink ladies" made an appearance at Rogers Arena.

BOTTOM: The Canucks drove a stake through the heart of the Sharks by cashing in on the power play. In Game 4, Sami Salo blasted two supersonic slapshots past Antti Niemi.

FACING: Daniel Sedin looks to his teammates after Ryan Kesler deflected his shot past Antii Niemi to even the score at 2–2 in Game 5 of the Western Conference Final.

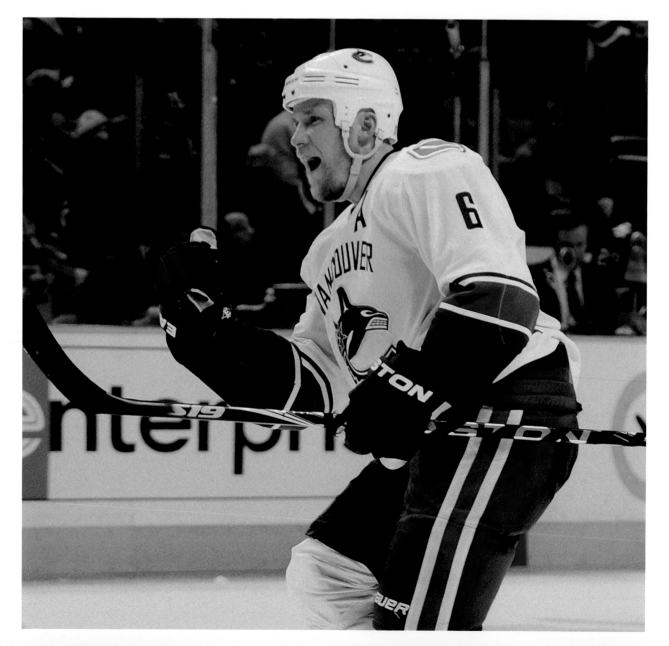

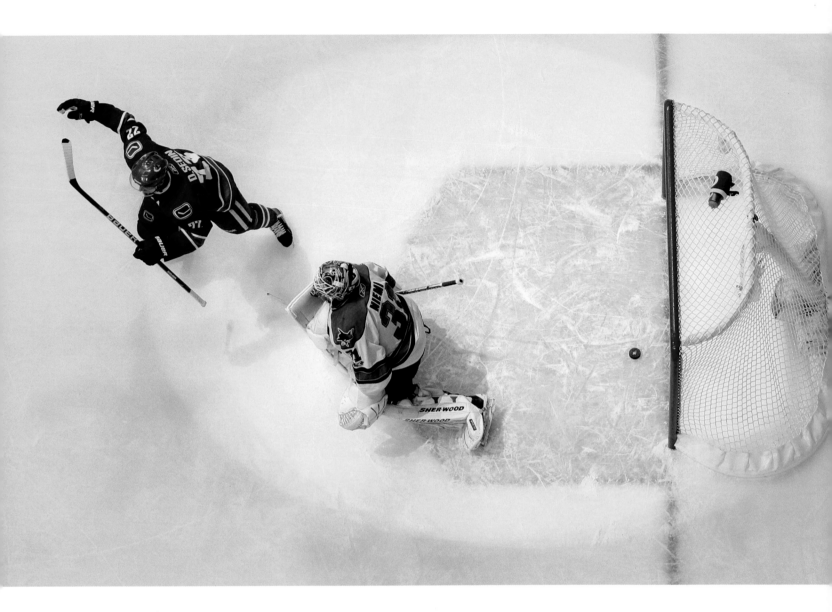

"I'm sure if a lot of guys met Ryan Kesler in a back alley there would be a lot of stuff happening. It's just the way it is. He plays hard and I give him respect as a player. Obviously, you're going to butt heads and go head-to-head, and that's been good."

SHARKS FORWARD RYANE CLOWE

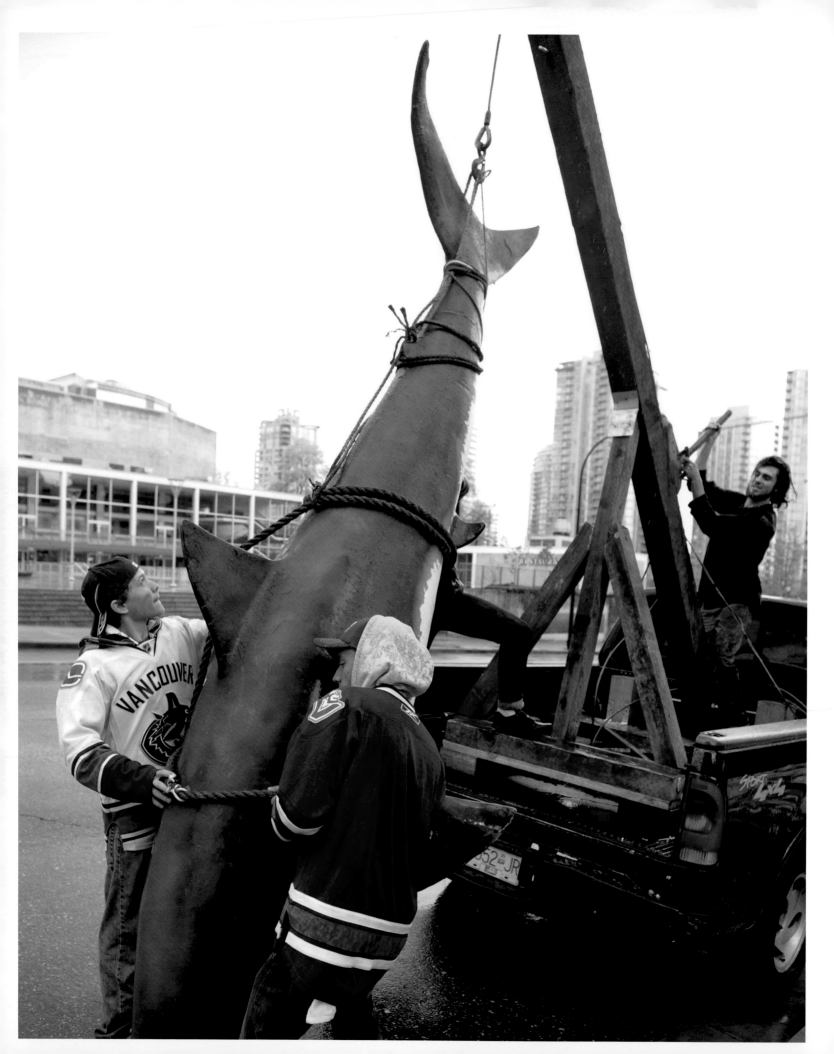

TOP: The Canucks were the hottest ticket in town, and the celebrities came out in droves. Kim Cattrall, Elvis Costello, Diana Krall, and Steve Nash made appearances. Lifelong Canucks fan Michael Bublé was there from day one, and was thrilled be at the game.

BOTTOM: The ugliest goal of Kevin Bieksa's career—and the sweetest—sends the Canucks to the Stanley Cup Final.

"You look on the faces of guys, it's excitement, disbelief, kind of, 'What's going on? Did we really just accomplish another one of our goals?' It's a great feeling."

MASON RAYMOND on making the Stanley Cup Final

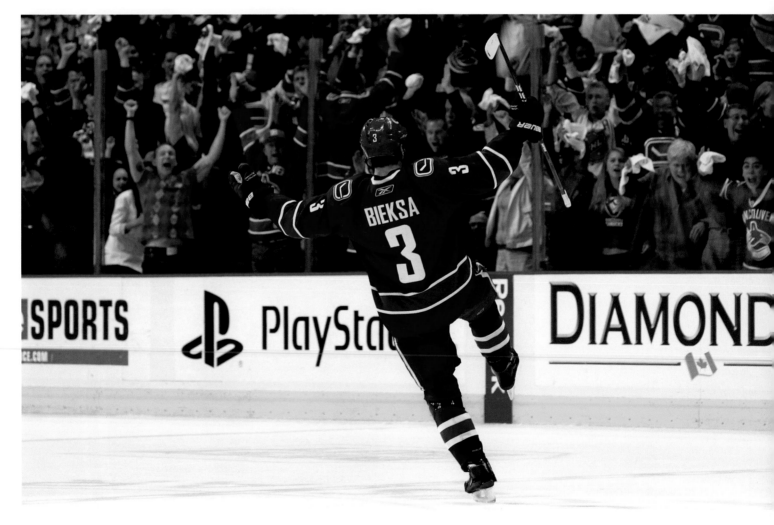

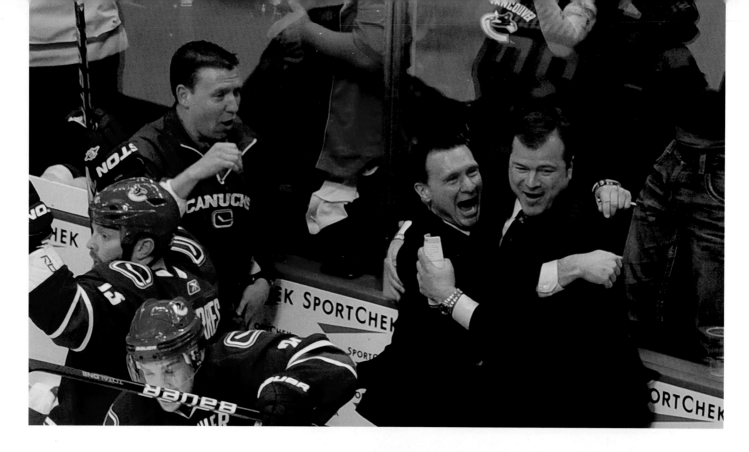

TOP: Coach Alain Vigneault and assistant coach Newell Brown join in the rink-wide celebration after Kevin Bieksa scored the series-winning goal against San Jose.

BOTTOM: Captain Henrik Sedin was presented with the Clarence S. Campbell Bowl after the Canucks won the Western Conference title. The superstitious nature of hockey players—you never hoist a trophy when you want something bigger—meant that Sedin posed next to the silverware but wouldn't lay a hand on it.

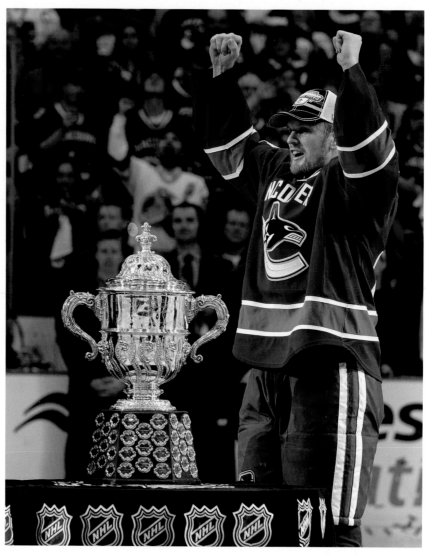

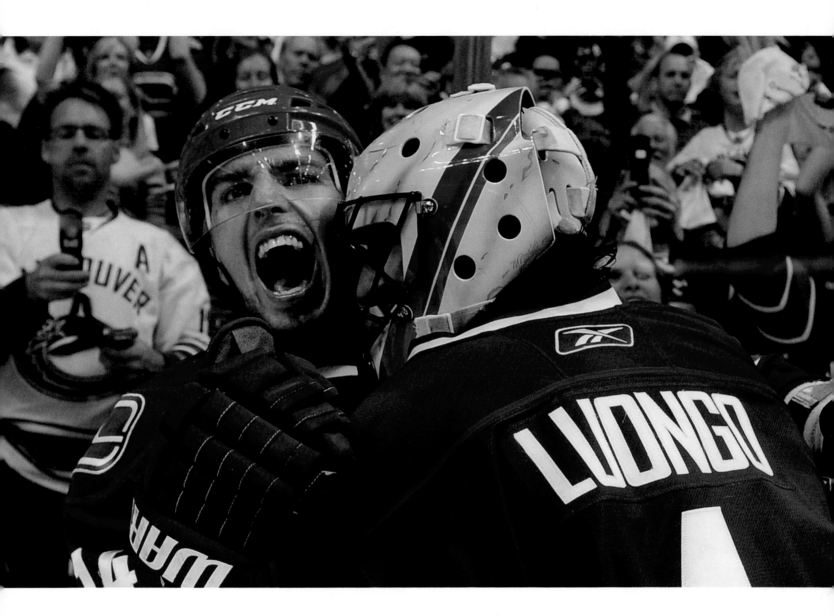

"You work all your life for the opportunity, all the ups and downs—that's probably the biggest thing. And now to be able to battle for the Stanley Cup, that's a pretty good feeling."

ALEX BURROWS, after the Canucks won the Western Conference title

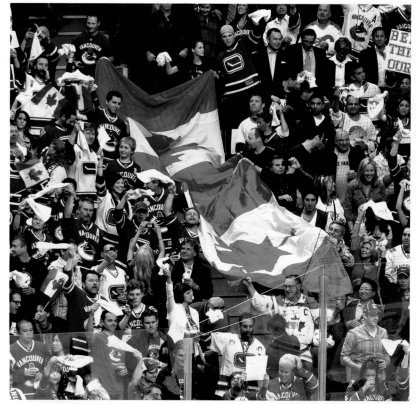

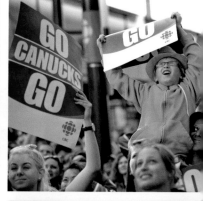

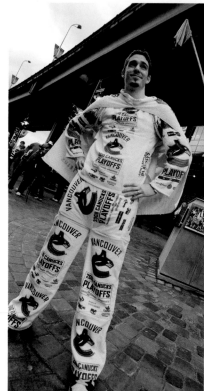

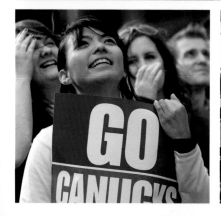
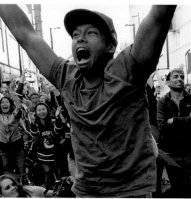

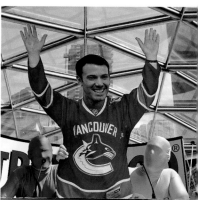

IF, AS THE TEAM MOTTO SAYS, "We are all Canucks," then Vancouver's fans have suffered as much as any other group in the sporting world.

Forty years, and only two trips to the Stanley Cup Final, both unsuccessful. But this year—this fortieth anniversary season, in which the Canucks dominated the league to win their first Presidents' Trophy—well, people hoped it would be different.

Fans wanted to believe, but they were understandably apprehensive after so many years of post-season futility. When the Canucks blew a three-game series lead in the first round against Chicago, it did little to alleviate the nerves.

But the Canucks came back to win Game 7 of that series in overtime, ousting the defending Stanley Cup champions and restoring hope to Canuck Nation. As the Canucks knocked off Nashville and then San Jose, then faced off against the Boston Bruins in the Cup Final, the bandwagon grew to epic proportions.

Car flags flew everywhere. Jersey maker Reebok-CCM sold out of its entire Canucks stock. Paraphernalia of every shape and size were gobbled up by fans caught up in the frenzy. CBC set records for nhl viewership throughout the final round, with Game 7 drawing an average audience of 8.76 million, making it the network's second most-watched sporting event of all time behind only the men's gold-medal hockey game at the 2002 Olympics. Of the top-five CBC sports broadcasts, four are part of this Stanley Cup Final series.

In the Lower Mainland, each game drew thousands to the downtown core, where giant TV screens were installed and streets were shut down, creating a scene reminiscent of the Olympics one year earlier. After each game, enthusiastic crowds flocked to places like Surrey's Scott Road and 72nd Avenue to revel in the party atmosphere.

Superfans continued to come up with quirky, heartwarming, and downright weird ways to show support for the historically maligned club. The airport was overrun with fans from far and away, returning to celebrate with the hometown crowd. Pejman Khoddami, for example, flew back from his marketing job in Sydney, Australia, after having a clause written into his contract granting him leave if the Canucks ever made it to the Stanley Cup Finals. "To tell you the truth, I never actually thought I would use it," Khoddami said. "Just like every [Canucks] season, it was a hope and a prayer."

During the final round, tickets to watch road games on the big screens at Rogers Arena were snapped up in half an hour, while on various websites the price of tickets for a home game rose with each round until they eclipsed $1,000 for nosebleed seats.

After the Game 7 loss, a shadow was cast on the many enthusiastic fans by a small group of rowdy hooligans intent on recreating the mayhem of the 1994 Stanley Cup riot. Terror reigned for a night, but the next day hundreds of Vancouverites banded together, volunteering to clean up debris and show the Canucks and the city what real fans look like.

Although their team fell short again, many were already looking towards a bright future.

"The hockey gods are against us," said Irwin Bhinder, who travelled from Brooks, Alberta to watch the final game. "When we ever win the Cup, that will be sweet. Maybe next year.""

THE BOSTON BRUINS

Round 4

"When saves needed to be made, we were both making them. I had a feeling we were going to go to overtime and play a little longer."

ROBERTO LUONGO, on his Game 1 battle with Tim Thomas: Luongo made 36 saves, Thomas 33

Game 1

THE ATMOSPHERE INSIDE Rogers Arena was at its most electric since Game 7 of the opening round, the Canucks' overtime victory over bitter rival Chicago. Just seconds in, Daniel Sedin almost gave Canuck fans reason to go apoplectic... but Bruins goaltender Tim Thomas lived up to his reputation with a superb save.

As the game wore on, however, it was Roberto Luongo who out-duelled Thomas. And the Canucks—surprisingly, given the stats coming in—outplayed Boston five-on-five, with the magnificent third line coming through for the Canucks yet again.

"They've played great the whole playoffs," said first-liner Daniel Sedin, who had a game-high eight shots. "It's because of those guys that we are where we are. They are going to win us games and they did tonight."

With time ticking down on a scoreless game in the third period, Ryan Kesler—on the ice in place of trade-deadline pickup Max Lapierre—made a superb play at the Boston blueline to get the puck to Jannik Hansen. Hansen drew Thomas and towering Boston captain Zdeno Chara to him, then slipped a nifty pass against the grain to speeding Raffi Torres. Torres buried it with 18.5 seconds left in regulation and Rogers Arena went wild.

"Kes made a heads-up play holding on to the puck and got it to Hansen, and I just tried to get open," Torres said. "Janny made a great play to get it over and I was fortunate enough to get it into the back of the net... Jannik and Lappy had a hell of a third period to go along with a pretty solid game. It's pretty simple hockey. Get pucks deep and try to work their defence."

A plan carried out to perfection in Game 1 of the Stanley Cup Final, when it mattered the most.

CANUCKS 1, BRUINS 0
Rogers Arena in Vancouver

FIRST PERIOD

GOALS: None

PENALTIES
D Sedin VAN (High-sticking) 4:03
Kelly BOS (High-sticking) 8:47
Burrows VAN (Holding) 10:18
Marchand BOS
(Stick holding) 13:25
Bergeron BOS (Roughing) 20:00
Burrows VAN
(Roughing, double minor) 20:00

SECOND PERIOD

GOALS: None

PENALTIES
Bieksa VAN (High-sticking) 0:28
Krejci BOS (Cross-checking) 4:00
Seidenberg BOS (Kneeing) 9:28
Peverley BOS (Hooking) 9:54
Burrows VAN (Tripping) 10:02
Bergeron BOS (Tripping) 17:50

THIRD PERIOD

GOALS
Torres 3 VAN (Hansen, Kesler) 19:41

PENALTIES: None

SHOTS ON GOAL
Boston: 17/9/10—36
Vancouver: 12/8/14—34

POWER PLAYS (goals–chances)
Boston: 0–6, Vancouver: 0–6

GOALIES
(shots–saves, result, record)
Boston: Thomas (34–33, L, 12–7)
Vancouver: Luongo
(36–36, W, 13–6)

REFEREES
Stephen Walkom, Dan O'Rourke

LINESMEN
Pierre Racicot, Steve Miller

TOP: Home games at Rogers Arena featured the music of the Canucks house band, the Odds, with front man Craig Northey (right), guitarist Murray Atkinson (left), drummer Pat Steward, and Doug Elliott on bass. The band members even grew playoff beards.

BOTTOM: Tim Thomas matched Roberto Luongo almost save-for-save in Game 1, here stopping a shot by Jannik Hansen and (facing photo) surviving a collision with Daniel Sedin.

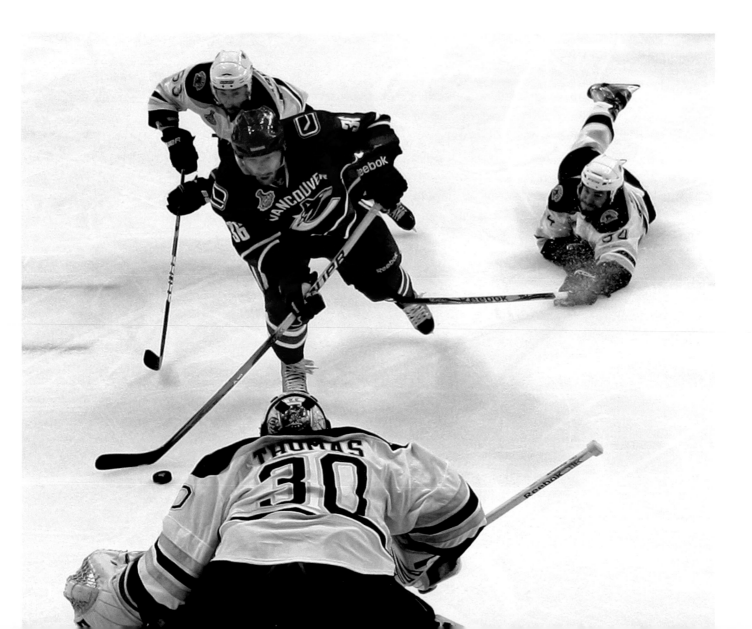

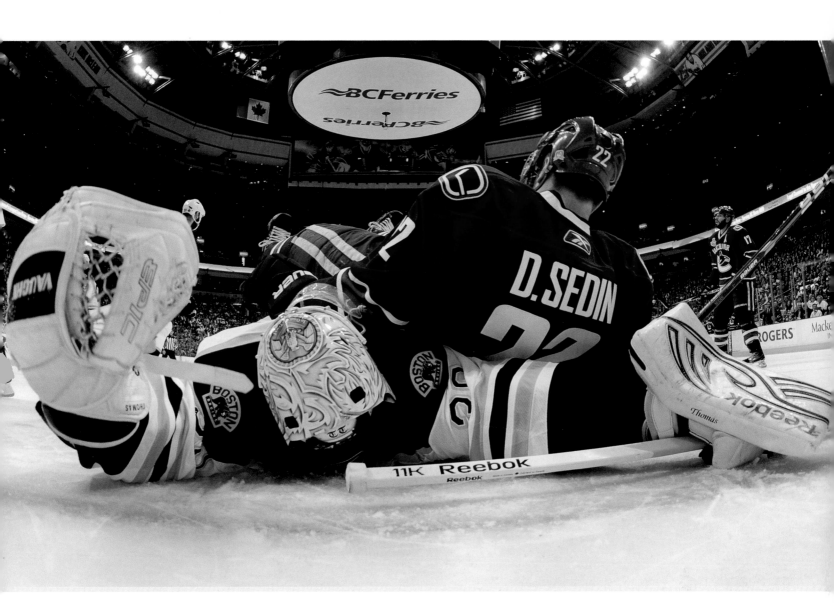

"I thought for the first two periods we played a pretty even game. Obviously, in the third, we just seemed to lack some energy and lost our legs. They just seemed to come at us pretty hard."

BOSTON COACH **CLAUDE JULIEN**

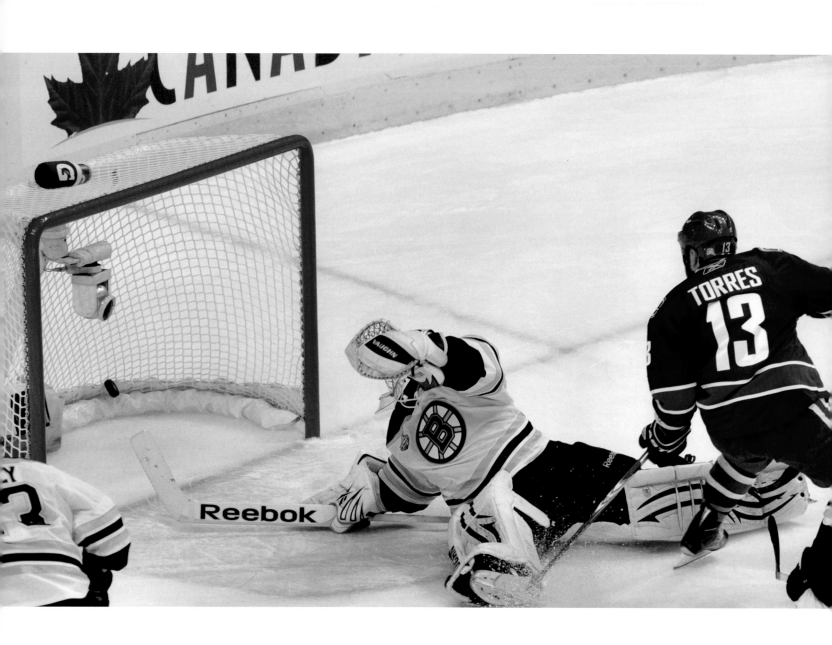

"That was easily the best period I've ever seen him play. He was outstanding, chance after chance … an absolute warrior for us tonight."

MASON RAYMOND on Jannik Hansen, who picked up an assist on Raffi Torres's game-winning goal

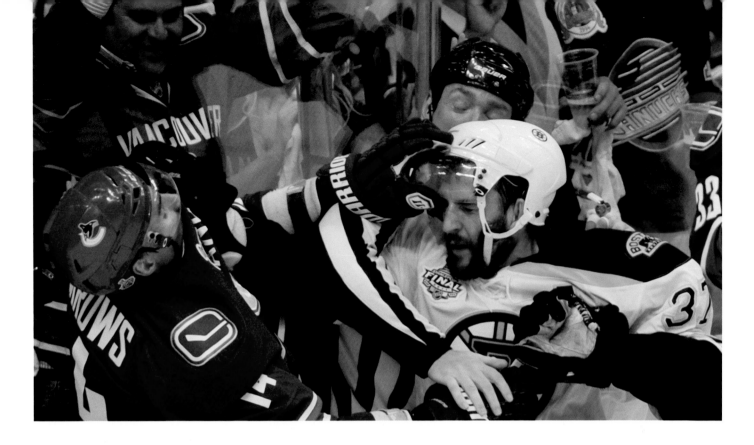

FACING: Vancouver's third line continued to thrill as Raffi Torres scored the lone goal of the series opener with 18.5 seconds left in the third period. The goal secured Roberto Luongo's third shutout of the post-season—all in series openers.

TOP: Did he or didn't he? Alex Burrows denied chomping down on Patrice Bergeron's finger, while Bergeron insisted he had the bite marks to prove it. Bruins fans called for a suspension—it didn't happen—and the finger-waggling extended into Game 3.

BOTTOM: Canuck fans Carlo D'Onofrio and Kyle Harding got into the spirit by going bear hunting prior to the series opener.

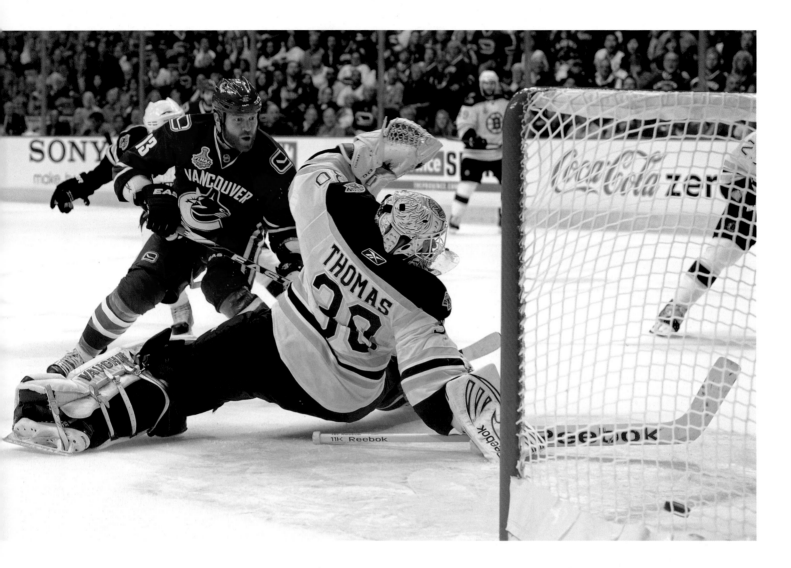

TOP: Another angle on Raffi Torres's game-winning goal, the latest go-ahead goal in a Stanley Cup Final game since Mario Lemieux scored with thirteen seconds left to lift Pittsburgh over Chicago in 1992.

BOTTOM: These fans are hoping for a sweep, as the Canucks appear to be getting more efficient each round.

FACING: Raffi Torres and Jannik Hansen celebrate their game-clinching goal, which gave the Canucks their fourth series-opening win of the post-season.

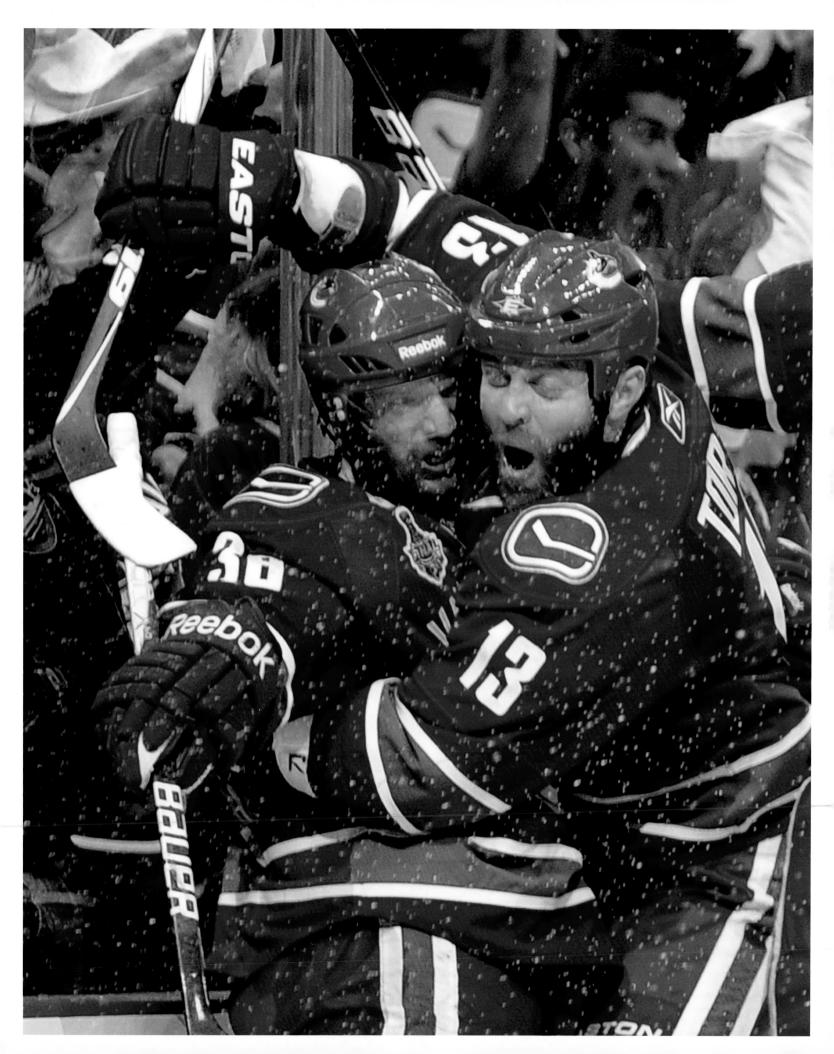

"To say the fans [in Vancouver] are passionate would be a gross understatement. To be out there again, to hear them cheering, to hear an ovation like that, it definitely makes you feel like a Canuck, a part of the family."

MANNY MALHOTRA, on his return to play in Game 2, after being out with an eye injury since March 16

GAME 2 ARRIVED on a brilliantly sunny Saturday evening, with more than seventy thousand fans packing Vancouver's downtown core to watch the game on big screen TVs erected for public viewing parties. Similar events were taking place in Richmond and Surrey, and across the Lower Mainland.

Those lucky enough to have tickets to the game didn't need another reason to blow the roof off Rogers Arena, but they got it when Manny Malhotra made his first appearance of the post-season, completing a miraculous comeback from an eye injury that just two months earlier looked like it might end his career.

The monstrous storyline of Game 2, however, was Alex Burrows. Ignoring talk that he should have been serving a suspension for biting Patrice Bergeron in the opening game of the series, the Canucks winger scored twice and added an assist to give the Canucks a 3–2 win and a 2–0 series lead.

But the win wasn't an easy one.

Burrows opened scoring in the first period, beating Tim Thomas with a laser-beam shot on the power play.

But the momentum shifted Boston's way in the second, with the Bruins taking full advantage of a lull in Vancouver's energy. The damage was inflicted by two B.C. boys—Milan Lucic of East Vancouver and Mark Recchi of Kamloops—who scored twice within two minutes and thirty-five seconds to give Boston its first lead of the series.

CANUCKS 3, BRUINS 2 (OT)
Rogers Arena in Vancouver

FIRST PERIOD
GOALS
Burrows 8 VAN (PP)
(Higgins, Salo) 12:12

PENALTIES
Chara BOS (Interference) 10:24

SECOND PERIOD
GOALS
Lucic 4 BOS (Boychuk, Krejci) 9:00
Recchi 3 BOS (PP)
(Chara, Bergeron) 11:35

PENALTIES
Bieksa VAN (Delay of game) 1:03
Rome VAN (Holding) 10:26
Rome VAN (Interference) 18:59

THIRD PERIOD
GOALS
D Sedin 9 VAN
(Burrows, Edler) 9:37

PENALTIES
Seidenberg BOS (tripping) 0:52

OVERTIME
GOALS
Burrows 9 VAN (Sedin, Edler) 0:11

PENALTIES: None

SHOTS ON GOAL
Boston: 11/14/5/0—30
Vancouver: 11/10/11/1—33

POWER PLAYS (goals–chances)
Boston: 1–3, Vancouver: 1–2

GOALIES
(shots–saves, result, record)
Boston: Thomas (33–30, L, 12–8)
Vancouver: Luongo
(30–28, W, 14–6)

REFEREES
Dan O'Halloran, Kelly Sutherland

LINESMEN
Jay Sharrers, Jean Morin

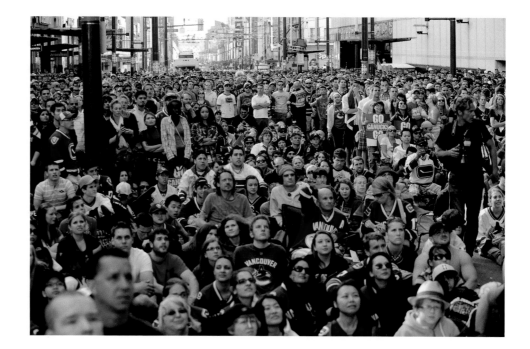

The Canucks picked it up again in the third, and the cranked-up intensity worked. Midway through the period, Burrows slid a perfect pass to Daniel Sedin, who buried the chance, tying the game and ultimately sending it to overtime.

Nervous energy filled the building heading into the extra session. A loss, and home-ice advantage for the series would shift to Boston.

But fans didn't have to wait long. Just eleven seconds into the frame, Burrows tormented the Bruins again. Alex Edler picked up an errant banking attempt from Andrew Ference and scooped it up-ice to Daniel Sedin, who chipped the puck into the middle. Burrows swung wide to beat an aggressive Thomas poke check, tipped the puck behind the net, then out-muscled Boston behemoth Zdeno Chara, tucking the wrap-around into the empty net for the winner.

Rogers Arena—in fact all of downtown and the entire Lower Mainland— erupted as the Canucks secured a 2–0 series lead. The Cup hadn't been won, but fans had this to think about as they partied late into the night, the joy on the streets similar to that experienced during the 2010 Olympic Games: of the last forty-six teams to win the first two games of the Final, forty-two went on to win the Stanley Cup.

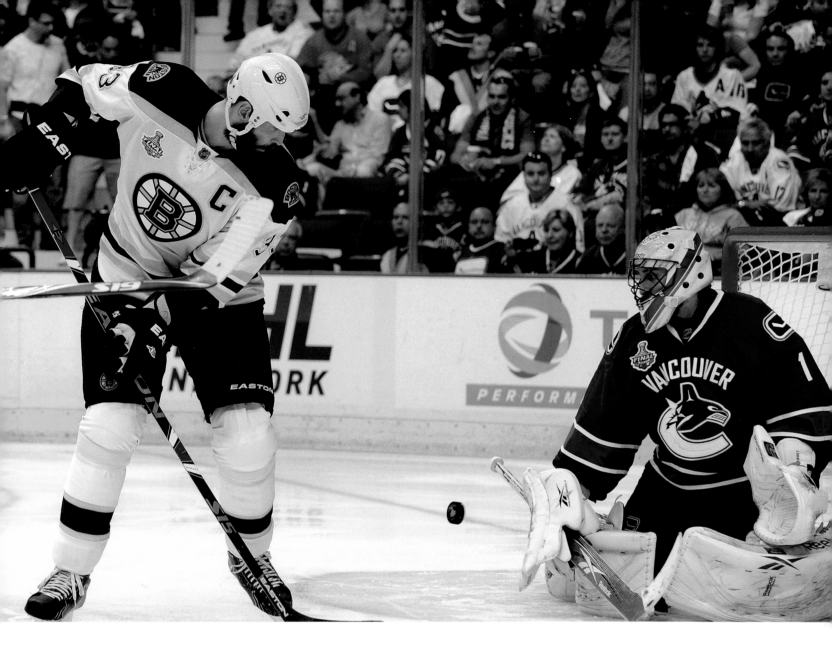

"We've seen it happen in front of our own eyes. We were down 2–0, came back and won the series. I don't think there's any reason here to not be positive. You don't get this far and all of a sudden hang your head. They had home-ice advantage, won their first two home games. We've got to go back home and do the same."

BRUINS COACH CLAUDE JULIEN, alluding to his team's comeback against Montreal.

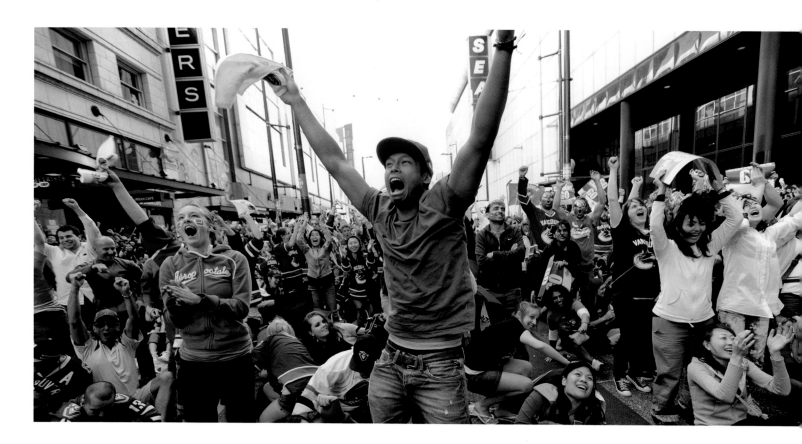

TOP: Canucks fans on Granville Street celebrate Alex Burrows's first-period goal, which gave the Canucks an early 1–0 lead.

BOTTOM: Alex Burrows beat Tim Thomas twice on the night, midway through the first (shown here) and again in overtime, just eleven seconds in. He also set up Daniel Sedin's game-tying goal in the third.

FACING: Mason Raymond blocks a shot in front of Roberto Luongo during the second period. Luongo finished the night with thirty-one saves.

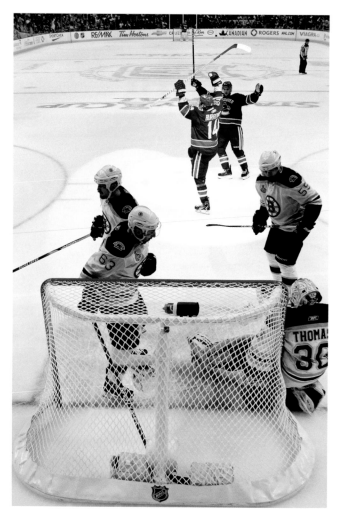

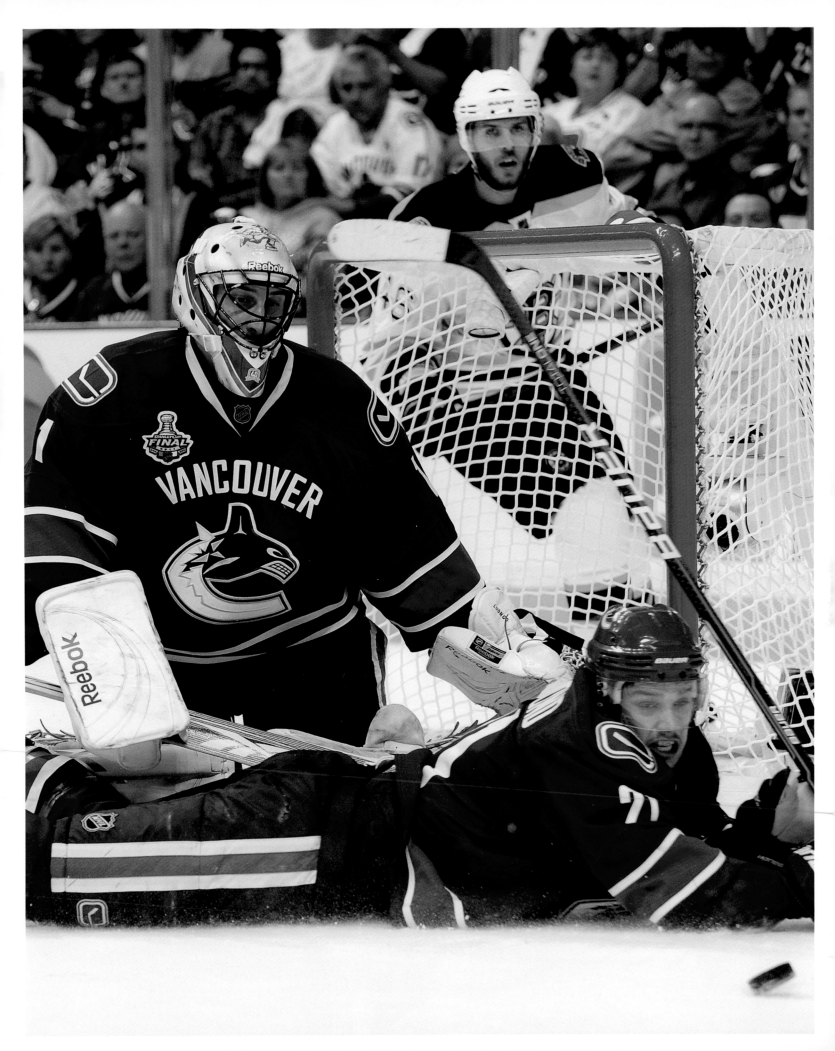

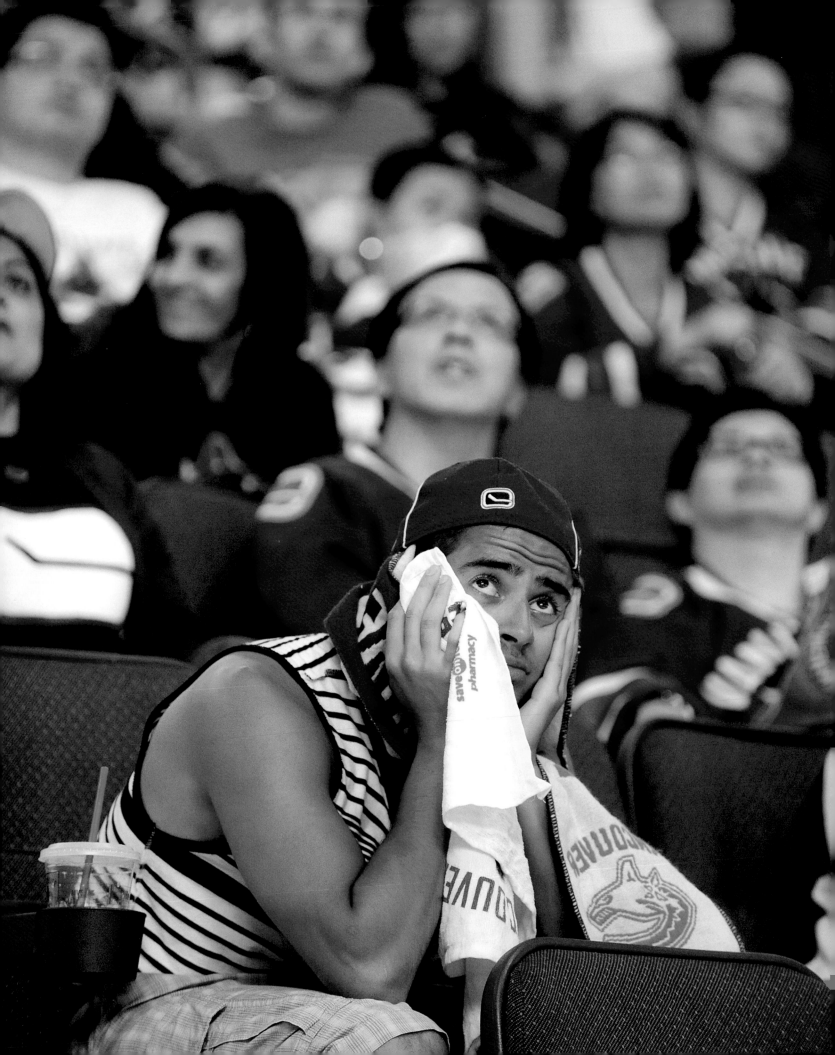

Game 3

THE CITY OF VANCOUVER was buzzing as the Canucks headed into Game 3 in Boston. Premier Christy Clark lit the Olympic cauldron, Rogers Arena and all of downtown was packed for public viewing parties, and the anticipation was that nothing could stop the Canucks. Confidence—cockiness, even—reigned supreme. At coffee shops and on sports radio, people dared to express the hope that the Canucks would lose so they could win the Cup at home.

After a scoreless first period, the Bruins exploded. They scored eleven seconds into the second period and never let up, scoring four times in the second and four more in the third, scoring on the power play, scoring short-handed, scoring almost at will.

BRUINS 8, CANUCKS 1
TD Garden in Boston

FIRST PERIOD

GOALS: None

PENALTIES
Rome VAN
(Interference, major) 5:07
Rome VAN (Game misconduct) 5:07
McQuaid BOS (Delay of game) 11:41

SECOND PERIOD
GOALS
Ference 3 BOS (PP)
(Peverley, Krejci) 0:11
Recchi 4 BOS (Ryder, Ference) 4:22
Marchand 7 BOS (SH)
(unassisted) 11:30
Krejci 11 BOS (Ryder, Chara) 15:47

PENALTIES
Tambellini VAN (Hooking) 2:42
Ference BOS (Tripping) 6:22
Lucic BOS (Slashing) 10:30
Boychuk BOS
(High-sticking, double minor) 17:36

THIRD PERIOD
GOALS
Paille 3 BOS (SH) (Boychuk) 11:38
Hansen 3 VAN (Torres, Lapierre) 13:53
Recchi 5 BOS
(Marchand, Bergeron) 17:39
Kelly 5 BOS (Paille, Chara) 18:06
Ryder 6 BOS (PP) (Kaberle) 19:29

PENALTIES
Ryder BOS (Roughing) 2:50
Burrows VAN (Unsportsmanlike
conduct) 3:33

Chara BOS (Unsportsmanlike
conduct) 3:33
D Sedin VAN (Misconduct) 6:59
Ference BOS (Misconduct) 6:59
Thornton BOS (Roughing) 7:58
Thornton BOS (Misconduct) 7:58
Kesler VAN (Boarding) 9:11
Burrows VAN (Slashing) 11:16
Kesler VAN (Fighting, major) 11:16
Seidenberg BOS (Misconduct) 11:16
Seidenberg BOS (Fighting, major) 11:16
Kesler VAN (Misconduct) 11:16
Burrows VAN (Misconduct) 11:16
Lucic BOS (Slashing) 11:16
Lucic BOS (Roughing) 11:16
Lucic BOS (Misconduct) 11:16
Bieksa VAN (Misconduct) 17:51
Ference BOS (Misconduct) 17:51
Torres VAN (Charging) 18:53

SHOTS ON GOAL
Vancouver 12/16/13—41
Boston 7/14/17—38

POWER PLAYS (goals–chances)
Vancouver: 0–8, Boston: 2–4

GOALIES
(shots–saves, result, record)
Vancouver: Luongo
(38–30, L, 14–7)
Boston: Thomas (41–40, W, 13–8)

REFEREES
Stephen Walkom, Dan O'Rourke

LINESMEN
Pierre Racicot, Steve Miller

And the game was rough, with 145 minutes in penalties, ten misconducts, two unsportsmanlike penalties, three roughing penalties and one fight, between Dennis Seidenberg and Ryan Kesler. Once the game got out of hand, even Daniel Sedin took a ten-minute misconduct for a tussle with Bruins defenceman Andrew Ference.

Aaron Rome received a five-minute major and a game misconduct in the first for an open-ice head shot on Nathan Horton, who had to be taken off the ice

on a stretcher. The incident seemed to motivate the Bruins to change their game, and it left a gap on the Canucks' blueline. Alain Vigneault took issue with Rome's misconduct, saying, "The hit was head-on, a player looking at his pass. It was a little bit late. I don't think that's the hit the league is trying to take out of the game. This is a physical game, you have big guys with a fraction of a second to decide what's happening out there." Horton would miss the rest of the series with a severe concussion, and on June 7 the NHL served Rome a four-game suspension, ensuring that he too was gone for the playoffs.

The Canucks lost most puck battles and had no push-back for Boston's physical play. After being criticized for his overly aggressive play in Game 2, Tim Thomas was spectacular in the Bruins net, making forty saves. Although the Bruins outscored the Canucks 4–0 in the second period, the Canucks outshot Boston 16–14, Thomas making big saves off Raffi Torres and Manny Malhotra. And Boston's power play, which was struggling at around 8 per cent heading into the series, scored twice.

"Luckily it's not aggregate scores, it's not Champions League. It's the Stanley Cup Final," Canucks defenceman Kevin Bieksa summed up.

"We weren't good enough. Our passes weren't good, we didn't help out the defence and the forecheck. We took a step back, we gave them momentum."
DANIEL SEDIN

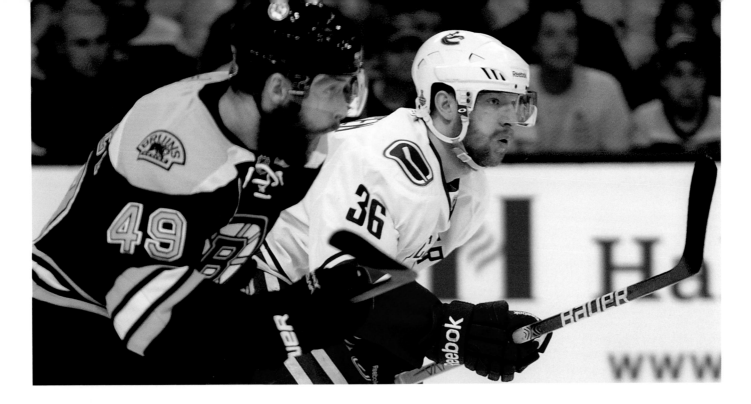

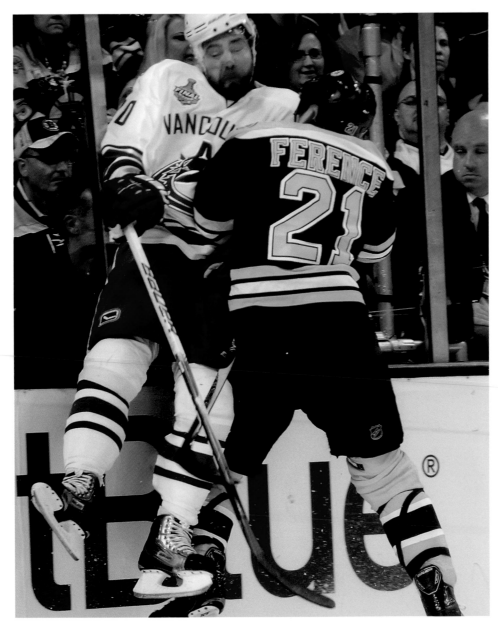

TOP: Speedy Jannik Hansen competes with Rich Peverley.

BOTTOM: Game 3 was rougher than the first two games of the series, with 145 minutes in penalties handed out. Here, Andrew Ference collides with Chris Higgins during the first period.

TOP: Bruin Nathan Horton is wheeled off the ice on a stretcher after a hit by Aaron Rome during the first period of Game 3. Horton missed the rest of the Final with a concussion. Rome was given a four-game suspension and was also out for the duration.

BOTTOM: Manny Malhotra crashes into goalie Tim Thomas and Adam Mc-Quaid. Thomas was close to perfect in the 8–1 victory, making forty saves.

FACING: The biting controversy from Game 1 makes its final appearance as Milan Lucic taunts Alex Burrows. Bruins coach Claude Julien, who'd criticized Canuck Maxim Lapierre for a similar gesture in Game 2, scolded his player.

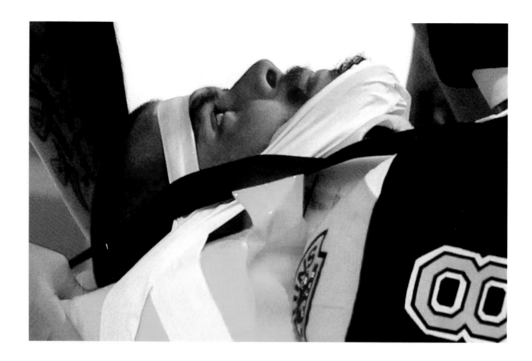

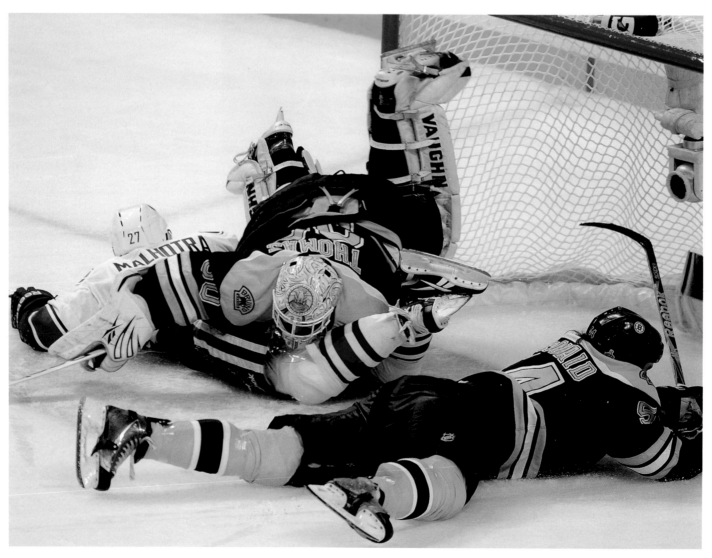

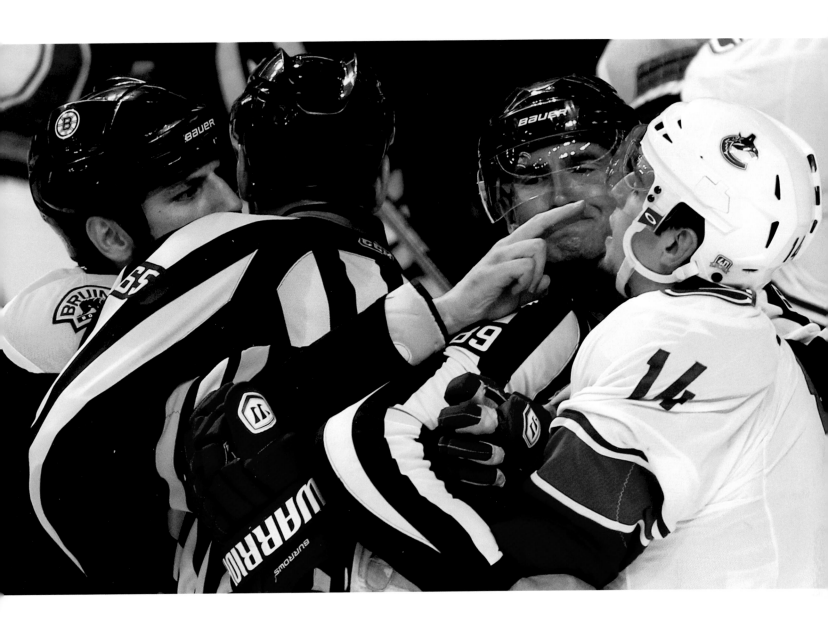

"I'm sure they don't like us and we don't like them.
There is a lot on the line. That's what makes this
a fun series to be a part of."

BRUINS FORWARD **MILAN LUCIC**

> ## "I just wanted to make the most of it and not get the team further in a hole. You never know what's going to happen, so I just tried to make a few saves."
>
> **CORY SCHNEIDER,** who replaced Roberto Luongo in the third period and stopped all nine shots he faced

ALL THE OLD QUESTIONS AROSE: Could Roberto Luongo win the big game? Could the Sedins raise their play? Could Ryan Kesler spark the offence? Could the Canucks overcome adversity? In the context of Game 4 against the Boston Bruins, the answers were no, no, no, and no.

This 4–0 loss pulled the series even at 2–2 and left the Canucks outscored 12–1 over two games in Boston, unable to solve Bruins goalie Tim Thomas and unable to overcome Boston's grit.

Bobby Orr kicked off the game by waving a Bruins flag. Boston fans went wild, and the emotion from that gesture seemed to carry the Bruins onto the ice. But it was the Canucks who could have used Orr on their blueline, even at his age and with one knee.

BRUINS 4, CANUCKS 0
TD Garden in Boston

FIRST PERIOD
GOALS
Peverley 3 BOS
(Krejci, Chara) 11:59

PENALTIES
Ryder BOS (Tripping) 6:58
Marchand BOS
(Cross-checking) 16:10

SECOND PERIOD
GOALS
Ryder 7 BOS (Seguin, Kelly) 11:11
Marchand 8 BOS (Bergeron) 13:29

PENALTIES
Raymond VAN (High-sticking) 7:41
Alberts VAN (Slashing) 12:05
Peverley BOS
(Cross-checking) 12:05
Boychuk BOS
(Delay of game) 18:49.

THIRD PERIOD
GOALS
Peverley 4 BOS (Lucic, Krejci) 3:39

PENALTIES
H Sedin VAN (Slashing) 0:52
Recchi BOS (High-sticking) 9:14
Kesler VAN (Slashing) 10:25
Lapierre VAN (Slashing) 14:35

Marchand BOS (Holding) 17:33
Marchand BOS (Roughing) 17:33
Ballard VAN (Roughing) 17:33
Marchand BOS (Tripping) 17:33
McQuaid BOS (Misconduct) 17:33
Burrows VAN
(Cross-checking) 18:09
Kesler VAN (Roughing) 18:09
Kesler VAN (Misconduct) 18:09
Chara BOS (Roughing) 18:09
Chara BOS (Misconduct) 18:09
Thomas BOS (Slashing) 18:09

SHOTS ON GOAL
Vancouver 12/13/13—38
Boston 6/12/11—29

POWER PLAYS (goals–chances)
Vancouver: 0–6, Boston: 0–4

GOALIES
(shots–saves, result, record)
Vancouver: Luongo (20–16, L, 14–8),
Schneider (9–9)
Boston: Thomas (38–38, W, 14–8)

REFEREES
Dan O'Halloran, Kelly Sutherland

LINESMEN
Jay Sharrers, Jean Morin

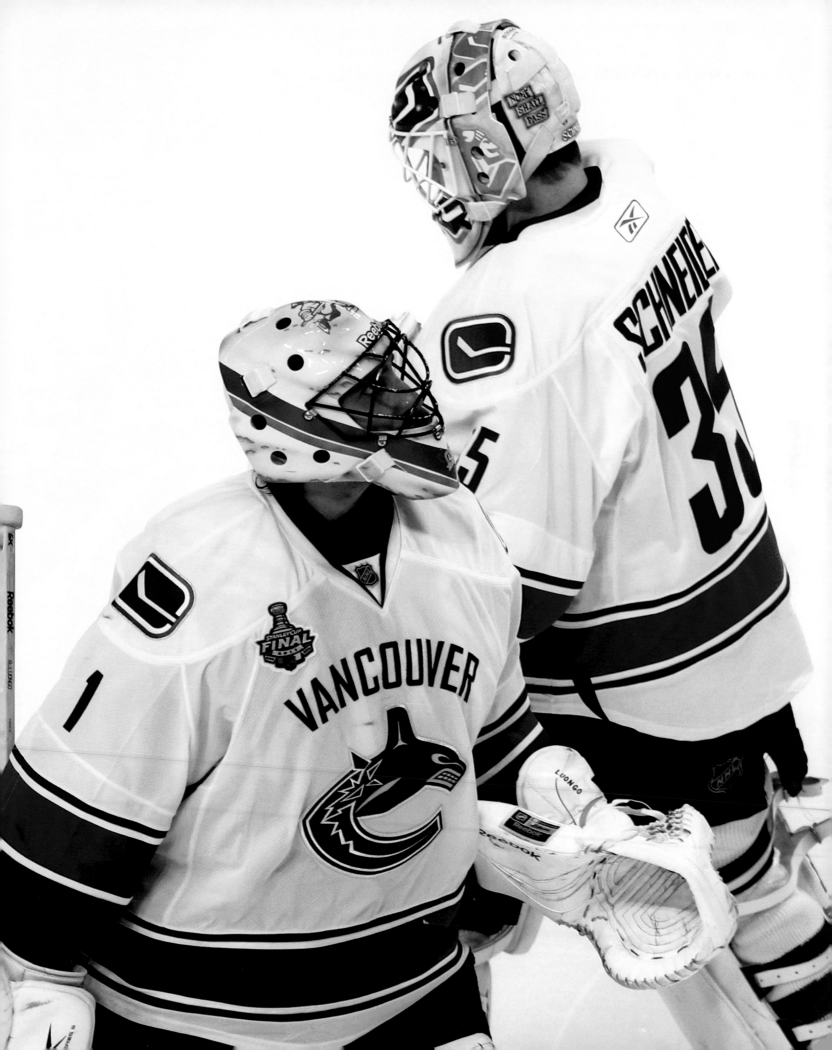

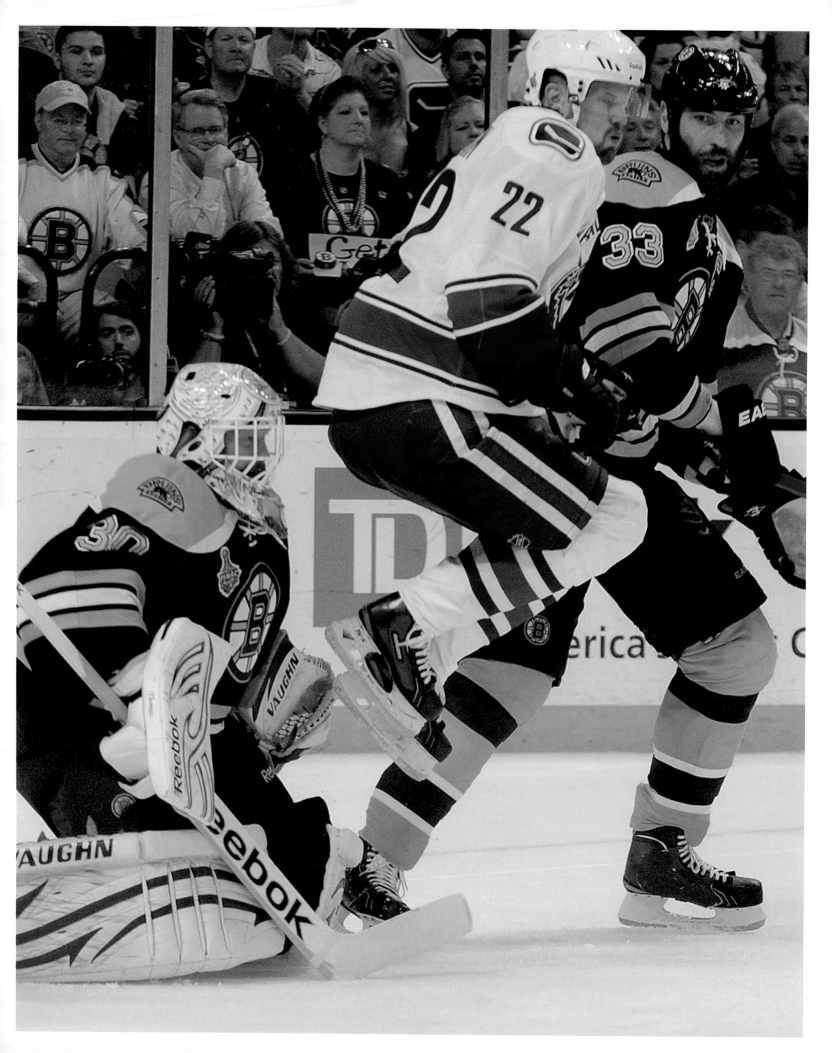

Missing Aaron Rome (suspended for the duration of the playoffs for his late hit on Nathan Horton the previous game) and Dan Hamhuis (with an undisclosed injury), Alex Edler, Christian Ehrhoff, Keith Ballard, and Sami Salo all took turns being beaten on rushes, turning pucks over, and blowing coverages. Roberto Luongo left the ice at 3:39 of the third period; his replacement, Cory Schneider, stopped all nine shots he faced.

When the Canucks managed to create some offensive pressure, Tim Thomas was unbeatable. "We've got to solve Thomas, that's the main thing," said Henrik. "That's our job. I don't think we gave up a whole lot of chances five-on-five, but they scored on the couple they had."

To add to the misery, the Canucks power play was shut out again, going 0-for-4. The only goal the once-lethal power play had scored in this series was by the second unit, leaving a dismal record of 1-for-19 in the first four games of the Stanley Cup Final.

It was a quiet night back home, as a subdued crowd filed out of Rogers Arena and into the streets of downtown Vancouver—shocked, nervous, but still knowing it wasn't over.

FACING: Even leaping in the air, Daniel Sedin found it tough to measure up to Boston's six-foot-nine behemoth, Zdeno Chara. The bruising Bruin found his game at home and knocked the Sedins around like bowling pins.

TOP: It was hard for anyone on the Canucks bench to put on a happy face during a brutal Boston beatdown.

TOP: It wasn't easy being green in Boston. Vancouver's unofficial mascots, the Green Men, needed protection from Boston's finest after they became a distraction in the stands.

BOTTOM: Tim Thomas was nearly infallible in Boston. Alex Burrows's frustration boiled over at the end of Game 4 as he tried to knock the stick out of the goalie's hands. Thomas responded with a brutal slash across the back of Burrows's legs and a blocker punch to the head.

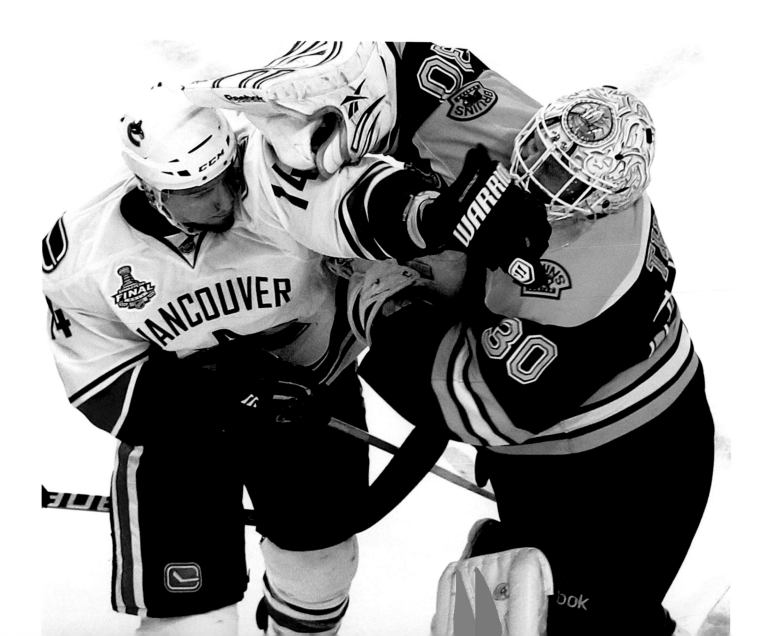

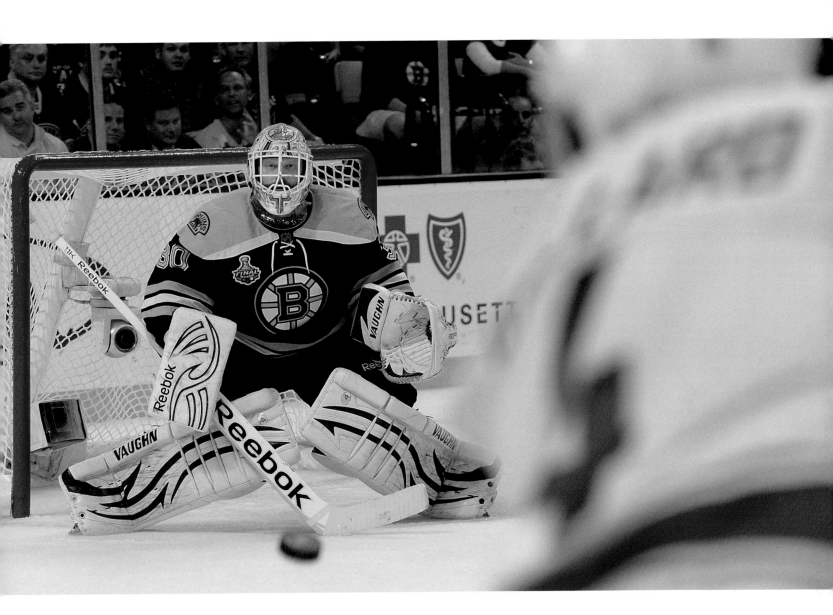

"I thought I'd give him a little love tap and let him know: I know what you're doing, but I'm not going to let you do it forever."

BOSTON GOALIE **TIM THOMAS,** on his skirmish with Alex Burrows to end Game 4. He received a slashing penalty for the effort.

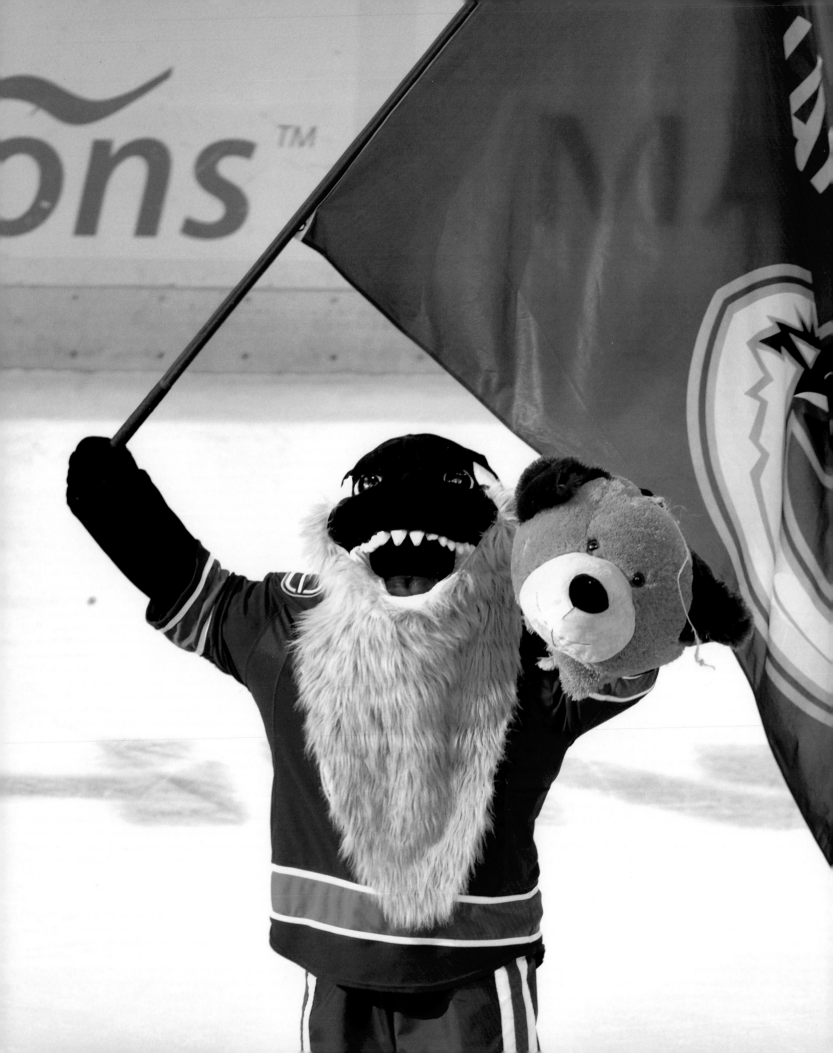

Game 5

MAXIM LAPIERRE, cast off by two teams this season, was a hero in Vancouver as he scored his first game-winning goal since the 2010 Eastern semifinal to lift the Canucks to a 1–0 win in Game 5.

Taking a bank pass off the end boards from a Kevin Bieksa slap-pass, Lapierre ended Tim Thomas's shutout streak at 110 minutes and 42 seconds at 4:35 of the third period. Roberto Luongo, with thirty-one saves, became the twelfth goalie in NHL history to record two shutouts in a Stanley Cup final, and just the second to have two 1–0 shutouts.

Lapierre's play since replacing Manny Malhotra as the third-line centre redeemed a career that was in danger of going off the tracks. "I'm lucky I had the chance to play for this team," said a joyful Lapierre, who arrived at the trade deadline.

The Canucks' penalty-kill units had plenty of early work, holding Boston off the scoresheet over four straight Bruins power plays in the game's first twenty-five minutes. Twenty-one-year old rookie Chris Tanev was impressive in his first Stanley Cup Final game and just his third NHL playoff game ever, replacing Keith Ballard. Tanev played twelve minutes and forty-five seconds—more than veteran Andrew Alberts—of error-free hockey. "He could play with a cigarette in his mouth, he's so calm and cool," Bieksa said.

More than 100,000 ecstatic fans filled the streets of downtown Vancouver, and an enthusiastically supportive crowd appeared at the airport the next morning to send their heroes off to Boston to—they hoped—wrap up the series.

CANUCKS 1, BRUINS 0
Rogers Arena in Vancouver

FIRST PERIOD
GOALS: None

PENALTIES
Torres VAN (Tripping) 1:39
H Sedin VAN (Interference) 6:54
Alberts VAN (Roughing) 14:13
Lucic BOS (Tripping) 19:27
Burrows VAN (Unsportsmanlike conduct) 19:27

SECOND PERIOD
GOALS: None

PENALTIES
Kesler VAN (Interference on goalkeeper) 4:18
McQuaid BOS (Holding) 07:22
Bergeron BOS (Holding) 15:56

THIRD PERIOD
GOALS
Lapierre 2 VAN
(Bieksa, Torres) 4:35

PENALTIES
Peverley BOS (Tripping) 12:09

SHOTS ON GOAL
Vancouver 6/12/7—25
Boston 12/9/10—31

POWER PLAYS (goals–chances)
Vancouver: 0–5, Boston: 0–4

GOALIES
(shots–saves, result, record)
Vancouver: Luongo
(31–31, W, 15–8)
Boston: Thomas (24–25, L, 14–9)

REFEREES
Stephen Walkom, Dan O'Rourke

LINESMEN
Pierre Racicot, Steve Miller

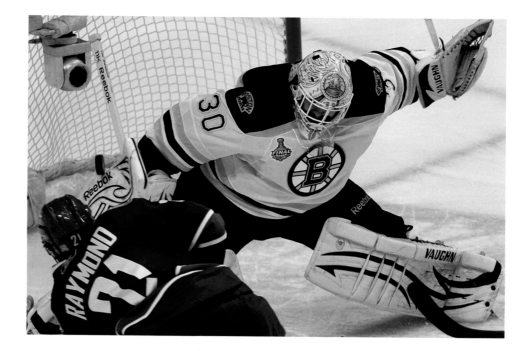

TOP: Speedy winger Mason Raymond gets behind the defence but can't beat Tim Thomas. The Boston goalie continued to thwart the Canucks in Game 5.

BOTTOM: Thomas's aggressive style finally provided a breakthrough for Vancouver. Kevin Bieksa intentionally blasted the puck wide off the end boards to Maxim Lapierre, who quickly banked the puck off Thomas and into the net, providing the only goal the Canucks would need to grab a 3–2 lead in the series.

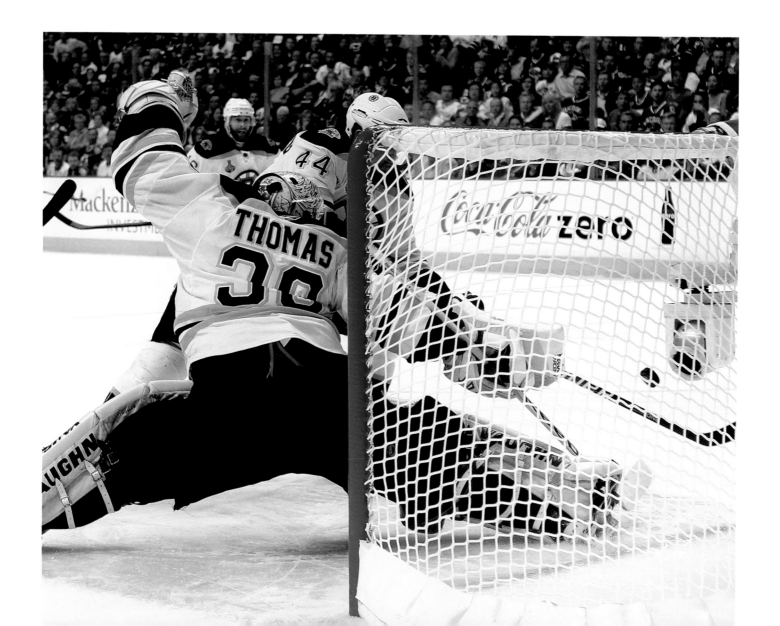

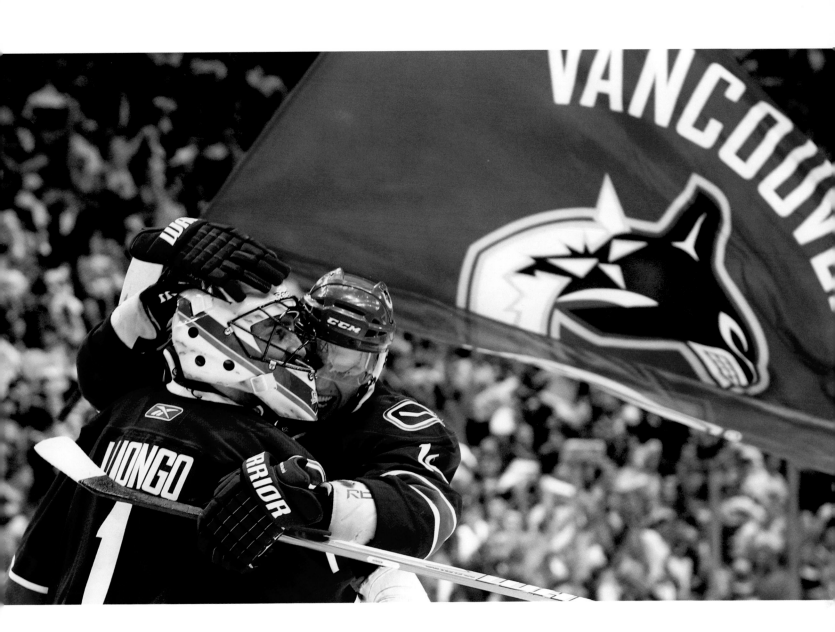

"The only people I have to prove things (to) is myself, my teammates, and my family and friends. That's who I play for. I play the game because I love it and I want to win a Stanley Cup."

ROBERTO LUONGO, after notching his second shutout of the Final

"It's been six months I've been thinking about a goal... a long time. I had so many [thoughts] in my head, I didn't know what to do. So I just started jumping."

MAXIM LAPIERRE, on what went through his head after he scored the lone goal in Game 5

TOP: Going into Game 5, Rogers Arena and the entire downtown core was a bundle of nerves. The Canucks' slogan all year was "Believe in Blue," and that belief paid off for fans when Maxim Lapierre's third-period goal moved them within one win of the Cup.

BOTTOM: Lapierre's decisive goal sent him into the arms of his teammates as the arena exploded in relief, and more than 100,000 fans watching the game on the streets of Vancouver added to the frenetic joy.

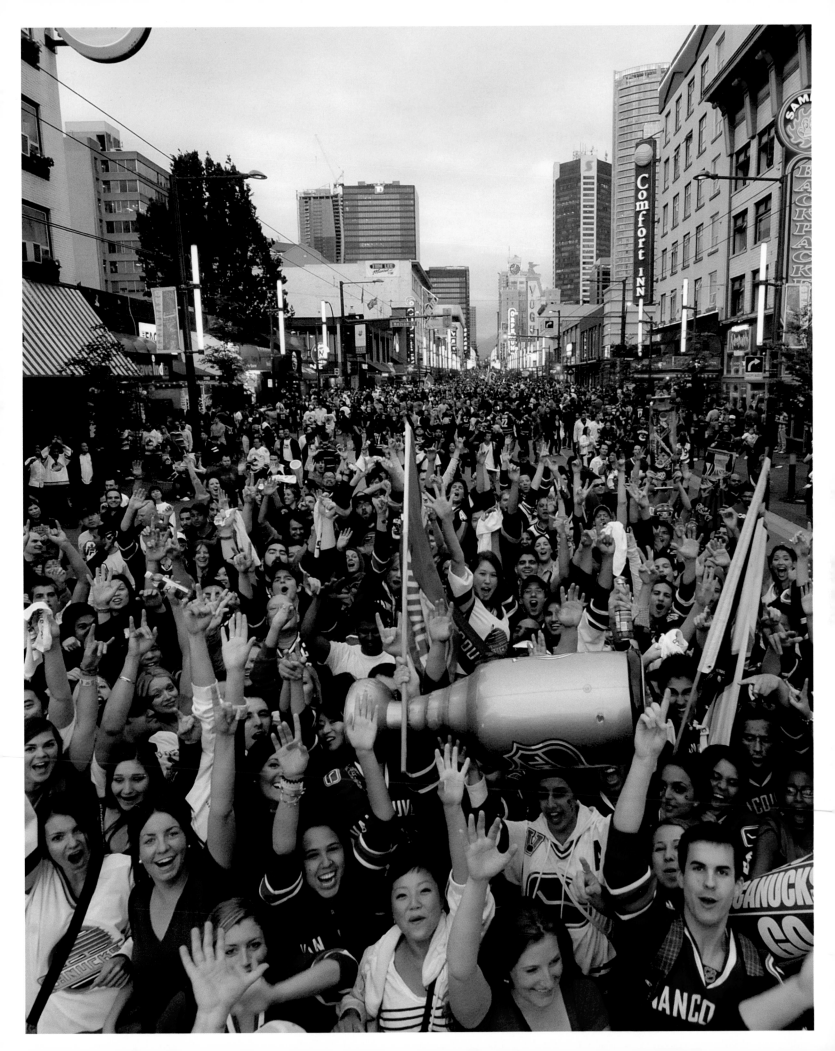

"We've got one game, do or die for the Stanley Cup— that's what you dream of as a kid."

KEVIN BIEKSA

THE STANLEY CUP was in the building, but it remained in its case as the Boston Bruins notched four goals in four minutes, fourteen seconds—a Stanley Cup record for the four fastest goals. Roberto Luongo was yanked by coach Alain Vigneault for the second time in the TD Garden, after giving up three of those goals on just eight shots. In fewer than seven periods in Boston, Luongo let in fifteen goals in his three starts.

Brad Marchand opened the scoring, beating Luongo with a high wrist shot to the glove side at 5:31 to end the goalie's shutout streak at 65:31. The goal continued a series trend: the team that had scored first went on to win every game. Thirty-five seconds later, Milan Lucic sent another wrist shot that trickled between Luongo's pads. It was Boston's fifth shot on net. When Andrew Ference scored on a power play point shot at 8:35, Luongo got the hook. Michael Ryder made it 4-0 with a goal on Cory Schneider just one minute and ten seconds later.

FACING: The game was in Boston, the party was downtown, the pain was familiar. Canucks fans were expecting the Cup; what they got was another goalie meltdown and a game that was over before the first period was out, dampening the mood and gripping the city with two more days of tension.

BRUINS 5, CANUCKS 2
TD Garden in Boston

FIRST PERIOD

GOALS

Marchand 9 BOS
(Recchi, Seidenberg) 5:31
Lucic 5 BOS (Peverley, Boychuk) 6:06
Ference 4 BOS (PP)
(Ryder, Recchi) 8:35
Ryder 8 BOS (Kaberle) 9:45

PENALTIES

H Sedin VAN (Unsportsmanlike
conduct) 0:56
Chara BOS (Interference) 0:56

Edler VAN (Boarding) 7:55
Kesler VAN (Holding) 10:31
Team VAN (Too many men) 17:09

SECOND PERIOD

GOALS: None

PENALTIES

Bergeron BOS (Goaltender
interference) 0:28
Bergeron BOS (Interference) 12:15
Bergeron BOS (Elbowing) 19:08

THIRD PERIOD

GOALS

H Sedin 3 VAN (PP) (Sedin, Ehrhoff) 0:22
Krejci 12 BOS (PP) (Recchi, Kaberle) 6:59
Lapierre 3 VAN (D Sedin, Hansen) 17:34

PENALTIES

Torres VAN (Tripping) 5:23
Alberts VAN (Cross-checking) 6:11
Burrows VAN (Slashing) 6:59
Bergeron BOS (Cross-checking) 6:59
Recchi BOS (Tripping) 11:32
D Sedin VAN (Misconduct) 18:29
Lapierre VAN (Misconduct) 18:29
Marchand BOS (Roughing) 18:29
Marchand BOS (Misconduct) 18:29
Thornton BOS (Misconduct) 18:29
Seidenberg BOS
(Cross-checking) 19:03

SHOTS ON GOAL

Vancouver 11/11/16—38
Boston 19/8/13—40

POWER PLAYS (goals–chances)

Vancouver: 1–6, Boston: 2–5

GOALIES

(shots–saves, result, record)
Vancouver: Luongo (8–5, L, 15–9),
Schneider (32–30).
Boston: Thomas (38–36, W, 15–9)

REFEREES

Dan O'Halloran, Kelly Sutherland

LINESMEN

Jay Sharrers, Jean Morin

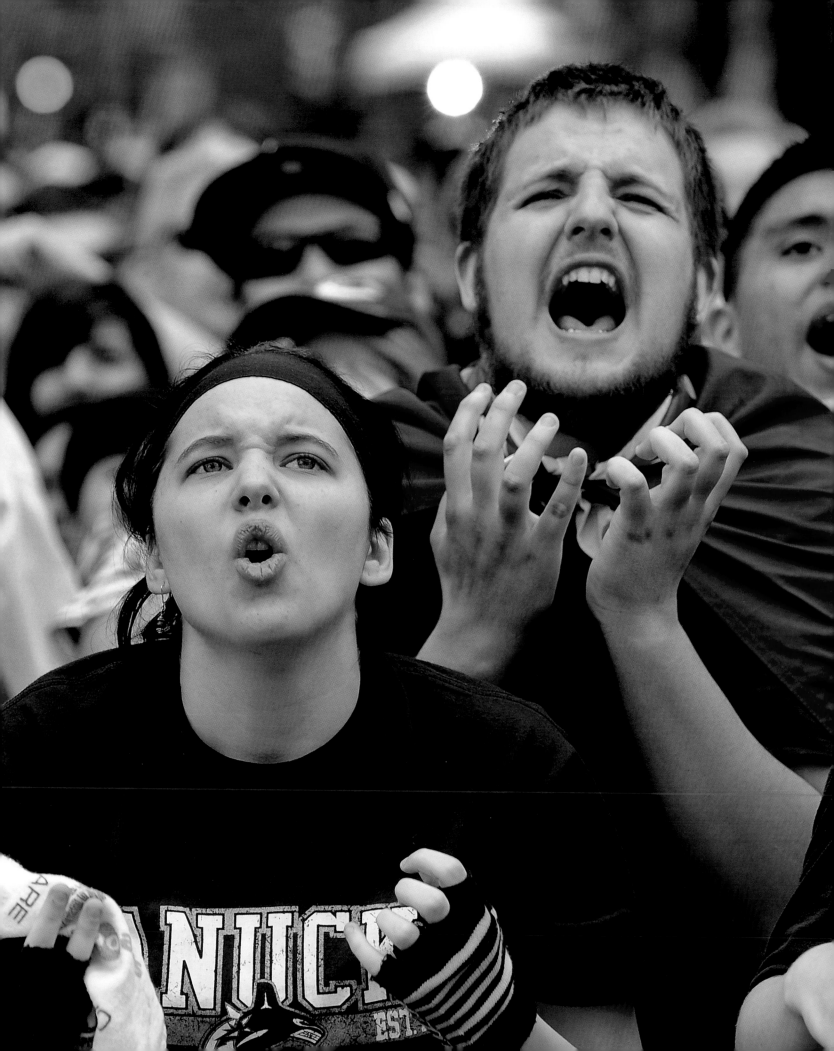

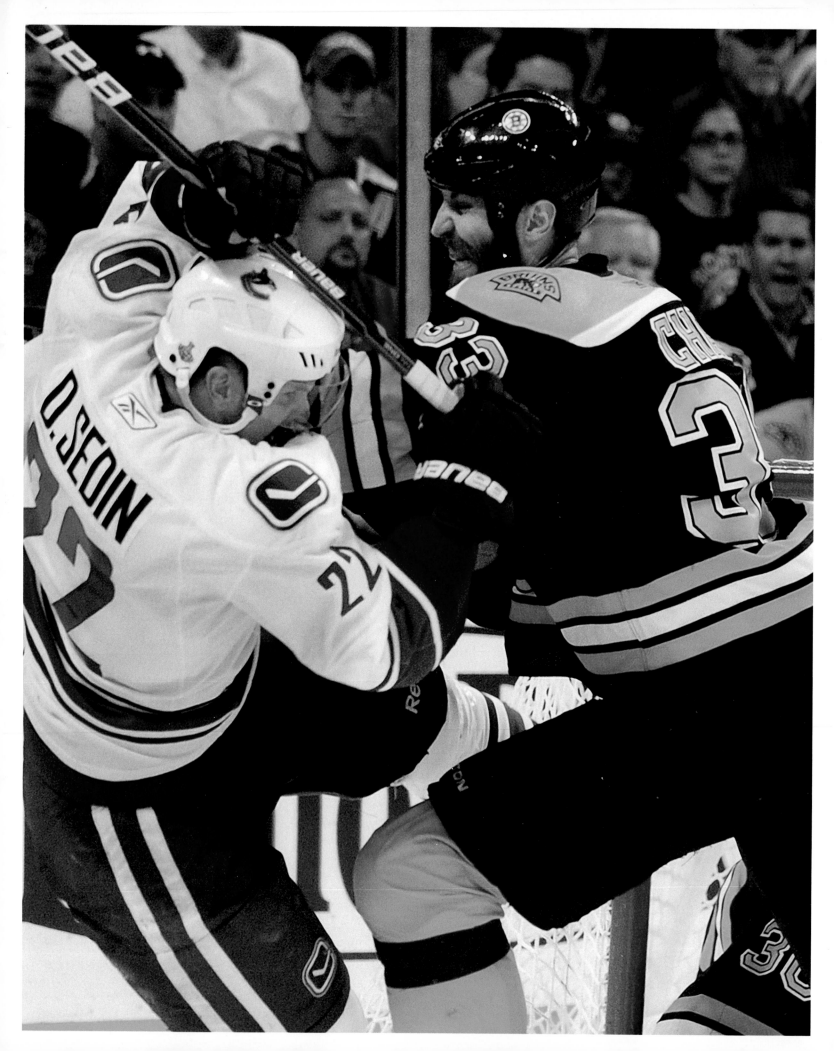

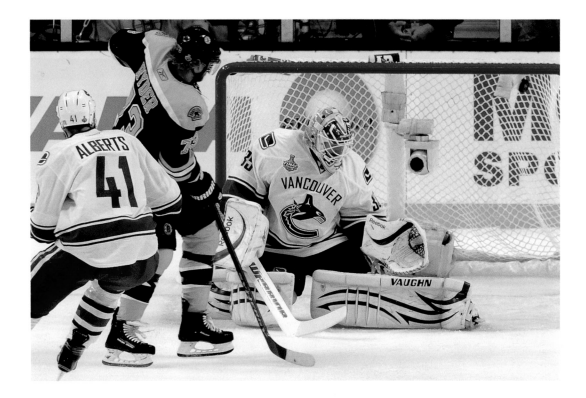

After numerous close calls and fanned-on opportunities for the Canucks, Henrik Sedin registered his first point of this series with a high backhand just twenty-two seconds into the third period, but by then the game had already been lost. David Krejci made it 5–1 with a power play goal before Maxim Lapierre capped the scoring.

"We moved the puck, we had Tim Thomas moving," Henrik Sedin said. "We battled harder... It was a step in the right direction."

The Canucks would be forced to take the next step without valuable forward Mason Raymond, who left the game after being injured in the first minute with a vertebrae compression fracture following a collision with Johnny Boychuk. There was no penalty on the play, although the teams combined for seventy penalty minutes on the night.

Despite the poor showing, the Canucks remained optimistic, knowing they'd come back from worse losses in the post-season. "We've done it before—that's the only thing," Sedin said. "We've got a good team in here with a lot of guys who have battled hard and we showed up all season. And we'll show up in the final game. We're confident on home ice and it's going to be a great game. If somebody had told me we'd have a Game 7 for the season at home, I would have taken it any day. That's where we are right now. We've got one game left."

FACING: Zdeno Chara continued to set the tone, bouncing the Sedins around without repercussion. There was little push-back or answer for the Bruins' predetermined plan of slashes, punches, and face-washes.

TOP: After the Bruins managed the fastest three goals in Stanley Cup Final history, Roberto Luongo got the hook; replacement Cory Schneider was beaten on a Michael Ryder tip to make it four goals in 4:14, another record.

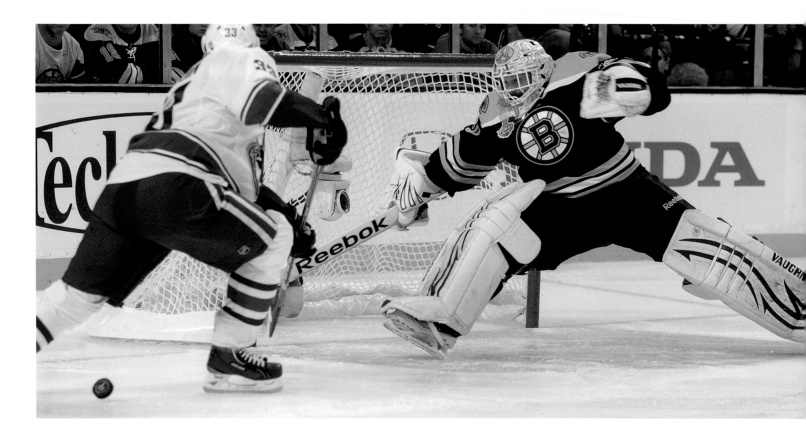

"We had a good chance right off the hop, it jumps over Hank's stick and they come back and get four in a row. That's just kind of how it's been in this building."

CORY SCHNEIDER on the Canucks' unlucky start

TOP: Canucks fans have endured forty years of pain, and expectations were that it would all end with a Game 6 win. Just another cruel joke from the Hockey Gods?

BOTTOM: Just twenty seconds in, Mason Raymond was slammed backwards into the boards by Bruin Johnny Boychuk. There was no penalty, no suspension, and the battered Canucks lost another soldier.

FACING: Patrice Bergeron was a thorn in Vancouver's side in every game in Boston.

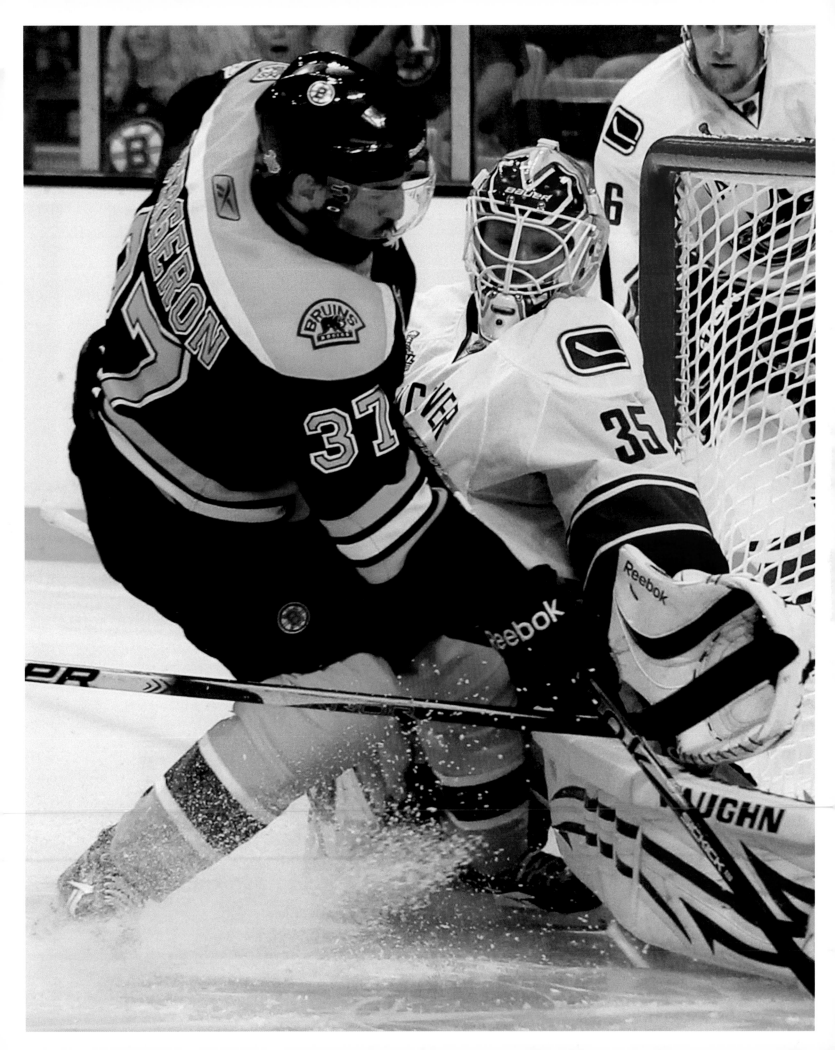

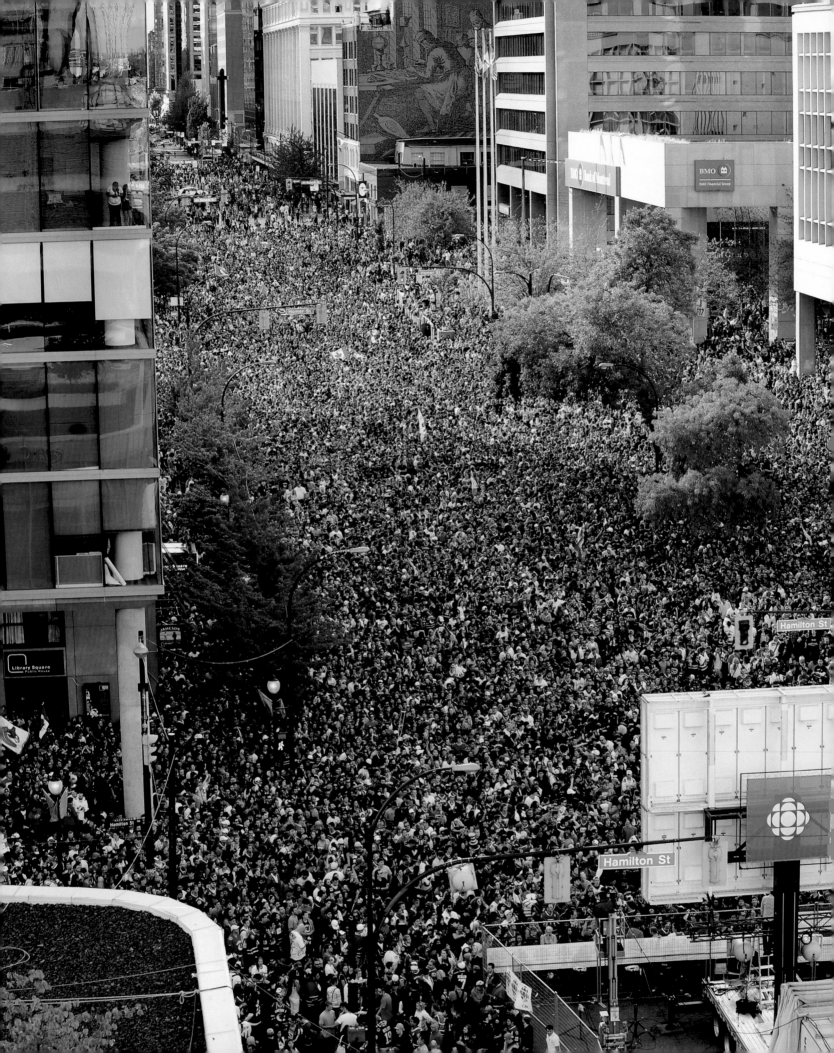

> ## "It's probably the hardest thing I've done in my life."
>
> **RYAN KESLER**

Game 7

IN ONE OF LIFE'S ironies, the Canucks' shortest summer by the calendar will seem like the longest ever as they ponder the what-ifs and what-could-have-beens. One of just a handful of teams to blow a 2–0 series lead in the Stanley Cup Final, the Canucks lost four of their last five games, the most stinging the 4–0 Game 7 defeat at home. The front-runner all season was passed just before the finish line, clearly out of gas.

After the game, it was revealed that Ryan Kesler was playing with a torn groin and labrum. Alex Edler had two broken fingers. Christian Ehroff needed shots for his shoulder, just to be able to play. Mason Raymond, Mikael Samuelsson, and Dan Hamhuis, injured earlier in the post-season, couldn't even dress for the game. What if they'd all been healthy? All those fanned-on shots in the last two games—what if only a couple of those had got past Tim Thomas?

Asked if he was suffering from anything, captain Henrik Sedin did not offer any excuses. "Yes," he replied, "a scoring slump."

While neither Henrik nor Daniel were able to beat Thomas in the final game, they were leaders to the end, fielding questions from reporters from all over Canada, the U.S., and Europe until the last one had asked her last question.

Outside, part of the city was burning courtesy of hooligans and troublemakers; inside, even as commissioner Gary Bettman was awarding the the Conn Smythe to Thomas and the Stanley Cup to Zdeno Chara,

BRUINS 4, CANUCKS 0
Rogers Arena in Vancouver

FIRST PERIOD
GOALS
Bergeron 5 BOS (Marchand) 14:37

PENALTIES: None

SECOND PERIOD
GOALS
Marchand 10 BOS
(Seidenberg, Recchi) 12:13
Bergeron 6 BOS (SH)
(Seidenberg, Campbell) 17:35

PENALTIES
Chara BOS (Interference) 16:07

THIRD PERIOD
GOALS
Marchand 11 BOS
(unassisted) 17:16

PENALTIES
Hansen VAN (Interference) 5:33
Lucic BOS (Hooking) 11:34

SHOTS ON GOAL
Boston 5/8/8—21
Vancouver 8/13/16—37

POWER PLAYS (goals–chances)
Boston: 0–1, Vancouver: 0–2

GOALIES
(shots–saves, result, record)
Boston: Thomas (37–37, W, 16–9)
Vancouver: Luongo
(20–17, L, 15–10)

REFEREES
Stephen Walkom, Dan O'Halloran

LINESMEN
Jay Sharrers, Jean Morin

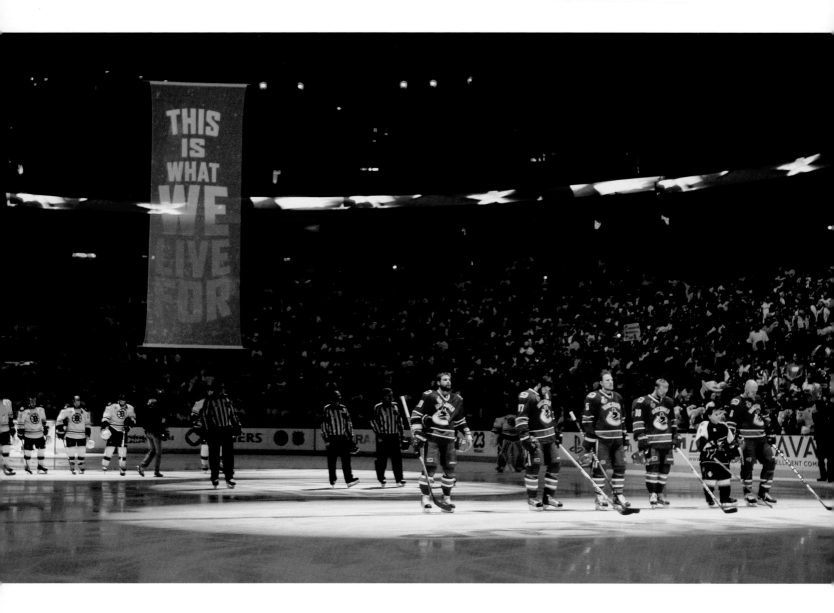

Daniel and Henrik were owning up to their failure to score when it mattered. "For sure, [Thomas] was obviously great, but it's still our line's job to score, and if we don't do that, it's going to be tough for us to win," said Daniel. "Eight goals in seven games isn't enough. It was enough to get us to Game 7, but when we got the chances we needed to step up."

"Tim Thomas," added Henrik. "We couldn't beat him."

Asked to describe their emotions at coming just one win shy of the most magical season in Canucks history, they struggled. "I can't put into words," Daniel said, "how badly we actually feel."

The bright light in this otherwise empty end to such a thrilling year? The players are already looking towards next season. "We have a real good team," said Luongo. "We'll be back." Canucks owner Francesco Aquilini built on this optimism. In the dressing room after the end of the game, he told reporters, "They're all going to be back. I love these guys." The fans will be waiting.

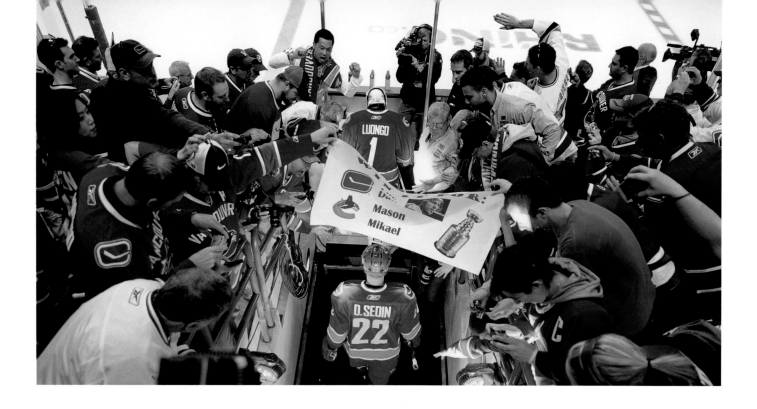

FACING: This is what they live and die for. The anticipation and electricity before Game 7 at Rogers Arena was unlike anything Canucks fans had ever experienced.

TOP: Roberto Luongo lead his team out of the tunnel to the strains of U2's "Where the Streets Have No Name" as the fans were ready to provide the home-ice advantage Vancouver had worked all season to attain.

BOTTOM: Fans were hopeful and the players were ready as Kevin Bieksa prepared for the final battle. The rugged defenceman's face is all the evidence necessary to know how big a toll the playoff grind takes on those who endure it.

RIGHT: Video introduction, projection screens, U2, Mark Donnelly anthem—Canucks faithful were whipped into a frenzy as the puck was ready to drop. Few NHL arenas can match the pre-game passion at Rogers Arena.

BELOW: Henrik Sedin tried everything he could to beat Tim Thomas, but defenceman Dennis Seidenberg and every other Bruin threw everything in front of each Canuck chance.

FACING: If a Canuck beat Thomas, as Alex Burrows did, Zdeno Chara was there to keep the puck out of the net. The hockey gods had decided Thomas would have a shutout—an exclamation point on his Finals performance.

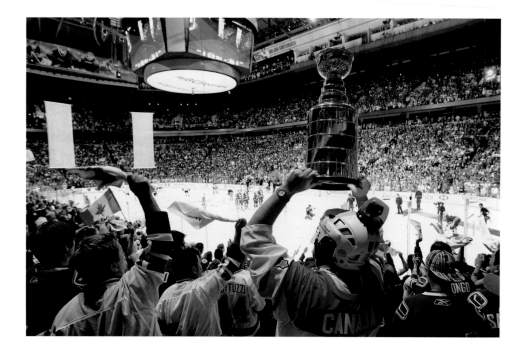

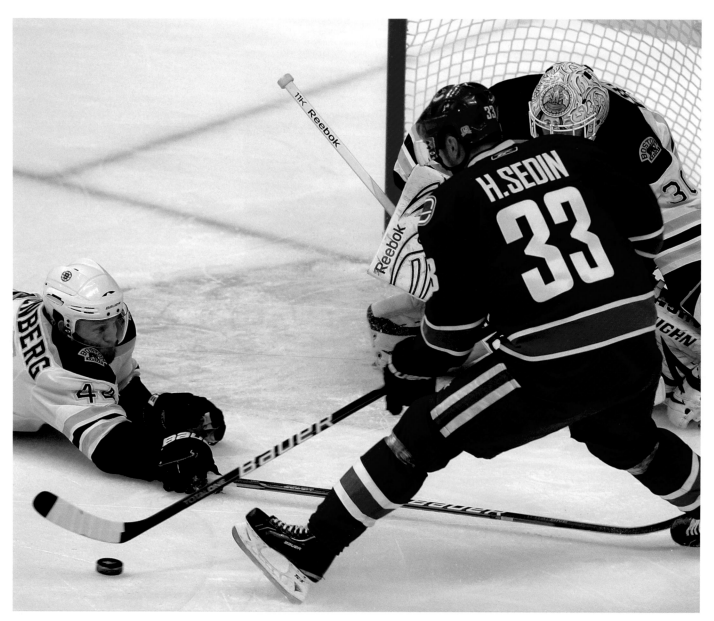

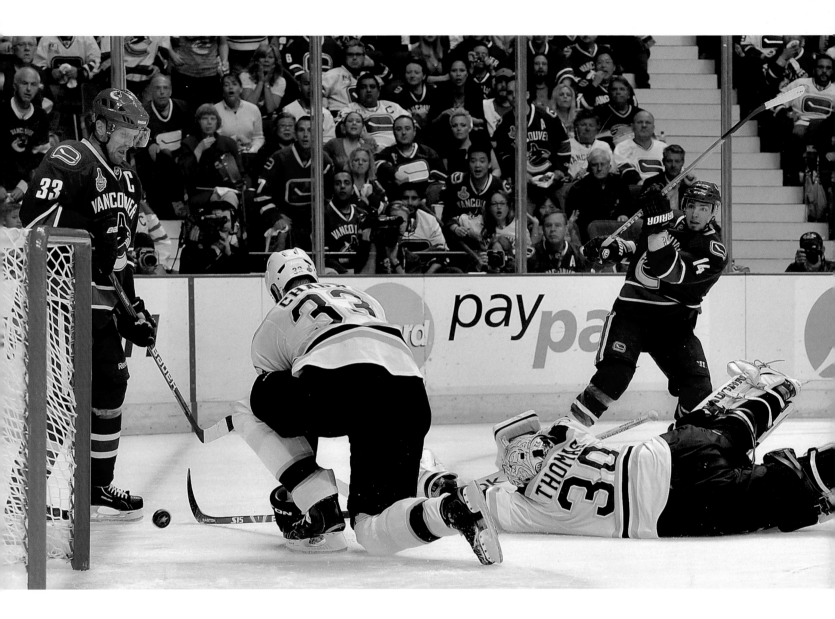

"This is the best team I've been on, by far. A lot of us have grown up here and we've become a team here. We wanted to win for us foremost, but we wanted to win for the city as well."

HENRIK SEDIN

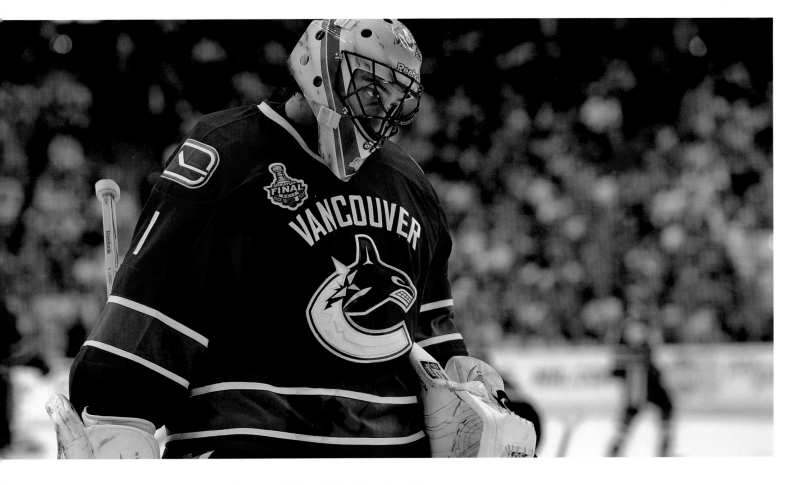

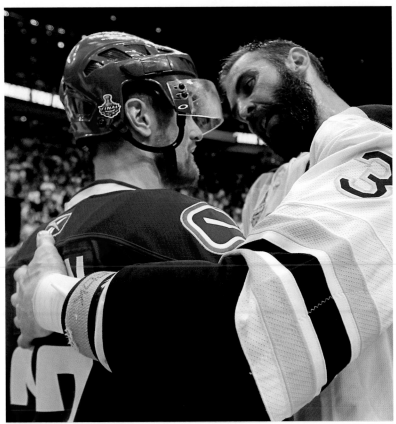

FACING: Jannik Hansen, perhaps the best Vancouver player in the final series, gets mugged. The Canucks were smothered defensively by the Bruins.

ABOVE: The focus always falls on Roberto Luongo, but his performance in Game 7 wasn't the deciding factor. Luongo, like the rest of the team, appeared to have little left in the tank.

LEFT: The captains meet and—like true warriors—share a moment of clarity. Zdeno Chara looks Henrik Sedin in the eye, although he has to stoop to do so.

RIGHT: The Canucks couldn't solve Tim Thomas, the eventual—and much deserved—winner of the Conn Smythe Trophy as playoff MVP. His stats in the final round were an otherworldly 1.15 goals against average, .967 save percentage, and two shutouts.

BELOW: NHL Commissioner Gary Bettman had to look up—way up!—to present the trophy to towering Bruins captain Zdeno Chara. Unpopular Bettman was booed by the Rogers Arena crowd, but Chara and the Bruins received respectful applause and admiration from Canucks fans.

FACING: The Canucks salute their loyal fans before leaving the ice for the last time this season.

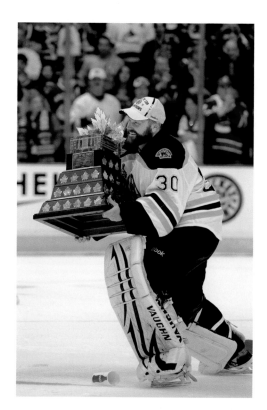

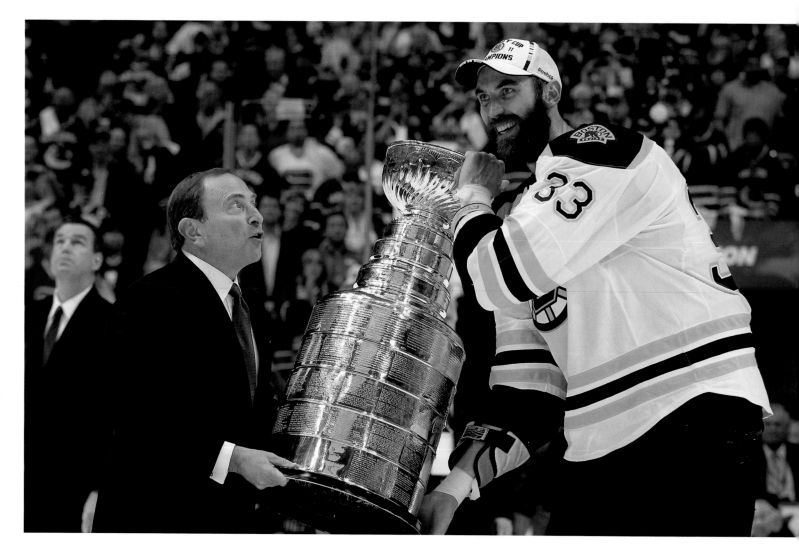

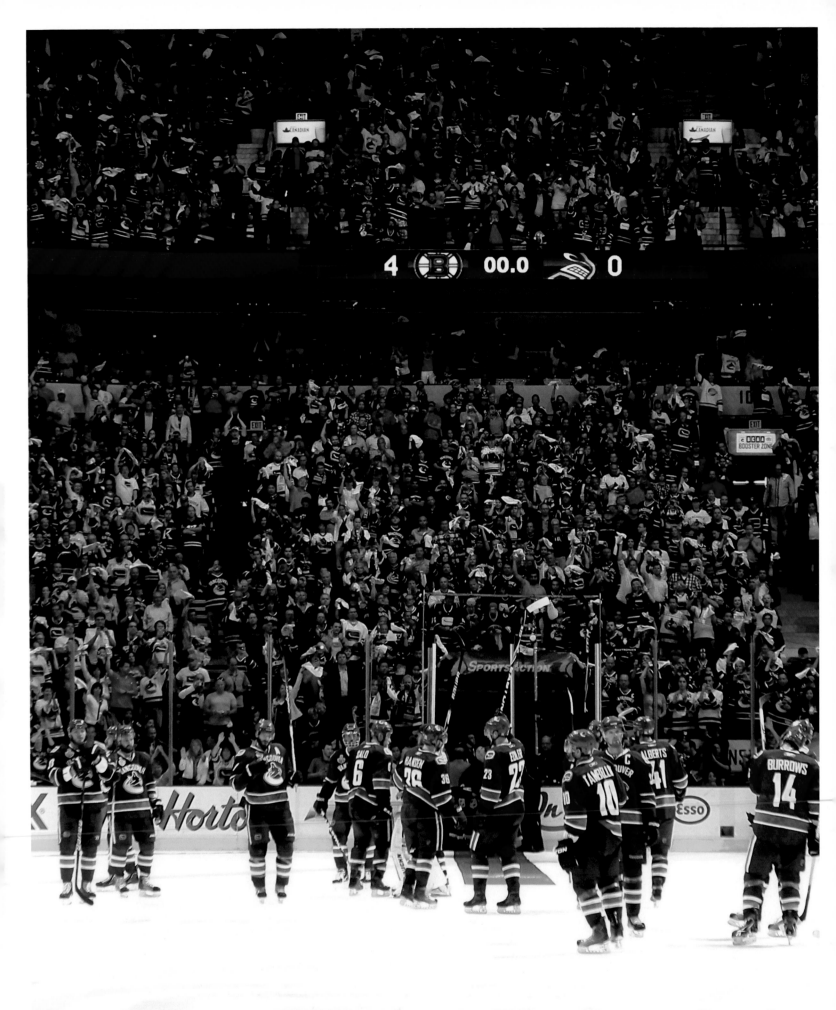

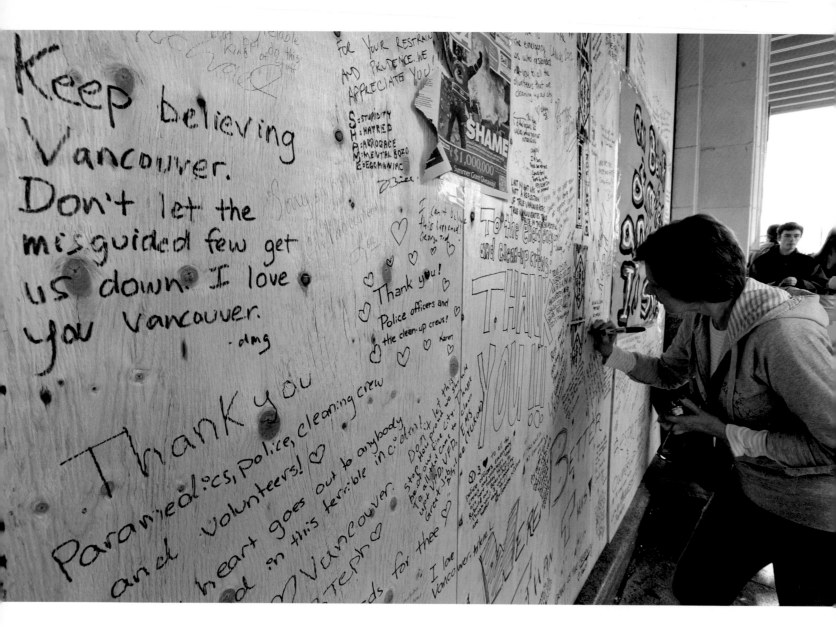

As the pain of what happened on the ice was settling in, the horror of what was happening outside the arena took over. The joy of more than 100,000 fans sharing their love for the Canucks at public viewing parties had vanished as angry mobs flipped and burned cars, smashed windows, and looted stores. The next day, real Canucks fans and committed citizens took to the streets with organized clean-up teams, leaving messages of love and hope on the boarded-up windows of the Bay. The thousands of messages, and the boards they were written on, will form a permanent reminder of the love Vancouverites have for their city and their team, and of this magnificent, magical thrill ride.

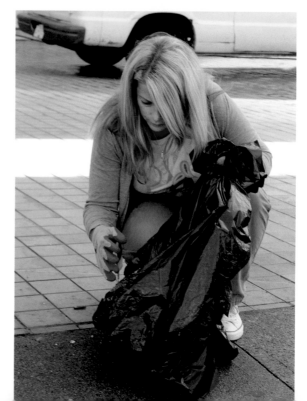

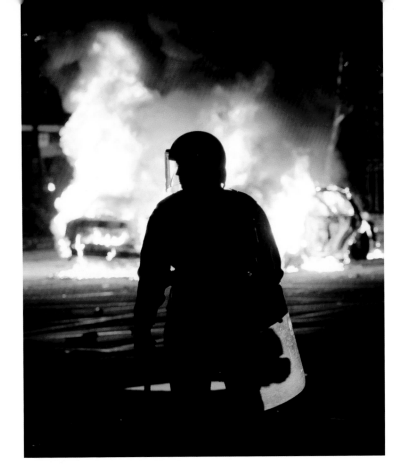

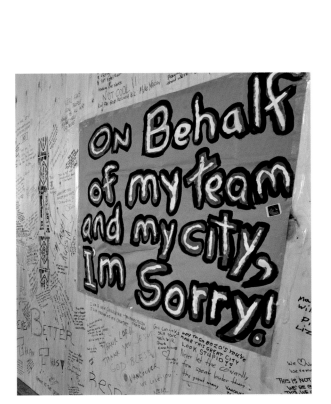

THE VANCOUVER CANUCKS' MVP

DANIEL SEDIN

IF YOU WERE GOING to poll one hundred people to select the MVP from the Vancouver Canucks' remarkable season, they'd probably all select Daniel Sedin. And why not? From Games one through eighty-two, Sedin was the best player on the NHL's best team, leading the league in scoring by a comfortable margin while avoiding any prolonged dry spells.

But here's the real measure of the Canucks' year. While you can't dismiss the statistical weight of Daniel's campaign, you can still make a very good argument for at least two other players to be on that list—and that doesn't even include Henrik Sedin, the reigning Hart Trophy winner who finished fourth in the NHL in scoring. If you were wondering why the Canucks had the NHL's most dominating regular season since the fabled Montreal Canadiens of '77–78, you need look no farther than its depth.

What other NHL team, for example, could boast a second-line centre who scored forty-one goals while being nominated for the Selke Trophy as the NHL's best defensive forward? Say hello to Ryan Kesler, who was in the larger conversation about the league's overall MVP award before a late-season flat spell. This season, he also emerged as the best two-way centreman in the league, surpassing the likes of Boston's Patrice Bergeron, Philadelphia's Mike Richards, and Anaheim's Ryan Getzlaf. Kesler turns twenty-seven this summer and is just entering his peak years. Suffice to say it will be interesting to track his career arc.

Note, too, that until the final few games of the Stanley Cup Final, a debate raged concerning the Canucks' playoff MVP. This time, if you polled those same one hundred people, it would have been Kesler, who scored seven goals and eleven assists through the first three rounds while shutting down Chicago's Jonathan Toews in the first round and almost beating Nashville single-handedly. That performance will be remembered as the greatest individual series in Canucks' history.

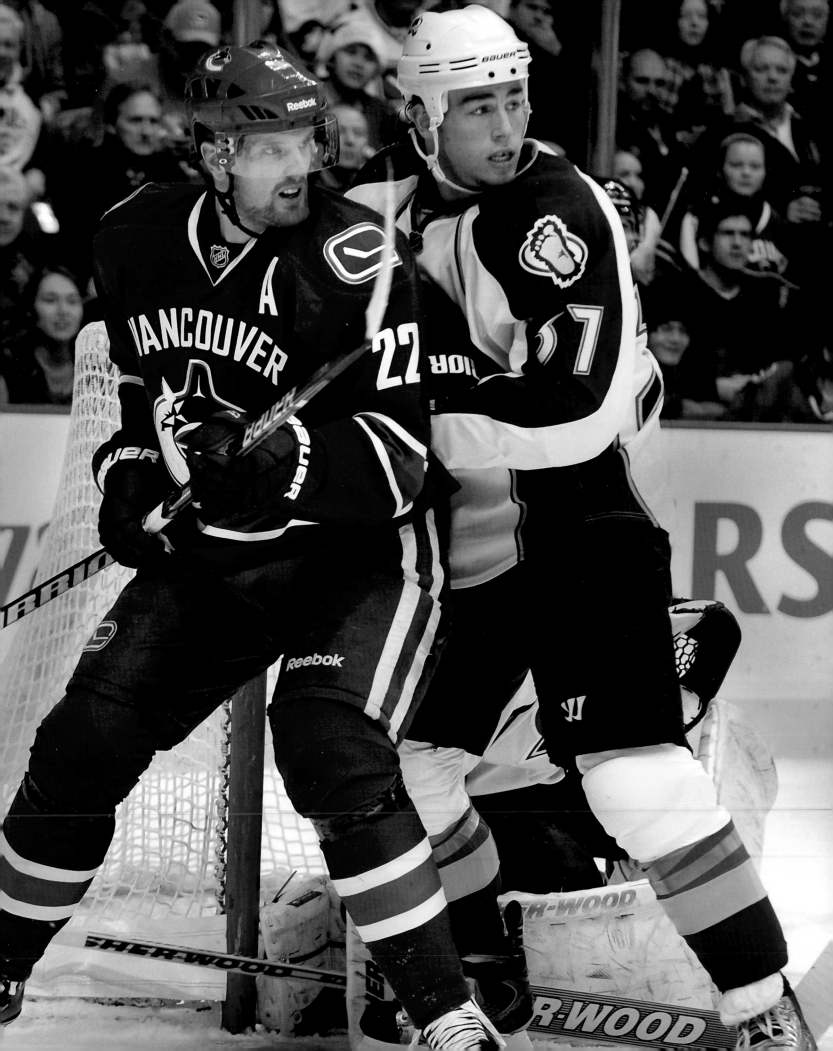

And how about Roberto Luongo? We can argue about Luongo's playoff performance until we're blue in the face, but there's no argument about his regular season. We're talking about a goalie who led the NHL in saves, finished third in save percentage, and was a Vezina finalist. Some seasons, that makes a finalist for the Hart. On this well-rounded team, Luongo was the likely the third-most valuable Canuck.

Of course, by the late stages of the Stanley Cup Final, Luongo had surpassed Kesler as the Canucks' MVP with shutouts in Games 1 and 5 in Vancouver and

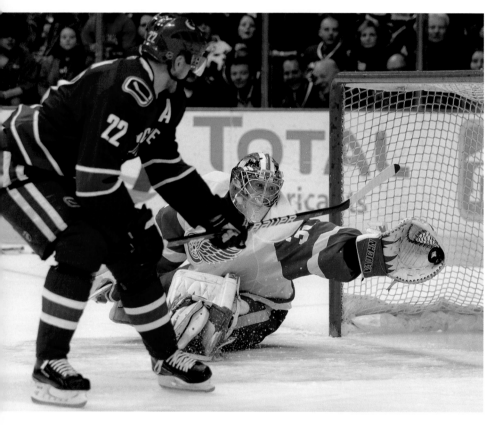

an overtime victory in Game 2. Henrik had also barged his way into that conversation with a bravura performance of his own against San Jose, which lifted him to the top of the playoff scoring lead just ahead of—you guessed it—his twin brother.

So they didn't get the ending right. Some combination of Tim Thomas—the man who won the Conn Smythe—the Bruins' own depth and excellence, and the almost inhuman wear and tear of the playoff grind conspired to end the Canucks' season one game short of the only trophy everyone on the team really wanted. Unfortunately, the lasting image for many from the Canucks' spring of 2011 will be Bruins captain Zdeno Chara holding the Grail over his head in the Canucks' home building.

There's no disguising the bitter disappointment of that moment but, in the fullness of time, the Canucks' regular season with its roster of valuable players and long list of record-setting achievements will be remembered with a greater appreciation.

But in the end, you can't ask for a better representation of this team than Daniel Sedin. By now, the Sedins' story has been committed to memory by every Canucks fan, but that shouldn't stop anyone from taking a moment to fully consider Daniel's year.

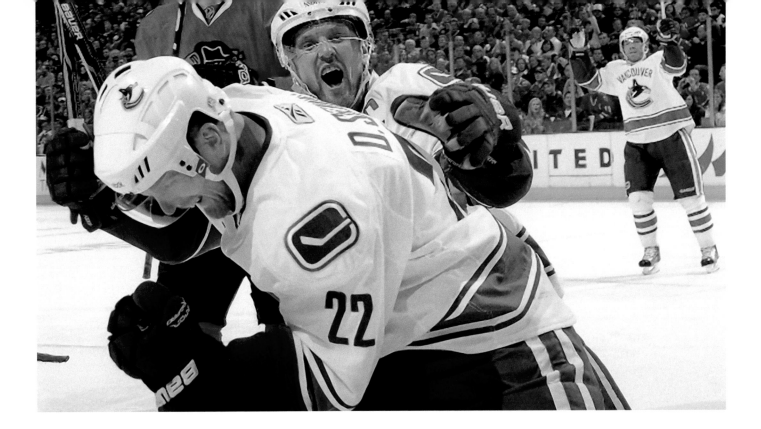

One season after his brother carted off the NHL's most coveted individual trophy, Daniel came back and took his own place among the game's greatest players. The 104 points says a lot—it was five more than second-place Martin St. Louis from Tampa—but it was the way the total was reached that reveals so much about this player. He was superb, but he was also superbly consistent and earned his points within the larger framework of the Canucks' team game. He and Henrik keyed the NHL's best power play. Among his forty-one goals were ten game-winners. Of the league's top-ten scorers, only Anaheim's Teemu Selanne averaged less ice per game than Daniel's 18:33—that's efficiency.

And as great as he was on the ice, he—alongside brother and best friend Henrik—was just as good off it. The Sedins will always be revered in Vancouver for their selfless gift of $1.5 million to Vancouver Children's Hospital and their tireless good works.

To be around them every day, to see the way they represent themselves and their team, to see the work they put into their craft, to see the game-in, game-out excellence, is the real measure of both players. And a most valuable part of the Vancouver Canucks.

ED WILLES, *The Province*

FACING: While his brother Henrik is known as the one with the great pass, Daniel Sedin has the nose for the net. That was never more apparent than in this magical season.

ABOVE: In the first round of the play-offs—the epic battle against the Black-hawks—Daniel Sedin proved he could handle the pressure cooker of the United Center. Henrik supplied the passes; Daniel finished the job.

A SEASON TO REMEMBER

THIS FORTIETH SEASON, this season of all seasons, included the miraculous—Manny Malhotra returning from eye surgery in time for the Stanley Cup Final and Alex Edler coming back from back surgery—and the tragic: Mason Raymond's near-paralysis.

It included a second NHL scoring champion, Daniel Sedin, following the lead of his brother Henrik from the season before. And it included the emergence of Ryan Kesler as a true star.

All it lacked was the much-longed-for fairy-tale ending as the Canucks finished one win short of claiming the first Stanley Cup in the club's forty-year history.

The season began with most reasonable observers figuring Shane O'Brien would be on the team and Kevin Bieksa would not. It included Rick Rypien grabbing a fan in Minnesota, Darcy Hordichuk losing out to Guillaume Desbiens for a roster spot, Dan Hamhuis playing even better than advertised, and Keith Ballard becoming an expensive spare part while the player he was traded for— Michael Grabner—became one of the best rookies in the league.

It began with high expectations and wrapped up with downtown Vancouver—and the dreams of Canucks fans—in flames.

But for one evening the Canucks gave Vancouver the gift of hope: a seventh game in the Stanley Cup Final, a chance to erase forty years of hurt. A record 8.76 million Canadians tuned into the game on CBC, making it the most watched NHL broadcast in CBC history. More than 100,000 people flooded the downtown core to watch on big screen TVs. In the end, the Canucks came up short, but they added another exhilarating chapter to the team history.

The final series wasn't filled with heroic hockey, but it offered up great drama. Things made as much sense as abstract art: Roberto Luongo let in fifteen goals in three games in Boston, but was nearly unbeatable at Rogers Arena, until the most important game of all; back-to-back scoring champions Henrik and Daniel Sedin could barely muster a point in the final series—nor could Kesler, a warrior in the previous two series. There was hardly a more

ABOVE: The Stanley Cup Final brought all sorts of spectacle to Rogers Arena, including appearances by Don Cherry, and introduced a global audience to the magic of Mark Donnelly's rendition of "O Canada" accompanied by eighteen thousand fans.

fringe player in the lineup than defenceman Aaron Rome, but his concussion-inducing hit on Nathan Horton in Game 3 and the suspension that followed turned the series on its head.

The Canucks entered the season as odds-on favourites to win the Stanley Cup, and responded with a Presidents' Trophy as the top team in the NHL during the regular season. It isn't the silverware teams live and die for, but it was a feat to be admired, and it was the first time for this franchise. And it held promise for what was to come.

But while the promised Cup wasn't delivered, taking a detour at the last turn, several new heroes emerged over the course of the season.

Bieksa was expected to be traded due to salary cap issues, but he was saved by Sami Salo's ruptured Achilles. Salo's successful rehab was anything but assured, given his history of injury, but he returned to the lineup in fine form. Bieksa, meanwhile, paired with Hamhuis to become one of the best shut-down tandems in the league. A defenceman named Chris Tanev, who grew a foot in Grade 12 and was playing Junior A in Ontario two seasons ago, made a huge contribution after his shock inclusion in the Final. Alex Burrows, after returning from off-season shoulder surgery, claimed his place on the Sedin line with his solid, focused play. Backup goalie Cory Schneider emerged as a legitimate number-one netminder and got his name, alongside Luongo's, on the Jennings Trophy for fewest goals allowed in the regular season.

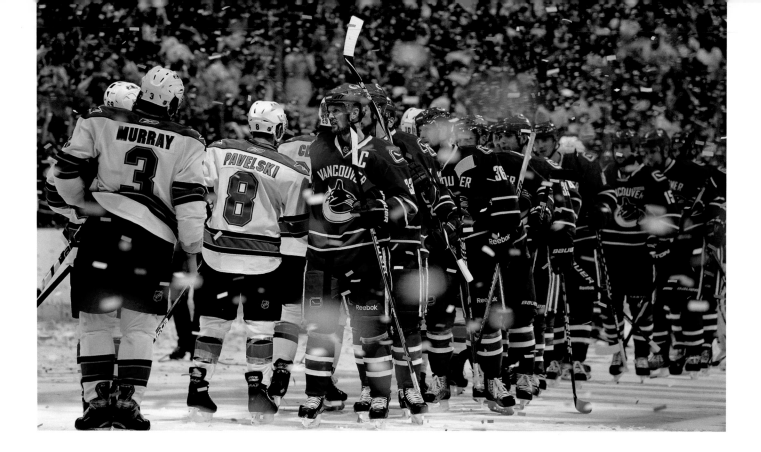

Up front, Daniel Sedin followed in twin brother Henrik's footsteps, leading the league in scoring to win the Art Ross Trophy. Think about that for a second: brothers, identical twins, winning the NHL scoring title in back-to-back seasons.

And who would have predicted Ryan Kesler, a first-time all-star this year, matching Daniel in goals scored during the regular season?

In the end—as the Boston Bruins lifted the Cup and skated across the Rogers Arena ice—the Canucks were only able to watch and declare, as Pittsburgh Penguins star Sidney Crosby had done before them: We don't ever want to feel this way again. In 2009, one long year after his team fell to the Detroit Red Wings in the Stanley Cup Final, Crosby won his Cup. And these Canucks may very well do the same thing.

Each season starts with promise. This team has a great core. There's room to add and subtract, to sharpen the points that made the Canucks an elite team—the league's best over eighty-two games—in 2010–2011.

This post-season brought with it a painful learning experience, but it's nothing other teams haven't gone through. They must learn how to lose before they learn how to win.

It was a season to remember for so many reasons, a season to savour, but ultimately a season from which to move on and build. Again.

Believe.

GORD MCINTYRE, *The Province*

THE VANCOUVER CANUCKS

2010–11 TEAM ROSTER

TEAM CAPTAIN: Henrik Sedin

ALTERNATE CAPTAINS: Kevin Bieksa, Ryan Kesler, Manny Malhotra, Daniel Sedin

FORWARDS

#	NAME	HEIGHT	WEIGHT	BIRTHDAY	BIRTHPLACE
49	Alexandre Bolduc	6' 1"	197	26 JUN 1985	Montreal, QC
14	Alexandre Burrows	6' 1"	188	11 APR 1981	Pincourt, QC
15	Tanner Glass	6' 1"	210	29 NOV 1983	Regina, SK
36	Jannik Hansen	6' 1"	195	15 MAR 1986	Herlev, DNK
20	Chris Higgins	6' 0"	205	2 JUN 1983	Smithtown, NY, USA
39	Cody Hodgson	6' 0"	185	18 FEB 1990	Toronto, ON
17	Ryan Kesler	6' 2"	202	31 AUG 1984	Livonia, MI, USA
40	Maxim Lapierre	6' 2"	207	29 MAR 1985	Saint-Léonard, QC
27	Manny Malhotra	6' 2"	220	18 MAY 1980	Mississauga, ON
38	Victor Oreskovich	6' 3"	215	15 AUG 1986	Whitby, ON
21	Mason Raymond	6' 0"	185	17 SEP 1985	Cochrane, AB
37	Rick Rypien	5' 11"	190	16 MAY 1984	Coleman, AB
26	Mikael Samuelsson	6' 2"	218	23 DEC 1976	Mariefred, SWE
22	Daniel Sedin	6' 1"	187	26 SEP 1980	Ornskoldsvik, SWE
33	Henrik Sedin	6' 2"	188	26 SEP 1980	Ornskoldsvik, SWE
25	Sergei Shirokov	5' 10"	195	10 MAR 1986	Moscow, RUS
10	Jeff Tambellini	5' 11"	186	13 APR 1984	Calgary, AB
13	Raffi Torres	6' 0"	216	8 OCT 1981	Toronto, ON
54	Aaron Volpatti	6' 0"	215	30 MAY 1985	Revelstoke, BC

DEFENCEMEN

#	NAME	HEIGHT	WEIGHT	BIRTHDAY	BIRTHPLACE
41	Andrew Alberts	6' 5"	218	30 JUN 1981	Minneapolis, MN, USA
4	Keith Ballard	5' 11"	208	26 NOV 1982	Baudette, MN, USA
3	Kevin Bieksa	6' 1"	198	16 JUN 1981	Grimsby, ON
23	Alexander Edler	6' 3"	215	21 APR 1986	Ostersund, SWE
5	Christian Ehrhoff	6' 2"	203	6 JUL 1982	Moers, GER
2	Dan Hamhuis	6' 1"	209	13 DEC 1982	Smithers, BC
29	Aaron Rome	6' 1"	218	27 SEP 1983	Nesbitt, MB
6	Sami Salo	6' 3"	212	2 SEP 1974	Turku, FIN
57	Lee Sweatt	5' 9"	195	13 AUG 1985	Elburn, IL, USA
18	Christopher Tanev	6' 2"	185	20 DEC 1989	Toronto, ON

GOALTENDERS

#	NAME	HEIGHT	WEIGHT	BIRTHDAY	BIRTHPLACE
1	Roberto Luongo	6' 3"	217	4 APR 1979	Montreal, QC
35	Cory Schneider	6' 2"	195	18 MAR 1986	Marblehead, MA, USA

THE VANCOUVER CANUCKS

REGULAR SEASON STATISTICS

POS	POSITION
GP	GAMES PLAYED
G	GOALS
A	ASSISTS
P	POINTS
+/−	PLUS/MINUS
PIM	PENALTIES IN MINUTES
PP	POWER PLAY GOALS
SH	SHORT-HANDED GOALS
GW	GAME WINNERS
SHOTS	SHOTS ON GOAL
W	WINS
L	LOSSES
OT	OVERTIME LOSSES
SA	SHOTS AGAINST
GA	GOALS AGAINST
GAA	GOALS AGAINST AVERAGE
SV%	SAVE PERCENTAGE
SO	SHUTOUTS
TOI	TIME ON ICE

PLAYER	POS	GP	G	A	P	+/−	PIM	PP	SH	GW	SHOTS
Daniel Sedin	L	82	41	63	104	30	32	18	0	10	266
Henrik Sedin	C	82	19	75	94	26	40	8	0	4	157
Ryan Kesler	C	82	41	32	73	24	66	15	3	7	260
Mikael Samuelsson	R	75	18	32	50	8	36	5	0	2	215
Christian Ehrhoff	D	79	14	36	50	19	52	6	0	3	209
Alexandre Burrows	L	72	26	22	48	26	77	1	1	4	152
Mason Raymond	L	70	15	24	39	8	10	2	1	5	197
Alexander Edler	D	51	8	25	33	13	24	5	0	1	121
Manny Malhotra	C	72	11	19	30	9	22	3	1	2	111
Raffi Torres	L	80	14	15	29	4	78	3	0	4	115
Jannik Hansen	R	82	9	20	29	13	32	0	0	2	113
Dan Hamhuis	D	64	6	17	23	29	34	2	0	1	109
Kevin Bieksa	D	66	6	16	22	32	73	1	0	2	105
Jeff Tambellini	L	62	9	8	17	10	18	1	0	0	114
Tanner Glass	L	73	3	7	10	−5	72	0	0	1	45
Sami Salo	D	27	3	4	7	−3	14	1	0	0	39
Keith Ballard	D	65	2	5	7	10	53	0	0	0	53
Andrew Alberts	D	42	1	6	7	0	41	0	0	0	21
Chris Higgins	L	14	2	3	5	0	6	1	0	0	34
Aaron Rome	D	56	1	4	5	1	53	0	0	0	50
Alexandre Bolduc	C	24	2	2	4	1	21	0	0	1	21
Victor Oreskovich	R	16	0	3	3	1	8	0	0	0	19
Peter Schaefer	L	16	1	1	2	−3	2	0	0	0	10
Aaron Volpatti	L	15	1	1	2	−1	16	0	0	0	6
Cody Hodgson	C	8	1	1	2	1	0	0	0	0	9
Lee Sweatt	D	3	1	1	2	4	2	0	0	1	4
Maxim Lapierre	C	19	1	0	1	−1	8	0	0	0	23
Mario Bliznak	C	4	1	0	1	1	0	0	0	0	1
Sergei Shirokov	R	2	1	0	1	1	0	0	0	0	6
Christopher Tanev	D	29	0	1	1	0	0	0	0	0	15

GOALTENDERS

PLAYER	GP	W	L	OT	SA	GA	GAA	SAVES	SV%	SO	TOI
Roberto Luongo	60	38	15	7	1,753	126	2.11	1,627	.928	4	3,589:39
Cory Schneider	25	16	4	2	714	51	2.23	663	.929	1	1,371:47

NHL

2010–11 REGULAR SEASON LEAGUE STANDINGS

WESTERN CONFERENCE

TEAM	W	L	OT	PTS	GF	GA	HOME	AWAY
Vancouver	**54**	**19**	**9**	**117**	**262**	**185**	**27–9–5**	**27–10–4**
San Jose	48	25	9	105	248	213	25–11–5	23–14–4
Detroit	47	25	10	104	261	241	21–14–6	26–11–4
Anaheim	47	30	5	99	239	235	26–13–2	21–17–3
Nashville	44	27	11	99	219	194	24–9–8	20–18–3
Phoenix	43	26	13	99	231	226	21–13–7	22–13–6
Los Angeles	46	30	6	98	219	198	25–13–3	21–17–3
Chicago	44	29	9	97	258	225	24–17–0	20–12–9
Dallas	42	29	11	95	227	233	22–11–8	20–18–3
Calgary	41	29	12	94	250	237	23–13–5	18–16–7
St. Louis	38	33	11	87	240	234	23–13–5	15–20–6
Minnesota	39	35	8	86	206	233	19–17–5	20–18–3
Columbus	34	35	13	81	215	258	17–19–5	17–16–8
Colorado	30	44	8	68	227	288	16–21–4	14–23–4
Edmonton	25	45	12	62	193	269	13–22–6	12–23–6

EASTERN CONFERENCE

TEAM	W	L	OT	PTS	GF	GA	HOME	AWAY
Washington	48	23	11	107	224	197	25–8–8	23–15–3
Philadelphia	47	23	12	106	259	223	22–12–7	25–11–5
Boston	46	25	11	103	246	195	22–13–6	24–12–5
Pittsburgh	49	25	8	106	238	199	25–14–2	24–11–6
Tampa Bay	46	25	11	103	247	240	25–11–5	21–14–6
Montreal	44	30	8	96	216	209	24–11–6	20–19–2
Buffalo	43	29	10	96	245	229	21–16–4	22–13–6
N.Y. Rangers	44	33	5	93	233	198	20–17–4	24–16–1
Carolina	40	31	11	91	236	239	22–14–5	18–17–6
Toronto	37	34	11	85	218	251	18–15–8	19–19–3
New Jersey	38	39	5	81	174	209	22–16–3	16–23–2
Atlanta	34	36	12	80	223	269	17–17–7	17–19–5
Ottawa	32	40	10	74	192	250	16–20–5	16–20–5
N.Y. Islanders	30	39	13	73	229	264	17–18–6	13–21–7
Florida	30	40	12	72	195	229	16–17–8	14–23–4

W	WINS
L	LOSSES
OT	OVERTIME LOSSES
PTS	POINTS
GF	GOALS FOR
GA	GOALS AGAINST
HOME	HOME RECORD
AWAY	ROAD RECORD

NHL

2010–11 REGULAR SEASON SCORING LEADERS

	PLAYER	TEAM	POS	GP	G	A	P	+/−	PIM	PP	SH	GW	SHOTS
1	**Daniel Sedin**	VAN	L	82	41	63	104	30	32	18	0	10	266
2	Martin St. Louis	TBL	R	82	31	68	99	0	12	4	0	7	254
3	Corey Perry	ANA	R	82	50	48	98	9	104	14	4	11	290
4	**Henrik Sedin**	VAN	C	82	19	75	94	26	40	8	0	4	157
5	Steven Stamkos	TBL	C	82	45	46	91	3	74	17	0	8	272
6	Jarome Iginla	CGY	R	82	43	43	86	0	40	14	0	6	289
7	Alex Ovechkin	WSH	L	79	32	53	85	24	41	7	0	11	367
8	Teemu Selanne	ANA	R	73	31	49	80	6	49	16	0	5	213
9	Henrik Zetterberg	DET	L	80	24	56	80	−1	40	10	0	3	306
10	Brad Richards	DAL	C	72	28	49	77	1	24	7	0	3	272
11	Eric Staal	CAR	C	81	33	43	76	−10	72	12	3	8	296
12	Jonathan Toews	CHI	C	80	32	44	76	25	26	10	1	8	233
13	Claude Giroux	PHI	R	82	25	51	76	20	47	8	3	5	169
14	Ryan Getzlaf	ANA	C	67	19	57	76	14	35	7	0	4	117
15	**Ryan Kesler**	VAN	C	82	41	32	73	24	66	15	3	7	260
16	Patrick Marleau	SJS	L	82	37	36	73	−3	16	11	2	9	279
17	Thomas Vanek	BUF	L	80	32	41	73	2	24	11	0	5	238
18	Loui Eriksson	DAL	L	79	27	46	73	10	8	10	1	6	179
19	Patrick Kane	CHI	R	73	27	46	73	7	28	5	0	2	216
20	Anze Kopitar	LAK	C	75	25	48	73	25	20	6	1	6	233

POS	POSITION
GP	GAMES PLAYED
G	GOALS
A	ASSISTS
P	POINTS
+/−	PLUS/MINUS
PIM	PENALTIES IN MINUTES
PP	POWER PLAY GOALS
SH	SHORT-HANDED GOALS
GW	GAME WINNERS
SHOTS	SHOTS ON GOAL

AWARDS

PRESIDENTS' TROPHY: VANCOUVER CANUCKS
Given to the team that finishes with the most
points in the league during the regular season

ART ROSS TROPHY: DANIEL SEDIN
Given to the player who leads the league in
scoring points at the end of the regular season

JENNINGS TROPHY: ROBERTO LUONGO AND CORY SCHNEIDER
Given to the goalkeeper(s) having played a minimum
of 25 games for the team with the fewest goals scored
against it in regular-season play

AWARD NOMINATIONS

Winners to be announced at the NHL Awards Ceremony on June 22, 2011

HART MEMORIAL TROPHY: DANIEL SEDIN
Given to the player judged to be the most valuable to his team as selected in
a poll of the Professional Hockey Writers' Association in all NHL cities

VEZINA TROPHY: ROBERTO LUONGO
Given to the goalkeeper judged to be the best at this position as voted by
the general managers of all NHL clubs.

FRANK J. SELKE TROPHY: RYAN KESLER
Given to the forward who best excels in the defensive aspects of the game,
as selected in a poll of the Professional Hockey Writers' Association

JACK ADAMS AWARD: ALAIN VIGNEAULT
Given to the coach judged to have contributed the most to his team's success;
presented by the National Hockey League Broadcasters' Association

TED LINDSAY AWARD: DANIEL SEDIN
Given to the "most outstanding player" in the NHL as voted by fellow members
of the National Hockey League Players' Association

NHL FOUNDATION PLAYER AWARD: DANIEL SEDIN, HENRIK SEDIN
Given to the player(s) who applies the core values of commitment,
perseverance, and teamwork to enrich the lives of people in his community

GENERAL MANAGER OF THE YEAR: MIKE GILLIS

THE VANCOUVER CANUCKS

PLAYOFF STATISTICS

FORWARDS AND DEFENCEMEN

#	POS	PLAYER	GP	G	A	P	+/−	PIM	PP	SH	GW	S	S%
33	C	Henrik Sedin	25	3	19	22	−11	16	2	0	1	46	6.5
22	L	Daniel Sedin	25	9	11	20	−9	32	5	0	2	99	9.1
17	C	Ryan Kesler	25	7	12	19	0	47	4	0	2	76	9.2
14	L	Alexandre Burrows	25	9	8	17	0	34	1	1	2	62	14.5
5	D	Christian Ehrhoff	23	2	10	12	−13	16	1	0	0	50	4.0
23	D	Alexander Edler	25	2	9	11	−4	8	0	0	0	58	3.4
3	D	Kevin Bieksa	25	5	5	10	6	51	1	0	1	47	10.6
36	R	Jannik Hansen	25	3	6	9	7	18	0	0	0	50	6.0
20	L	Chris Higgins	25	4	4	8	1	2	1	0	3	49	8.2
21	L	Mason Raymond	24	2	6	8	−1	6	0	0	0	57	3.5
13	L	Raffi Torres	23	3	4	7	2	28	0	0	1	20	15.0
2	D	Dan Hamhuis	19	1	5	6	5	6	1	0	0	26	3.8
6	D	Sami Salo	21	3	2	5	−4	2	3	0	1	33	9.1
40	C	Maxim Lapierre	25	3	2	5	2	66	0	0	1	42	7.1
26	R	Mikael Samuelsson	11	1	2	3	−4	8	0	0	1	20	5.0
29	D	Aaron Rome	14	1	0	1	3	37	0	0	0	10	10.0
39	C	Cody Hodgson	12	0	1	1	−4	2	0	0	0	12	0.0
27	C	Manny Malhotra	6	0	0	0	−1	0	0	0	0	6	0.0
41	D	Andrew Alberts	9	0	0	0	−8	6	0	0	0	6	0.0
4	D	Keith Ballard	10	0	0	0	−4	6	0	0	0	12	0.0
10	L	Jeff Tambellini	6	0	0	0	−3	2	0	0	0	2	0.0
49	C	Alexandre Bolduc	3	0	0a	0	0	0	0	0	0	2	0.0
15	L	Tanner Glass	20	0	0	0	−5	18	0	0	0	7	0.0
38	R	Victor Oreskovich	19	0	0	0	−6	12	0	0	0	14	0.0
18	D	Christopher Tanev	5	0	0	0	0	0	0	0	0	2	0.0

GOALTENDER

#	GOALTENDER	GPI	GS	MIN	GAA	W	L	OT	SO	SA	GA	SV%
1	Roberto Luongo	25	24	1427	2.56	15	10	0	4	711	61	.914
35	Cory Schneider	5	1	163	2.58	0	0	0	0	82	7	.915

POS	POSITION
GP	GAMES PLAYED
G	GOALS
A	ASSISTS
P	POINTS
+/−	PLUS/MINUS
PIM	PENALTIES IN MINUTES
PP	POWER PLAY GOALS
SH	SHORT-HANDED GOALS
GW	GAME-WINNING GOALS
S	SHOTS
S%	SHOOTING PERCENTAGE

GPI	GAMES PLAYED IN
GS	GAMES STARTED
MIN	MINUTES PLAYED
GAA	GOALS AGAINST AVERAGE
W	WINS
L	LOSSES
OT	OVERTIME LOSSES
SO	SHUTOUTS
SA	SHOTS AGAINST
GA	GOALS AGAINST
SV%	SAVE PERCENTAGE

NHL

PLAYOFF STATISTICS

PLAYER	TEAM	POS	GP	G	A	P	+/−	PIM	PP	SH	GW	OT	S	S%	TOI/G	SFT/G	FO%
David Krejci	BOS	C	25	12	11	23	8	10	2	0	4	1	57	21.1	20:07	24.3	51.8
Henrik Sedin	VAN	C	25	3	19	22	−11	16	2	0	1	0	46	6.5	20:56	29.6	45.8
Martin St Louis	TBL	R	18	10	10	20	−8	4	4	0	1	0	50	20.0	21:11	25.0	16.7
Daniel Sedin	VAN	L	25	9	11	20	−9	32	5	0	2	0	99	9.1	20:12	28.6	25.0
Patrice Bergeron	BOS	C	23	6	14	20	15	28	0	2	1	0	67	9.0	18:42	28.8	60.2
Brad Marchand	BOS	C	25	11	8	19	12	40	0	1	1	0	61	18.0	16:46	24.1	28.6
Ryan Kesler	VAN	C	25	7	12	19	0	47	4	0	2	1	76	9.2	22:34	30.6	54.1
Vincent Lecavalier	TBL	C	18	6	13	19	6	16	3	0	3	1	56	10.7	19:51	24.7	49.9
Alexandre Burrows	VAN	L	25	9	8	17	0	34	1	1	2	2	62	14.5	20:40	31.1	50.0
Nathan Horton	BOS	R	21	8	9	17	11	35	1	0	3	2	52	15.4	16:54	21.9	33.3
Michael Ryder	BOS	R	25	8	9	17	8	8	2	0	2	1	44	18.2	14:34	19.3	0.0
Teddy Purcell	TBL	R	18	6	11	17	4	2	1	0	1	0	46	13.0	13:42	19.4	18.2
Joe Thornton	SJS	C	18	3	14	17	−5	16	0	0	2	1	48	6.3	22:15	31.4	59.2
Dan Boyle	SJS	D	18	4	12	16	−7	8	2	0	1	0	67	6.0	26:10	31.1	0.0
Ryane Clowe	SJS	L	17	6	9	15	5	32	3	0	0	0	39	15.4	19:27	26.3	33.3
Pavel Datsyuk	DET	C	11	4	11	15	10	8	2	0	0	0	38	10.5	21:09	28.7	55.2
Logan Couture	SJS	C	18	7	7	14	2	2	1	0	0	0	64	10.9	19:23	28.8	45.2
Mark Recchi	BOS	R	25	5	9	14	7	8	2	0	1	0	40	12.5	16:09	22.5	47.4
Steve Downie	TBL	R	17	2	12	14	7	40	0	0	1	0	27	7.4	12:35	17.4	47.8
Patrick Marleau	SJS	L	18	7	6	13	−1	9	3	0	1	0	59	11.9	22:21	31.2	47.2
Joel Ward	NSH	R	12	7	6	13	4	6	3	0	0	0	28	25.0	20:25	29.5	39.5
Steven Stamkos	TBL	C	18	6	7	13	−5	6	3	0	1	0	46	13.0	19:43	24.0	50.8
Chris Kelly	BOS	C	25	5	8	13	11	6	0	0	0	0	28	17.9	15:28	23.0	47.9
Milan Lucic	BOS	L	25	5	7	12	11	63	1	0	0	0	56	8.9	17:54	22.7	21.4
Simon Gagne	TBL	L	15	5	7	12	6	4	0	0	1	0	21	23.8	15:52	21.5	75.0
Rich Peverley	BOS	C	25	4	8	12	6	17	0	0	2	0	42	9.5	16:11	23.2	53.5
Christian Ehrhoff	VAN	D	23	2	10	12	−13	16	1	0	0	0	50	4.0	22:26	28.6	0.0
Claude Giroux	PHI	R	11	1	11	12	2	8	0	0	0	0	21	4.8	21:57	28.6	55.7
Sean Bergenheim	TBL	L	16	9	2	11	2	8	0	0	1	0	46	19.6	14:09	21.1	47.4
Dominic Moore	TBL	C	18	3	8	11	−3	18	1	0	0	0	26	11.5	17:46	24.8	48.4

POS	POSITION	**SH**	SHORT-HANDED GOALS
GP	GAMES PLAYED	**GW**	GAME-WINNING GOALS
G	TOTAL GOALS	**OT**	OVERTIME WINS
A	TOTAL ASSISTS	**S**	TOTAL SHOTS
P	TOTAL POINTS	**S%**	SHOOTING PERCENTAGE
+/−	PLUS/MINUS	**TOI/G**	TIME ON ICE PER GAME
PIM	PENALTY MINUTES	**SFT/G**	AVERAGE SHIFTS PER GAME
PP	POWER PLAY GOALS	**FO%**	FACEOFF WIN PERCENTAGE

PHOTO CREDITS

THE PROVINCE AND THE VANCOUVER SUN ROSTER

CAPTAINS

From humble beginnings as a peanut vendor at the Pacific Coliseum during the Canucks' early days, **PAUL CHAPMAN** has gone on to cover most aspects of the Vancouver sports scene. After covering the CFL, NHL, NBA, and the Olympics for *The Province*, he became Sports Editor in 1998. He became City Editor, News Editor, and Olympics Editor for the 2010 Winter Games and is now *The Province*'s Senior News Editor, in charge of all things digital.

BEV WAKE is the Projects and Features Editor at *The Vancouver Sun*. A former Sports Editor at *The Sun* and the *Ottawa Citizen*, where she'd also worked as a reporter, Wake led *The Sun*'s Olympic coverage from 2006 through 2010, attending the Games in Turin, Beijing, and Vancouver. An avid sports fan, she has hockey in her blood: she was born in "Canada's Hockey Factory"—Kelvington, Saskatchewan. She grew up in Brentwood Bay, B.C., and worked as a sports reporter at newspapers in Victoria and Parksville.

THE TEAM

JASON BOTCHFORD joined *The Province* in June 2005 after spending seven years at the *Toronto Sun* as a cops, court, features, and sports reporter. Botchford moved to the Canucks beat in 2006 and has become a national source for Canucks and NHL information, regularly appearing on sports radio and TV shows across the country, notably TSN's *Inside Hockey*. He was one of the lead hockey writers for the 2010 Winter Olympics.

CAM COLE joined *The Vancouver Sun* in 2005 after seven years in Toronto as principal sports columnist at the *National Post*. He began his sports writing career at the *Edmonton Journal* in 1975 and has been writing a daily sports column for the last twenty-six years. Cole has covered twenty-seven Stanley Cups and thirteen Olympic Games.

MIKE HAGER began working at *The Vancouver Sun* in the spring of 2011, just as the Canucks hit their playoff stride. He fondly remembers their previous run to the finals seventeen years earlier and recalls his first NHL game in the Pacific

Coliseum, when he was hit in the head by a Trevor Linden clearing attempt. After brief stints writing in Chile and South Korea, Hager is happy to be reporting in his hometown.

JIM JAMIESON has covered the NHL for fourteen seasons, and sports since 1980. He covered the Canucks' run to the Stanley Cup Final in 1994. He also chronicled the first big influx of Soviet hockey players into the NHL in 1989, and the careers of Canucks stars Trevor Linden and Pavel Bure. After a seven-year hiatus as a business reporter, he came back to the NHL beat in 2007.

BEN KUZMA has spent his three-decade career in the West, sandwiching a four-year stint at the *Calgary Herald* between two stays at the *Kamloops Daily News*, where he was a columnist and Sports Editor from 1992 to 1995. He came to *The Province*'s sports department in 1995, signing up for the Canucks beat three years later. A regular contributor to the TEAM 1040, he also covered the Flames' run to the Stanley Cup in 1989.

IAIN MACINTYRE was born and grew up in Vancouver. He joined *The Vancouver Sun* as a reporter in 1990—about ten years after he delivered the newspaper—and has been covering the Vancouver Canucks since 1991. In 2005, he became a columnist. MacIntyre also worked for the *Kamloops Daily News* and the *Review* in Richmond, where he lives with his wife and two children, near his old paper route.

GORD MCINTYRE has covered the NHL, NBA, CFL, and Indy racing for *The Province*. A native of Saskatoon, he was a business writer for the *Regina Leader-Post* before moving to Vancouver twenty years ago to join *Province* sports.

HARRISON MOONEY is a writer and the co-founder of PassItToBulis. com, the hockey blog that knows who needs the puck. He holds a Bachelor of Arts degree in English with a minor in Media & Communications from the University of the Fraser Valley and is currently completing a Master's of Arts and Interdisciplinary Humanities from Trinity Western University. In his spare time, he writes theatre, short fiction and music, plays Scrabble, and eats peaches.

IAN WALKER is in his eleventh year with *The Sun*; this season was his first on the Canucks beat. The transplanted Maritimer has carved out a niche in the country's NHL landscape with his conversational style, first-person approach, and focus on the human element of sport. Walker's past beats include the CFL, the Vancouver Whitecaps, and junior hockey, where he covered two Memorial Cups and the 2006 World Junior Hockey Championship.

ED WILLES started his journalism career in 1982 at the *Medicine Hat News*, then moved on to the *Regina Leader-Post* and the *Winnipeg Sun*, where he was the hockey writer for eight years. In 1998, he joined *The Province*, where his focus is the Canucks and Lions. Willes has penned two books: *Gretzky to Lemieux: The Story of the 1987 Canada Cup* and *The Rebel League*, on the WHA. One of Postmedia's main Olympics writers, he featured prominently in the 2010 Games in Vancouver and at seven other Olympic Games.

BRAD ZIEMER is a sportswriter at *The Vancouver Sun*, where he has worked since 1985. A past Sports Editor of *The Sun*, he currently covers the Canucks and the local golf scene. Before joining *The Sun*, he spent five years working for the Canadian Press news agency in Edmonton, where he covered his first Stanley Cup Final in 1983.

With special thanks to Debbie Millward, Manager, News Research Library for Pacific Newspaper Group; Kate Bird, Adrian Mitescu, and Carolyn Soltau, researchers and librarians at Pacific Newspaper Group; and Dick Cuddeford, for his help with images.